Women in American History

Mari Jo Buhle, Jacquelyn Hall,
and Anne Firor Scott,
*Editors*

*Books in the Series Women in American History*

———

Women Doctors in Gilded-Age Washington:
Race, Gender, and Professionalization
*Gloria Moldow*

Friends and Sisters: Letters between
Lucy Stone and Antoinette Brown Blackwell, 1846–93
*edited by Carol Lasser and Marlene Merrill*

Reform, Labor, and Feminism:
Margaret Dreier Robins and the Women's Trade Union League
*Elizabeth Anne Payne*

# Reform, Labor, and Feminism

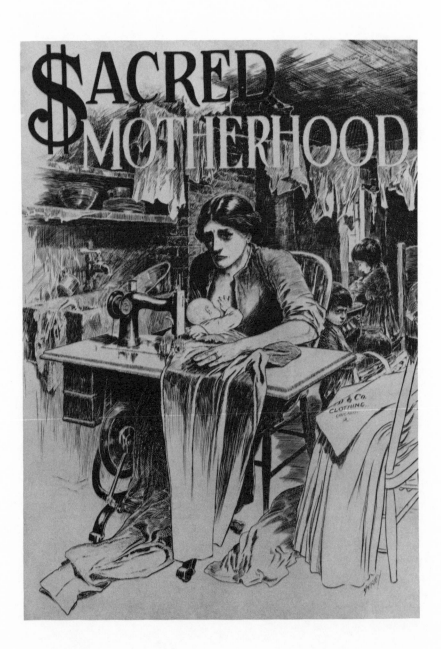

# *Reform, Labor, and Feminism*

## Margaret Dreier Robins and the Women's Trade Union League

### *Elizabeth Anne Payne*

University of Illinois Press
*Urbana and Chicago*

Publication of this work was supported in part by a grant
from the Andrew W. Mellon Foundation.

*This book is printed on acid-free paper.*

Library of Congress Cataloging-in-Publication Data

Payne, Elizabeth Anne, 1943–
  Reform, labor, and feminism.

  (Women in American history)
  Bibliography: p.
  Includes index.
  1. Robins, Margaret Dreier.   2. Women in trade-unions
—United States—Biography.   3. National Women's Trade
Union League of America—History.   4. Feminism—
United States—History.   I. Title.   II. Series.
HD6079.2.U5P38   1988      331.88′092′4   [B]      87-10794
ISBN 0-252-01445-6 (alk. paper)

*To the Memory of my Father*
Albert Dauley Payne

The nature of the attack of modern industrial despotism upon the integrity and promise of our individual and national life is such as to make a special call upon the women of our country, and it seems to have been reserved for this generation to work out a new basis for our industrial civilization. Freedom, maternity, education and morality—all the blessed and abiding interests of childhood and home—are at issue in the supreme struggle. All women who honor their sex and love their country should unite with us and our working sisters in the struggle for industrial freedom.

—*Margaret Dreier Robins*

# Contents

# Acknowledgments

It is a pleasure to express gratitude to those who helped me in my work. Burton J. Bledstein's seminars introduced me to cultural history, and his guidance in my research and writing was invaluable. Josephine Harper and Katharine Thompson at the Wisconsin State Historical Society gave me assistance in their collections. Eva Moseley and Barbara Haber of Schlesinger Library helped me explore their manuscript collections. The Graduate College of the University of Illinois at Chicago gave me a university fellowship that allowed uninterrupted research for a year. Robert L. Moore also provided support and encouragement in the early stage of this project. Theodore Dreier, Sr., graciously shared recollections of his family and allowed me access to papers and memorabilia. Lisa von Borowsky allowed me to quote from the Robins's papers and showed me around Chinsegut, the Robins's estate. Edward T. James, the editor of the papers of the Women's Trade Union League, passed on countless references to relevant material and gave me much useful advice. Friends and colleagues criticized portions of the manuscript: J. Leonard Bates, Jane DeHart-Mathews, William Chafe, Marie McGraw, Marion Miller, Karen Halttunen, Allen F. Davis, Michael Sherry, Eileen Boris, James Briscoe, Michael O'Brien, and Otis Graham. Most of Robert Wiebe's criticisms and suggestions are gratefully incorporated here. Mari Jo Buhle and Anne Firor Scott, editors of the Women in American History series, offered valuable advice in the final stage of writing.

Robert Bauer, June Schuster, and Terry Garrity provided cheerful and efficient assistance in typing the manuscript, and Carol Saller's copy-editing of the manuscript was exemplary. Suzanne Maberry's editorial help and bibliographical research were indispensable in helping me complete the final tasks for the book. As editor of the manuscript, Carole Appel gave excellent advice throughout. Carmen Russell helped in selecting illustrations.

Willard B. Gatewood, Jr., my colleague and friend, was generous with his counsel and assistance in helping me finish the book. My deepest thanks go to Robert Finlay, whose countless suggestions regarding style and structure helped shape the book itself. Most of all, however, I am grateful for his patience and companionship at all times. Conwill Payne Finlay, who is only a few weeks old at this writing, in no way aided my work, but her arrival at the time of its completion ensures that I shall always happily associate her with it.

# Introduction

Margaret Dreier Robins and the Women's Trade Union League (WTUL) expressed the values of an important branch of Progressivism, and their joint stories illuminate a significant aspect of early twentieth-century reform. Founded as an alliance of middle-class and working women in 1903, the WTUL led the drive to organize women into trade unions, secure protective legislation for female workers, and educate the public to the needs of working women. In the name of feminist ideals and labor reform, League women were committed to changing society by addressing the problems of workers and the urban poor. Unionism and feminism rarely were partners in the Progressive era, and the diversity of women in the League highlighted its unusual character. Jewish seamstresses, Italian candy makers, and Swedish boot workers joined with middle-class allies to organize and protect female wage earners. Members included former debutantes and box makers, heiresses as well as brewery workers. Middle-class women who were part of the social settlement movement in New York, Chicago, and Boston worked with the League, as did female trade unionists prominent in the labor movement during the Progressive period.[1]

Women of the WTUL organized trade unions and provided strike support during most of the major labor upheavals of the period. It was primarily women from the Chicago branch of the League who won passage of federal legislation calling for a massive pioneering survey of the conditions of wage-earning women

and children, an investigation that paved the way for much of the protective legislation of the Progressive era. The League offered reform-minded women an institutional base and a spiritual home, as well as a platform from which they could address the social consequences and civic implications of the new industrial order.

An analysis of the ideology and motivations of the Women's Trade Union League, especially as seen in Robins, its leading figure, contributes to understanding the conjunction of reform, labor, and feminism in the Progressive period. Examining the ideals and aspirations of Robins and her colleagues helps to illuminate the role of a certain kind of female reformer in the early decades of this century. This study begins by detailing Robins's movement toward reform at the end of the nineteenth century and concludes with an analysis of the confrontation between Robins's conception of reform and that embodied by the New Deal. The book therefore traces the shift in emphasis from benevolent activism through Progressivism to the bureaucratic liberalism of the New Deal and relates these changes to feminist sensibilities. The three central chapters deal respectively with the themes of reform, labor, and feminism during Robins's tenure as president of the League from 1907 to 1922.

The historical circumstances that brought Robins and the League together created a singularly felicitous union, for the individual and the organization exemplified an urge among socially conscious, well-to-do Americans to bridge the gap between themselves and wage earners. As a reformer, Robins was typical of the antistatist volunteer. Her moral passion and ambition for certain kinds of national regulation seemed natural companions. As a volunteer, she was equally at home as a stump orator and as a social investigator. She was proud to be part of the American tradition of voluntary social service and proud also that she had neither held a paid position nor accepted a government appointment. She remained suspicious of those whom she called "sociological settlement workers," like Grace Abbot, Sophonisba Breckenridge, and Florence Kelley. It was this outlook that led her to oppose the bureaucratic solutions of the New Deal, as did many (but certainly not all) Progressives.[2] In identifying the labor movement with Progressive values, however, Robins was certainly not representative

of contemporary reformers. Indeed, her concern for unskilled, immigrant working women distinguished her from the majority of her Progressive contemporaries, for few placed their central hopes for social regeneration in laborers and immigrants.

The records of her life as an activist testify to the impact Robins had upon her colleagues in reform. They were deeply moved by her message and thrilled by her eloquence; long after her retirement, she received letters of thanks from young women whose lives she had changed. She sustained the League not only with her money and energy but with the attractiveness of the ideas and motivations she set before her peers and followers. In order to understand her type of reformer—so much more common than a Jane Addams or a John Dewey—it is necessary to examine the source of her inspiration and certainty. This book attempts both to comprehend the nature of her appeal and to do justice to the integrity of her ideas.

Reform in the early twentieth century was diverse and complex, including movements for wider and more effective civic involvement, greater industrial efficiency, abolition of political corruption, regulation of business corporations, and prohibition of the liquor trade.[3] Robins was part of the social justice movement, which comprised mainly social workers like Jane Addams and Lillian Wald, clergy like Graham Taylor and Walter Rauschenbusch, and academics like John Dewey and George Herbert Mead. Holding a liberal, optimistic view of the individual, they aspired to reform society by improving the conditions of the urban working class. They saw society as malleable and responsive, the individual as laden with potential for self-development and rationality. Moreover, they perceived their era as a turning point in history and were committed to the idea that social problems could be mastered by effort and intelligence. As it turned out, however, events disappointed many of them, for they came to see the New Deal as a betrayal of the values of Progressives. People like Robins, Jane Addams, and John Dewey saw certain innovations of the 1930s as an abandonment of the American reform tradition, a substitution of bureaucratic liberalism for voluntary social service and civic education.

Labor, in the eyes of Robins and her colleagues, represented

America's best hope for social transformation. As a vehicle for that
transformation, the League was distinguished by its broad reform
agenda and cross-class character. As a coalition of middle-class
sympathizers and workers from various crafts, it enabled scores of
women an opportunity to work for the labor movement during a
time when the American Federation of Labor reserved that privi-
lege for highly skilled men in organized trades. The League had
dramatic successes with the International Ladies' Garment Work-
ers' Union and the United Garment Workers, and it helped prepare
the way for the creation of the Amalgamated Clothing Workers. The
League, however, faced overwhelming obstacles in bringing women
into unions because of the nature of the work force with which it
was dealing (unskilled, immigrant women), the opposition it faced
from men in the labor movement, and the nature of the WTUL itself
as a cross-class alliance. By addressing the problems of laborers,
raising funds during strikes, and lobbying for protective legislation,
League members made their most valuable contributions.

Feminism was at the basis of the League's conception of labor
and reform. Members of the WTUL believed that women could
transcend ethnic and class differences to forge an alliance con-
fronting social injustice. League women were immigrants' daugh-
ters who marched in suffrage parades, financiers' wives who bailed
out strikers, broom makers who lobbied legislators, club women
who inspected sweatshops and lead factories, and laundresses
and glove stitchers who looked to the women's movement as a
natural ally in their industrial struggle. These unusual juxtaposi-
tions were not to occur again in American history. They were pos-
sible in the Progressive era because the women of the League were
the heirs of a distinct female culture reaching back to the 1830s.
The first decades of the twentieth century witnessed a vigorous as-
sertion of that culture, with women working for reform across a
wide range of issues. At the same time, it was a final expression of
that tradition, for the very success of female reformers in influenc-
ing mainstream political culture spelled the end to a coherent
feminist program. In seeking to establish an alliance of women
across class and cultural lines, the League extended the ideal of
female solidarity further than any other feminist institution of the
period. As an examination of the feminist ideology of the League,

this book attempts to clarify the assumptions and aspirations of female culture in its mature and final days.

With regard to the three main themes of this study—reform, labor, and feminism—the League and many Progressives looked back to the movements of the nineteenth century rather than forward to the bureaucratic liberalism of postdepression America. In its conception of reform, the League represented a tradition that would be supplanted by the social programs and governmental initiatives of the New Deal. So, too, the League's notion of reform unionism was seen as disruptive within a labor movement defined by the narrow concerns of the American Federation of Labor. The feminism of the League was similarly overtaken in the 1920s by new ideas of woman's nature and prerogatives. For a brief time, however, labor concerns and feminist ideals met in an institution devoted to reform. And if the League's unique melding of reform unionism and social feminism failed to find a permanent place in American thought and institutions, if its ideals were not left as a legacy to the future, at least it can be said that Robins and the Women's Trade Union League shared that ideological failure with the Progressive movement itself. In the end, however, one turns to the League not so much to measure the limits of its success or even to place it in the history of American reform; rather, one seeks to understand the moral urgency, the values and aspirations, that impelled thousands of women from diverse backgrounds to join in efforts to change society as feminists and labor reformers.

## Notes

1. For institutional studies, see Gladys Boone, *The Women's Trade Union Leagues in Great Britain and the United States of America* (New York: Columbia University Press, 1942); Nancy Schrom Dye, *As Equals and as Sisters: Feminism, the Labor Movement, and the Women's Trade Union League of New York* (Columbia: University of Missouri Press, 1980); Robin Miller Jacoby, "The British and American Women's Trade Union Leagues, 1890–1925: A Case Study of Feminism and Class" (Ph.D. diss., Harvard University, 1977); also see James J. Kenneally, *Women and American Trade Unions* (St. Albans, Vt.: Eden Press Women's Publications, 1978), pp. 61–91; Allen F. Davis, "The Women's Trade Union League: Origins and Organization," *Labor History* 5 (Winter 1964): 3–17.

2. On Progressives and the New Deal, see Otis L. Graham, Jr., *An Encore for Reform: The Old Progressives and the New Deal* (New York: Oxford University Press, 1967).

3. On the diversity of Progressive reform, see John Whiteclay Chambers III, *The Tyranny of Change: America in the Progressive Era, 1900–1917* (New York: St. Martin's Press, 1980), pp. 105–39; see also Chambers's bibliographical essay (pp. 251–62).

# 1

## "A Woman Could Be Great": Margaret Dreier Robins and the Promise of Reform

"I've always wondered about you Dreier Sisters," an old reform colleague wrote to Mary Dreier in 1950, "what family background did you have which made you all so different from the average."[1] Indeed, few American families could claim four women as distinguished as the daughters of Theodor and Dorothea Dreier.[2] Margaret Dreier Robins (1868–1945) became the Progressive era's most energetic and articulate exponent of the rights of unskilled working women; from 1907 to 1922, she presided over the National Women's Trade Union League, the only significant feminist organization of the period to concentrate on working women. Dorothea Dreier (1870–1923), an artist trained in Impressionism, broke with that style to portray workers realistically; she developed tuberculosis while painting in the damp cottages of Dutch weavers and died in her early fifties. Mary Dreier (1875–1963) was a leader in labor, suffrage, and peace organizations, modeling her career after Margaret's. The two sisters were exceedingly close, and their voluminous correspondence chronicles a half century of involvement with American reform. Katherine Dreier (1877–1952) was also an artist concerned with social issues, but her attraction to an organic philosophy led in the 1930s to a sympathy for Nazism that appalled her progressive sisters. Her work was included in the famous 1913 Armory Exhibition, which introduced modern art to the American public; as the founder of Société Anonyme, she subsequently be-

came one of the ·country's foremost patrons of and propagandists for modern art.[3]

The parents of these talented and committed women came from Bremen, Germany. Theodor Dreier had emigrated to the United States in 1849 at the age of twenty-one, one of the migration of "Forty-Eighters" from Germany. He came to America to rebuild his family's fortune, for the revolutionary unrest had damaged the industry of Bremen, including the Dreier family's wholesale linen business. Dreier settled in New York City and became a clerk with Naylor and Company, an important iron supply firm. Competent and hard working, he was steadily promoted. When the company overextended itself during the Civil War, Dreier devised a plan to save the firm, and the grateful owners made him a partner.[4]

In 1864 Dreier, now thirty-six and established financially, returned to Bremen for a visit, probably in search of a wife. After a few weeks' courtship, he married his twenty-four-year-old cousin, Dorothea Adelheid Dreier. The daughter of a minister, Dorothea Dreier was both charming and exuberant. At the same time, she was an earnest product of Bremen's burgher class, refined in manner, accomplished in music and painting, and given to charitable work among her father's parishioners in the nearby village of Neuenkirchen. Dorothea and Theodor became intensely patriotic about America, and both saw their fervor as rooted in their Bremen citizenship. According to them, "the golden thread of democratic spirit" ran through the history of their native city. They emphasized that Bremen's burghers had wrested political power from the local archbishop, and that as an Imperial free city, Bremen jealously guarded its independence against surrounding forces. Overwhelmingly Protestant and still a republic at the time of Theodor's emigration, Bremen's civic identity was epitomized in the inscription on a statue of Roland in the main square, "Freedom I reveal to you. . . . for this give thanks to God."[5]

The Dreier family belonged to the assertive burgher class of Bremen, an important member of the Hanseatic League. Dreiers were among Bremen's leading merchants, civil servants, and clerics, and they traced their origins in the city back to the fourteenth century.[6] Theodor and Dorothea saw their family's history and Bremen's as interwoven, and in their eyes, Bremen's past had sig-

nificant parallels with America's. Both had resisted monarchy and the church, and both represented an antiauthoritarian quest for self-government and independence. Margaret Dreier Robins was proud that (as she understood it) not a single "Bremen man accepted knighthood from the Emperor . . . in the history of that little Republic."[7] When leading a march in 1907 protesting the trial of labor radicals, Margaret appealed as the basis for her action both to American values and to her legacy as a *Bremenerin*: "Is it so strange," she wrote to a friend, "that I, a free woman, whose fathers fought for their faith and founded the free cities of Germany, should take sides with those who are fighting for the fundamental right of personal liberty as guaranteed by our Constitution?"[8] The affection and allegiance of the Dreiers flowed to the city-state of Bremen, not to a united Germany. "I have always been proud of the fact," Mary Dreier wrote to Margaret, "that our branch of the family were democrats and never under the emperor—Father having come here when Bremen was still a free city."[9]

It became an article of family faith for the Dreiers that Theodor's arrival in America represented a virtually providential meeting of Old World republicanism with New World democracy. On the ninety-eighth anniversary of Theodor's emigration, Mary still celebrated his odyssey: "How great our good fortune that Father came to our country . . . and the spirit of the free Hanza [sic] City could find opportunity in our beloved U.S.A."[10] Throughout her reform career, Margaret pointed to Bremen as a source for her values and commitments. Her notions of civic virtue, self-reliance, and citizenship were in part based upon her idealized conception of the city-state of Bremen. At the same time, her ready acceptance of American political values was a natural extension of locating her roots in a German commune that survived into the nineteenth century. Seeing America in Bremen and Bremen in America, Margaret never was faced with the tangle of loyalties and traditions that often bedeviled the children of immigrants.

Theodor and Dorothea settled into a brownstone home in Brooklyn Heights. They had decided not to live in the nearby German community of College Park, for Dorothea was intent on being among Americans.[11] Brooklyn Heights was a middle-class community known for its civic institutions and populated mostly by de-

scendants of New England Protestants. The Heights considered it-
self at the crossroads of all that was promising in American life.[12]
That environment was to have a decided effect upon the Dreier
children.

Margaret Dorothea Dreier had been preceded by a sister who
died of diphtheria in infancy and by a brother who died shortly
after her own birth. No doubt because of these wrenching experi-
ences, the parents showed particular concern for their second
daughter, known in the family as Gretchen.[13] A Brooklyn Heights
friend later recalled her fascination with young Margaret, who in
the winter was heaped with blankets and drawn to school in a sleigh
by a zealous nurse. Lavished with care, Margaret was a robust
child, allegedly inheriting her dark good looks from a fancied
Spanish ancestor. Her best friend remembered that as a youngster
Margaret had "two outstanding external qualities then rarely seen
in our indigenous children—a rich rose-colored bloom on her
cheeks and an erect carriage that attracted attention everywhere."[14]
Her father's favorite of the five children—a brother, Edward, was
born in 1872—she exhibited self-assurance and a strong will from
early childhood. Toward her sisters and brother, she assumed a
quasi-parental authority, directing them in plays and tutoring them
in subjects she had mastered. Mary felt that the entire family had
been "ruled with a masterhand by the oldest daughter."[15] Margaret
early became accustomed to getting her way, and even her parents
did not present insuperable obstacles. On a visit to Bremen at the
age of twelve, she simply ignored her parents' complaints that she
was spending too much time at the cobbler's shop in Neuenkirchen,
a preoccupation they thought unbecoming for a middle-class girl;
eventually, however, they allowed her to act as the cobbler's ap-
prentice. Margaret's capacity in later years to deal with lower-class
working women without condescending superiority owes some-
thing to her childhood experience with the cobbler. As she re-
marked when arguing the merits of democratic culture, "I am glad I
met my old cobbler when I was a little girl in Neuenkirchen."[16] In
addition, her victories over her parents on issues such as that of
the cobbler confirmed her optimism, her sense that good inten-
tions combined with perseverance would always triumph.

A reserved man, Theodor Dreier was particularly close to his
outgoing eldest daughter, who of all the children looked most like

him. Margaret frequently recalled childhood experiences with her father:

> I used to go on long walks with him and always over to Pierrepont Place and Montague Terrace to see the great view. Then we drove always to the park and I remember as quite a little girl gathering chestnuts in Prospect Park with father and then going home and having him tell me stories while I sat with him in his great arm chair. . . . There was Copernicus and the stars, Charlemagne and his schools for everyday folk, and there were histories of Otto the Great and his son and grandson, with tales of Sicily and Italy and the glamour of the court and Queen Mathilde, mother of Otto the Great,—how well I remember father's telling me that a woman could be great.[17]

Margaret's father attributed to her a maturity well beyond her years and shared more of his world with her than with the other children. When she was twelve years old, she began serving as an occasional hostess at his dinner parties. As she grew older, she also helped her mother run the household, which numbered fifteen persons, including an uncle and seven servants. It was a busy and hospitable place. As many as sixty youngsters would attend the annual Christmas party for the Dreier children. Margaret's mother frequently invited musicians to dine and perform in her home, and when her children were young, she employed a tutor to teach them German and English songs each day. The home also welcomed immigrants, such as parishioners from Neuenkirchen or a "stray and somewhat lost German and Frenchman" who had heard that the Dreiers would offer help. "Mother . . . was generous and hospitable," Margaret said, "and at our table poor and rich, learned and unlearned, scholars and simple, ignorant folk met, and many a time became friends." There were limits to such democratic conviviality, however, for sometimes the children stayed home for Bible readings rather than attend church where they would be subject to "the smell of stale clothing" worn by poor German children.[18]

The Dreier family spent every other summer in Europe, mostly visiting Dorothea's parents in Neuenkirchen. Alternate summers were spent in a resort area of the Poconos, where Margaret taught Sunday school at a local church, an activity in keeping with her parents' stress upon self-improvement and social service. According to Mary, summer activities were planned "for development,"

including literature (but not novels), sketching, and music. In Brooklyn, the parents supplemented their children's formal schooling by hiring tutors in music, art, and language. Because the entire household spoke German during Margaret's early years, Theodor and Dorothea hired an English governess to supervise their children's studies.[19]

Margaret and her sisters were enrolled in George Brackett's School, a private institution for girls in Brooklyn Heights. Brackett and his sisters were pioneers in education, believing that the young girl should be introduced to the world, not "shut in conventional ignorance to preserve her purity of thought." Margaret later concluded that she received from the Bracketts the kind of schooling appropriate for a citizen, much superior to what was available to foreigners "who do not know the a, b, c, of democratic education."[20] She remained close to the Bracketts, and they in turn supported her career in social reform.

Since the Dreiers held the genteel view that higher education slighted the humanities, they would not allow their children to attend college. That decision did not reflect notions about circumscribed roles for women, for it applied as well to the Dreier son. Katherine Dreier recalled that in her childhood home, "There was no difference made between the daughters and the son; all were to be equally interested in the happenings of the day—politically or socially, in the nation or the community, among neighbors or friends."[21] Dorothea and Katherine studied art, Mary attended the New York School of Civics and Philanthropy for a year, while Margaret obtained private tutoring. Only Mary contested her parents' decision against college. Margaret never felt cheated or inhibited, as did Mary, in not being "a college woman." The approbation of her parents, who gave her considerable independence, as well as the atmosphere of her home allowed her to believe that she "could be great" without a degree.

Family tradition also supported the notion of female independence and initiative. The Dreier women were proud that in the seventeenth century Sarah Dreier, a childless widow, had established a family trust with the explicit proviso that needy descendants, both women and men, be equally entitled to aid for education or apprenticeships.[22] A less distant ancestor was more important to

Margaret's image of herself and her past: in addressing the League in 1913 on the subject of unemployment, she recalled her great-grandmother in Bremen in the 1840s who gathered poor women around her to weave and spin, while she recited to them the dramas of Schiller, and even assigned them roles to act out. As Margaret put it, this "woman of position and culture" organized workers to help themselves and inspired them with high culture to transmute "ragged life into splendor."[23] Margaret's image of her great-grandmother bears such a striking resemblance to the middle-class reformer of the Women's Trade Union League that one wonders to what extent she was reading her own reform values into her family background. Clearly, however, her ideals were entirely consonant with the legends of the Dreier family.

Margaret's religious background also inclined her toward the idea of social reform. Her minister-grandfather had placed great emphasis on service as an expression of faith, choosing at one time to foresake his parish and attend to the needs of emigrants leaving the Bremen area. In America the Dreiers chose to join the German Evangelical church, rather than the established Lutheran church. German Evangelicals, like their American counterparts, valued robust experiential religion, moral earnestness, and social service.[24] At home, there was much hymn singing, and every morning the family gathered together for Bible readings. Margaret's friend, Emily Ford Skeel, thought that twelve-year-old Margaret was exceptionally strenuous regarding religious matters: "You write in your last letter that you were afraid to speak to me on the topic of religion," Emily wrote to her in 1881. "To tell you the truth I 'have experienced religion' . . . but your first letter on that subject . . . hurt me a little as it sounded rather like a reproach, as though I had been wicked and you were trying to make me reform."[25] Margaret was confirmed in the German Evangelical church in her sixteenth year, an anniversary she observed for the rest of her life. Although in later years she abandoned the doctrinaire zeal that bothered her best friend, the religious dimension of social service always remained the basis of her reformism.

The Dreier children had models of civic virtue and social service in their parents. Theodor was active in the Chamber of Commerce and a trustee of Brooklyn Hospital. He and Dorothea be-

longed to the German Society of the City of New York, a service
organization that cared for German immigrants. A conscientious
and independent citizen, Theodor impressed his children with the
importance of voting when he cut short their European vacations
to return home and cast his ballot. When he died in 1898, he left an
estate worth over three million dollars, yet money-making was not
a characteristic trait among his offspring. Commenting on the lack
of financial acumen shown by her nieces and nephews, Mary Dreier
ruefully remarked, "They are true Dreiers in that it seems . . . Fa-
ther was the only one who had it."[26] Both Dreier parents taught
their children that they assumed social responsibilities with their
wealth. That was particularly important to their mother, who never
allowed herself to be bound to the household. Dorothea became a
leading member of the management board of the Brooklyn Indus-
trial School and Home for Destitute Children, founded to support
industrial training and to care for indigent children.[27] In its latter
aspect, the school evolved into an early day-care center, providing
for children who generally returned to their families in the evening.
Dorothea also showed her concern for poor families in a later
project, a vacation and recreation house in Brooklyn for mothers
who could not otherwise afford such a retreat. Margaret's mother
thus unknowingly joined social reformers who had come to view
the nation's poor not as dangerous classes but as families deserv-
ing support and protection.[28] The lesson was not lost on her daugh-
ter, who as head of the Chicago WTUL established retreat centers
for League working women. Dorothea's interest in child care and
industrial education also reappeared as central to Margaret's re-
form career.

The Dreier parents passed on to Margaret their strong sense of
civic and familial tradition. In her perception of herself both as a
daughter of free Bremen and as a descendant of a long line of so-
cially conscious women, Margaret was bent toward service and re-
form. The religious perspective, domestic environment, and uncon-
ventional education provided for her had the same effect. Theodor
and Dorothea Dreier thus unwittingly fashioned a reformer whose
certainties would rarely be shaken and whose optimism would be
indomitable. As a Christian, a citizen, and a woman of means, Mar-
garet came to see her life's task as the fortunate one of redressing
social wrongs and realizing the best in human nature. In all her

later struggles, she would be fortified by the conviction that she had been vouchsafed a clear image of the best of humanity in the life and character of her parents. Margaret would always look to them, indeed, idealize them, as exemplars of the values that she sought to realize in her work with the League.

Margaret's childhood was happy and secure, unafflicted with major problems or losses. There is no evidence of difficulties with her parents or with her siblings. She was well liked, with friends who found her striking, with her "raven black hair, her flashing dark eyes, high coloring and fine features." Her parents' wealth buffered her from the harsher aspects of urban life while also providing considerable opportunities for variety, culture, and excitement. Yet by the time she was twelve years old she began experiencing headaches, and by her early twenties they had become incapacitating.[29] In her late teens, the Dreiers consulted an eminent physician on a trip to London, who could find no physiological basis for Margaret's migraines. Nevertheless, to the distress of both parents and daughter, the physician "suggested the life of an invalid, painting what he thought would be a glowing picture of doing nothing but becoming the center of interest and adulation through her beauty and culture. To his astonishment, the young girl faced him in utter fury, declaring that she was going to live a normal life, come what may."[30]

Despite this determination, her migraines persisted, and in 1889 the Dreiers sought medical treatment for twenty-one-year-old Margaret in Switzerland, though exactly what kind is unclear. In any event, it was neither effective nor pleasant, perhaps because it was similar to that prescribed at the time for allied ailments: "nerve tonics; phosphorous or zinc phosphate, oxide of iron, arsenic, strychnia, for relief of spinal pains, electricity and the emplastrum, belladonna, etc."[31] Over forty years later, Katherine Dreier was still outraged by her sister's experience: "Will you ever forget that mad summer. . . . Why should you have been subject to such a summer—I have often wondered over it."[32] Margaret's headaches eventually lessened in severity, only to be followed by further obscure ailments that were serious enough in 1894, when she was twenty-six, for her physician to send her to a rest camp in the Adirondacks. In her early thirties, Margaret was diagnosed as suffering from a

"strained heart," a malady that brought with it fatigue, anxiety, and depression. She constantly complained of neuralgia, a problem so severe at times that she was unable to leave her home. Moreover, from her mid-twenties, Margaret's physical problems were accompanied by spiritual crisis. Those were the years that she later called the "dark hours," when she was (as she saw herself) a "stormy rebellious girl."[33]

From a robust, self-assured child, then, Margaret was transformed in her teens to a sickly, depressed young woman, prone to inexplicable illness as well as to physical and psychological enervation. The contrast is equally striking for Margaret's later years, for after she assumed a leading role in the WTUL and, at the age of thirty-six, married Raymond Robins, her problems vanished. Unfortunately, Mary Dreier's account of her sister's life offers no explicit help in determining either what caused Margaret's difficulties or what brought about their disappearance. Regarding her sister's recovery, Mary was content to assert that Margaret's "determination to be well and strong overcame all her disabilities and later, when heart strain appeared, she met that, too, by wise living till she was cured."[34] Mary's biography of Margaret is sentimental in tone and hagiographical in intent; she was not above bowdlerizing correspondence and blandly ignoring crucial episodes in her sister's life.[35] Nonetheless, her account of Margaret's early years gives a clue to the temperamental qualities that were to lead to her sister's physical and psychological distress.[36]

In Margaret's first school, she was often bored by the other children's recitations, hence "she discovered that by appearing inattentive, she could get her teacher to call on her to read, and quick as a flash she would continue where the last child had left off, delighted by her successful ruse." The same manipulative and self-centered streak is revealed in signing a letter to her best friend, Emily, who thought Margaret was "trying to make me reform," with "Now your enemy, hoping to be your friend." Margaret clearly delighted in being both the center of attraction and the controller of others. When her parents were abroad, they sent letters "addressed to her, though often written to all the children," and, as usual, her father singled Margaret out from the others, "always expressing the wish that his daughter Gretchen might have been with him."

Only two years younger than Margaret, Dorothea did not emerge as her elder's competitor because of her subdued personality, which, according to Mary, was a result of Margaret's domination. Another possible competitor, the third child, Edward, developed a similar personality. Every summer Margaret took charge of organizing a celebration of her parents' wedding anniversary, usually in "the form of plays either in German, English or French, as the spirit moved her." Once the spirit moved her to assign Edward, four years younger than herself, the role of a maid in petticoats, a humiliation that drove the boy to hide from the family. One suspects that more than the needs of dramaturgy impelled Margaret to cast her only brother as a subordinate female, by implication another younger sister. The dramas that Margaret incessantly organized were one of the ways in which, through striving to please her parents and direct her siblings, she remained the "masterhand" of her family, garnering both approbation and authority from her endeavors. In pursuing such ambition, the line between self-display and self-abnegation became well-nigh invisible, as when Margaret used her dress allowance as a teenager for "gifts and contributions to various charities." The shoddily made dresses she wore were testimony to her charity and sacrifice: "She was overgenerous," Mary wrote, "far exceeding any allotment given to her for that purpose."

Overgenerous and self-centered, affectionate and domineering, Margaret was her father's hostess, her mother's helper, her siblings' commander, and her family's "masterhand." She had no doubt come to expect that the world would be amenable to her wishes, that life would be but another drama whose direction she would supply. Her problems as a young adult can best be understood by viewing them as a response to her realization that the larger world was not as malleable to her desires and dictates as was her domestic realm. Imbued with principles of social and religious service, and told that "a woman could be great," it became increasingly difficult for the willful and domineering Margaret to see how her greatness could be manifest. She saw herself in her twenties as a "stormy rebellious girl," but in fact there is no evidence that she at any time rejected her parents and their values or opposed the conventions of society. She continued to be a dutiful,

adoring daughter, and outside the home she engaged in charitable activities that were considered admirable by both her parents and peers. She never gave serious thought to pursuing a life of hedonism, bohemianism, or indolence. Instead, she rebelled by falling ill.

Such a rebellion was well known to late nineteenth-century medical thought. The "life of an invalid" that the London physician prescribed for Margaret indicates that he had diagnosed her as a neurasthenic, one suffering from nervous exhaustion. The term "neurasthenia" was coined in 1869 by George M. Beard, an influential neurologist. By the time Beard died in 1883, a popular as well as technical literature surrounded the notion, and S. Weir Mitchell, a Philadelphia physician, had developed his famous rest cure as a treatment.[37] From the perspective of contemporary medicine, Margaret's ailments and anguish formed a somatic complex typical of a refined, unselfish nature overcome by conforming to the demands of society. Her migraines and neuralgia were linked to problems of the heart, that is, to a defective supply of blood to the brain, while the brain burned excess energy as a result of trying to cope with what Beard called "the conventionalities of society," the pace, expectations, and responsibilities of modern industrial society. The resulting breakdown in her delicate system led to depression, anxiety, and incertitude, a debilitating sense of powerlessness and spiritual crisis.[38]

Sexual drives were also seen by Beard as part of the neurasthenic personality, for "civilized morality" demanded the suppression of sexual desire, especially among women.[39] It is unclear whether this consideration can be applied to Margaret. She had numerous suitors, one of whom recalled much later "her rich color flushing with any emotion that excited her," though there is no indication that he pursued his suit after the "glowing girl" informed him that she was fond of reading Immanuel Kant.[40] Several suitors were discouraged when their attentions turned serious, and Margaret always maintained that until she met Raymond in 1905, she had been determined not to marry.[41] That she was acutely sensitive to the cost of such a decision is clear from her at times signing letters to her sisters as "Your Old Maid" in the eight years before her marriage.[42] In any event, the best medical minds of the day

would have urged Margaret to seek refuge in bed as an invalid, re-
treating from society while her nervous system repaired itself and
her energy was restored.

Neurasthenia was seen as a psychiatric disorder whose roots
were located in a normative conflict between a driven personality
and a demanding culture. Although the etiology of the disease re-
mained elusive and imprecise, the concept of neurasthenia was an
intelligent attempt to deal with what would later be called psycho-
somatic illness and, even later, psychoneurosis.[43] Moreover, since
Beard's concept of neurasthenia explained dysfunction among
middle-class young adults in terms of individual choice and social
change, it incorporated aspects of what later became known as an
identity crisis.[44] According to Beard, neurasthenia appeared most
frequently among those who were single, under thirty, and middle
class; and most of those afflicted achieved maturity and stability
after achieving a purpose in life. Post–Civil War America posed ex-
tremely difficult choices for young, educated men and women, and
many responded with undefined illness and breakdown reflecting
a crisis of confidence and self-reliance. Indeed, a resolution about
a vocation came to be seen as a decision about one's inner life or
character. Most deeply considered, a vocational dilemma became
a crisis of self-definition, a struggle to achieve an adult identity in a
confusing and inhospitable world.[45]

The interval between youth and adulthood, during which the
young person seeks a sense of rightness about a place in society, is
a "psychosocial moratorium," often typified by doubt and ner-
vousness.[46] William James's "dark hours" were from nineteen to
thirty-one, during which he yearned "for some stable reality to lean
upon," and even as late as 1895, when he was fifty-three, he con-
fessed, "I am a victim of neurasthenia and of the sense of hollow-
ness and unreality that goes with it."[47] Jane Addams also became a
victim of neurasthenia when in 1881 she graduated from college at
the age of twenty-one. Unable to reconcile her career ambitions
with familial responsibilities, she dropped out of medical school
and became a patient at S. Weir Mitchell's Hospital of Orthopedic
and Nervous Diseases in Philadelphia. Like William James and
Margaret Dreier, Addams went through a lengthy period of inac-
tion, indecision, and doubt: "It required eight years—from the

time I left Rockford in the summer of 1881 until Hull-House was opened in the autumn of 1889—to formulate my convictions even in the least satisfactory manner, much less to reduce them to a plan of action. During most of that time I was absolutely at sea so far as any moral purpose was concerned, clinging only to the desire to live in a really living world and refusing to be content with a shadowy intellectual or aesthetic reflection of it."[48] Charlotte Perkins Gilman, who later became a sociologist and feminist theoretician, was also diagnosed as neurasthenic. Mitchell's treatment eventually reduced her to such a state of infantilism that she played with rag dolls; she recovered only when she chose an independent career as a writer and lecturer.[49]

Of course, women were especially prone to debility and infantilism from treatment as neurasthenics, since the diagnosis reinforced stereotypes of the female as frail, irritable, and unworldly. Despite his melancholy and neurosis, William James never abandoned an active life; he bulled his way to philosophical and physical stability. In contrast, his sister Alice had her first breakdown at nineteen and never recovered. She was variously diagnosed during her life as suffering from neurasthenia, cardiac problems, and spiritual crisis. Her brother Henry urged her, "Try not to be ill—that is all; for in that is a failure."[50] After her death at the age of forty-three, Henry wrote that "her tragic health was, in a manner, the only solution for her of the practical problem of life."[51]

Clearly, there were insidious perils and exceptional difficulties for women in late nineteenth-century America in striving to move from the status of daughters to that of purposeful adults. Jane Addams recognized that her own hard experience in winning independence and a vocation was relevant to other women of her generation:

> It has always been difficult for the family to regard the daughter otherwise than as a family possession. . . . She is told to be devoted to her family, inspiring and responsive to her family circle, and to give the rest of her time to further self-improvement and enjoyment. She expects to do this, and responds to these claims to the best of her ability—even heroically sometimes. But where is the larger life of which she has dreamed so long? She has been taught that it is her duty to share this life, and her

highest privilege to extend it. This divergence between her self-centered existence and her best convictions becomes constantly more apparent. . . . Her life is full of contradictions.[52]

So it must have seemed to Margaret. Given her dominant role in the Dreier family and the high value she placed upon her abilities and ideals, it is unsurprising that she "rebelled" into sickness and melancholy when faced with the question of how to live a meaningful, fulfilling life. It was fortunate, however, that the same willfulness that drove her to be the center of her home also impelled her to reject the suggestion that she henceforth command attention from an invalid's bed. Perhaps her physical and psychological problems were the price she paid for being the darling of her father and the cynosure of her family. In effect, her problems were not to be resolved until she had recapitulated those roles in another, adult context, as the cherished wife of Raymond Robins and the inspiring leader of the Women's Trade Union League.

During her years of inner turmoil, Margaret found considerable hope and consolation in the philosophy of Ralph Waldo Emerson. As she later recalled, the sage of Concord set her on the path toward recovery. During her twenties, she later wrote, "my faith was jolted and a thousand and one questions of doubt assailed me. I refused to ignore the difficulties of those questions and I searched everywhere for the answer. . . . I had always cared greatly for Emerson, and in this hour I turned to him."[53] Emerson, who died in 1882, was an apposite choice for Margaret. By mid-century he had emerged as the cultural spokesman for the aspirations of young, middle-class Americans who were attracted by his oracular pronouncements on the powers of nature within the individual, on the search for self-reliance in life, and on the significance of young adulthood for the development of values. Margaret turned "to his translating the power of God into the everyday affairs of men and life," a theme that runs through Emerson's works, especially in his essays on reform and transcendence.[54] After reading Emerson, Margaret turned to the life of Jesus, particularly to Luke's description of Jesus's profession of his ministry. Of course, this was familiar material to Margaret. In the conte t of her own dilemmas, however, the declaration of Jesus that he had been called "to heal the broken-

hearted, to preach deliverance to the captives" made a striking impression. Perhaps it was at this point that she abandoned the dogmatism that had so affronted her best friend, for she concluded that "Jesus was no believer in dogma. He believed and taught a way of life. He came to show man his kinship with the spirit of God. . . . And the transformed human heart is the everlasting witness. He called to the freedom of the human spirit."[55]

Thus Margaret's "dark hours" of spiritual crisis ended with a restoration of belief. It cannot be said, however, that she emerged from her religious turmoil as one of William James's chastened "twice-born sick souls," forever tinged with morbidity and melancholy; rather, she remained "healthy-minded" to her core, unwilling to see evil as intrinsic to the human condition.[56] Consonant with her optimistic and determined nature, her recovered faith was both old and new: old, in that it was a reconfirmation of her childhood beliefs, especially the idea that one must realize one's self in service to others; new, in that she came to see the God-given self as holding promise for the larger society. Expansive, creative, and liberating, the self as she conceived it had vast potential that could be realized by human action. This vision of the individual as laden with potential for fulfillment and for socially constructive activity gave coherence to her otherwise seemingly disparate concerns. Throughout her career, and most poignantly at the end of it, Margaret would return to Emerson for reconfirmation of her convictions.[57]

Although Margaret resolved her religious doubts and laid the foundations for her reform ideology in her twenties, she was still plagued by illness and lacked a satisfying vocational commitment. At the age of nineteen, she joined the Women's Auxiliary at Brooklyn Hospital, where her father was a trustee.[58] Volunteer women wielded considerable authority through hospital auxiliaries, taking on responsibilities ranging from providing supplies to supervising student nurses. Margaret immediately became treasurer of the auxiliary, and for the next fifteen years the hospital was her primary civic concern. The nutrition of women and children in the charity wards occupied much of her attention, for patients were fed haphazardly, with no attempt to provide nourishing food or a balanced diet. In her early twenties and without training, Margaret became the hospital's dietitian. Throughout the 1890s, her correspondence

is replete with references to "my hospital," the nurses' training school, and fund-raising efforts. She even personally paid the salaries of certain nurses, and she always remained a benefactor and advocate of nursing education.[59]

Perhaps Margaret's responsibilities in the hospital made her aware of the need for more disciplined intellectual training, for in her late twenties she began reading philosophy and history under the tutelage of Richard Salter Storrs, an influential Brooklyn minister, and studied public speaking with Lucia Gilbert Runkle, the first woman in America to write for the editorial page of a major newspaper.[60] These prominent persons were important to Margaret. Not having gone to college, she lacked not only intellectual training but the institutional networks of support provided by college life. Storrs and Runkle—and later, Josephine Shaw Lowell—acted as mentors, providing the informal guidance characteristic of the careers of reform-minded women.[61] Indeed, Margaret's mentors guided her beyond charity work at Brooklyn Hospital to the wider social reform circles of New York City.

It was through them that Margaret came to the attention of Josephine Shaw Lowell, a prominent reformer. As Margaret recalled, these older patrons "opened worlds," providing her with the sort of relationship that she would later establish with young women in the League. In 1923 Margaret wrote to Mary Dreier urging her to let a young League member "look through your window for a little while. . . . please don't forget the young things! Remember what it meant to us to have fine women think it worth their while to show us the way. I always remember Josephine Shaw Lowell with such deep gratitude and reverence for that very thing."[62]

Margaret credited Lowell with showing her the path toward reform. The daughter of a radical abolitionist Boston family, Lowell began her charity work with the U.S. Sanitary Commission and continued it through the New York Charities Aid Association. She helped steer American philanthropic activity away from casual and spontaneous relief to a more disciplined approach, thereby shaping the contours of post–Civil War reform. She sought to establish a theoretical basis for philanthropic work in her *Public Relief and Private Charity* (1884).[63]

As Lowell became increasingly dissatisfied with the limitations of philanthropic relief, she turned to the problems of work-

ers, especially those of women. Lowell's new interest did not mark
the first time that female reformers had been concerned with work-
ing women. In the 1830s, the New York Moral Reform Society
moved from opposing prostitution to a concern for the wages and
employment conditions of women; by the 1850s, the society was
even urging female wage earners to join unions. A decade later,
Susan B. Anthony's Working Women's Association in New York City
attempted to merge feminist interests with trade-union activity. Re-
form-minded, middle-class women were among the more than
60,000 women who belonged to the Knights of Labor at its peak in
1886.[64] In the same year, Lowell and other reformers joined with a
group of female laborers in New York City to found the Working
Women's Society, an organization for the improvement of working
conditions.[65] Lowell resigned her position with the Charities Aid
Association and made labor her principal concern. As she ex-
plained her decision to a friend: "The interests of the working
people are of paramount importance, simply because they are the
majority of the whole people, and the indifference and ignorance
and harshness felt and expressed against them by so many good
people is simply awful to me and I must try to help them, if I can,
and leave the broken down paupers to others. Read what Mr. Emer-
son says about our relations toward the working people in 'Man the
Reformer.'"[66] Soon after her resignation, Lowell and other reform-
ers founded the Consumers' League of the City of New York, which
agitated for higher wages and better working conditions for women,
so as to prevent female employees from sliding into prostitution.[67]
In 1894 Lowell went on to establish the Woman's Municipal League
(WML), New York's first women's civic organization, in response to
a recent report that revealed the extent to which young women
were the victims of organized traffic in vice.[68]

By the time she recruited Margaret for the WML in 1902, Lowell
had become even more forceful in her advocacy of the rights of
workers and their organizations.[69] But Lowell could strongly influ-
ence Margaret only because the latter was highly receptive. By vir-
tue of her experience in hospital work and her own reading of
Emerson, Margaret was already prepared to move from charity to
reform, from paupers to workers. Still, her first steps in that direc-
tion were under the guidance of Lowell, and like her mentor, Mar-

garet approached the problems of women workers out of concern over the ravages of prostitution.[70] Soon after becoming head of the WML's legislative committee, Margaret turned her attention to links between organized prostitution and New York City's employment agencies. In fact, the connection was not new to her, for daughters of dockworkers who had played in the neighborhood of the Dreier mansion in Brooklyn Heights often had become prostitutes. As Margaret told a committee of the New York Assembly in 1904, "Again and again a young girl, ruined and desperate, comes to me, saying 'I don't know you. I only come because as a child I played on your steps.' Do you wonder that I was forced to study the question and learn what caused the trouble[?]" She concluded that "a so-called Employment Agency was responsible" for the dockworkers' girls becoming prostitutes.[71]

To correct that situation through legislation, Margaret needed to document her conviction. She asked Frances A. Kellor to expand her research on unemployment and crime to include the city's 522 licensed employment agencies. Kellor, who had studied sociology at the University of Chicago, had recently published a book that touched on the connection between delinquency and employment agencies. With Margaret's backing and the WML's resources, Kellor in 1903 began a major study of the agencies. As head of the WML's legislative committee, Margaret coordinated work between Kellor's staff of investigators and her own organization. The investigation looked into all aspects of the agencies, especially those dealing with recruitment for domestic service.[72] The result was a massive indictment of the agencies, documenting the manifold ways in which young women were led or forced into prostitution. Kellor's book, *Out of Work*, uncovered "an abyss of brutality," as Margaret put it, and was an exceptionally thorough and scholarly piece of muckraking at the beginning of the Progressive era.[73] A bill to regulate the agencies, drafted by Margaret's committee, was passed into law in 1904. Kellor credited Margaret, to whom she dedicated her book, with securing passage of the legislation. Margaret had stimulated public support for the bill, solicited assembly politicians for their votes, and testified before various committees. Although it was her first legislative campaign, she proved to be a superb organizer and lobbyist, adroit in argument

and unafraid to face down her opponents when necessary. In all, the work done by Kellor and Margaret played an important role in creating the public outcry that led to "white slave" legislation in New York and eventually to the federal Mann Act in 1910.[74]

Under the impact of her work with the WML, Margaret came to be more concerned with the plight of workers. Moreover, during the investigation of the agencies, many WML members seemed less heedful of the vulnerability of workers to prostitution than with protecting middle-class homes from libidinous domestic servants. Thus a prominent spokesman pleaded for passage of the regulatory legislation with the argument that employment agencies often dispatched servants "who should not be permitted to come into contact with the family circle."[75] In short, for all its good intentions, the WML was too elitist for Margaret, too distant from what she now saw as the fundamental problems of society.

In the spring of 1904, Margaret and Kellor founded (and Margaret entirely financed) the New York Association for Household Research to continue studying the conditions of domestic service. As with her investigation of the agencies, Margaret's work with the Household Research Association showed her how concern for one issue, such as domestic employment, necessarily led to a host of others, such as familial relations, traffic in prostitution, and acculturation of immigrants. In a fashion typical of Progressive reformers, Margaret was thus impelled to a comprehensive approach to remedying social injustices. From an initial interest in proper working conditions for domestics, she went on to help organize programs to greet countrywomen arriving in the city, to provide them with reputable lodging, and to establish nonprofit employment agencies. In fact, the Household Research Association pioneered in methods that by World War I came to be practiced routinely by volunteer and benevolent groups concerned for young, unattached women in the city. It placed one of its workers on Ellis Island, helped to establish the Clara deHirsch Home, a model institution for female Jewish immigrants, and hired investigators to check on employment agencies, several of which were closed after sending women to whorehouses.[76]

Margaret's work with the WML and the Household Research Association stemmed from her ambition to protect vulnerable

women—job seekers, domestics, and immigrants—from becoming ensnared by prostitution. Safe lodging houses and honest employment agencies were intended as bulwarks against the tide of vice inundating the city. Margaret was thus part of a great crusade in the first decade of the century against prostitution and the white slave trade. She opposed prostitution as a social worker who recognized that innocents needed defense against institutionalized vice and as an environmentalist who understood that economic forces contributed to the degradation of women.[77] Like female reformers throughout the nineteenth century, Margaret rejected the notion that women choose prostitution voluntarily. Instead, she contended that women should have the power to make choices for themselves; later she would use the same argument in favor of trade unions and the closed shop.[78]

Margaret moved quickly to identify with the labor movement after combatting prostitution because in her eyes both the sexual exploitation of women and the economic exploitation of laborers represented efforts to turn human beings into commodities, individuals into units of exchange. Just as prostitution destroyed a woman's individuality, reducing her potential to a generic state, so too brutal labor and unhealthy conditions diminished a worker's humanity. During her years at Brooklyn Hospital, Margaret achieved a vision of "the transformed human heart," of the capacity for goodness and creativity that could be released in humanity. The five years of her struggle against prostitution, between leaving her hospital charity work and assuming leadership of the League, graphically showed her that there was a quite different kind of transformation, dreadful and dispiriting. The world of prostitution revealed a nightmare landscape of stunted, dehumanized beings, seemingly beyond reform and redemption. Those years were the end of her apprenticeship to reform, but she was never to forget the lesson they taught. She remained aware that beneath the expansive rhetoric and sunny perspective she presented to working women during her career with the League, there lay a darker realm of blasted promises and lost possibilities.

When Margaret joined the Women's Trade Union League in December 1904, the organization was not much more substantial

or impressive than the Household Research Association that she had just set up with Kellor.[79] Founded early in 1904 with branches in Boston, Chicago, and New York City, the League had only fifty members in the latter, a mixture of middle-class reformers and working women. The New York WTUL had a treasury of fifty dollars, had done no effective work organizing unions, and held no regular meetings. No doubt because of her social connections and personal resources, Margaret was immediately made treasurer— a post that had not existed previously—and assumed practical leadership of the New York League by organizing assistance to striking box makers and cap makers. William English Walling, the founder of the League, acknowledged her vital contribution to the strikes: "I think we owe as much to you as to all the rest of us put together."[80]

Margaret assumed leadership in title the following March when she was elected president of the New York League; at the same time, she also became treasurer of the national WTUL. At her instigation, the New York League hired its first full-time secretary and began to recruit organizers. One of the most important of the latter was Rose Schneiderman, a garment worker vastly impressed by Margaret who eventually became president of the national League in the 1920s. Margaret's fund-raising and personal donations provided the New York League sufficient resources to assist local labor organizations with loans and to help fund strikes.[81] In short, within the space of a few months, Margaret had taken a moribund organization, barely existing on paper, and breathed life into it.

A month after her election as president of the New York WTUL, thirty-six-year-old Margaret Dreier met Raymond Robins (1874– 1954) after he had delivered a lecture on the social gospel to a Brooklyn church. Having met in April, they were engaged in May and married in June. The meteoric courtship and marriage startled Margaret's friends and family, for she had decided long ago not to marry; and given her ill health, she and her family believed in 1905 that she would live only "a few brief years." The spring of that year, Margaret later said, witnessed a breathtaking exception "to my all pervading slowness."[82]

Five years younger than his wife, Raymond Robins was head resident of the Northwestern University social settlement in Chi-

cago.[83] He had been drawn to that relatively staid occupation after a checkered and adventurous career. His mother went insane and his father deserted the family when Raymond was an infant. At the age of seven, he became part of a cousin's household in Kentucky, with lengthy stays in western Florida. Quitting school in his early teens, Raymond first worked in Florida phosphate mines and Tennessee coal mines. After being fired from the latter for union activity, he worked in the Colorado lead mines and joined the Western Federation of Miners. He concluded, however, that he would be more valuable to unions outside the mines, so by his early twenties he had earned a law degree. He set up practice in California, where he became involved with a range of Progressive concerns, especially advocacy of woman suffrage.

In 1897, at the age of twenty-three, Raymond joined the Alaskan gold rush. He made a modest fortune by means that were never fully explained, though he always claimed that he had sold a rich holding. Along with gold, Raymond, hitherto an atheist, discovered God: alone in the Yukon, he saw a flaming cross in the icy sky, a sign that he should devote himself to social service in the name of Jesus. His first step toward that end was to be ordained a minister in the Congregational and Methodist churches. With considerable courage, he chose Nome as his parish, where his ambition to clean up the rowdy mining town led to his life being threatened more than once.[84] In the end, he helped establish a degree of law and order, as well as a library and a hospital. That accomplished, he moved to Chicago in 1901.

As an essentially rootless reformer, it was natural that Raymond headed for Chicago. At the turn of the century, the city had some claim to be considered the premier center of Progressive reform. Jane Addams's immensely influential Hull House opened there in 1889. Graham Taylor, the founder of the Chicago Commons social settlement, was in the School of Civics and Philanthropy; the opportunity to work with him at Chicago Commons, run by a group of ministers, was probably the specific reason Raymond settled in Chicago. George Herbert Mead, Albion Small, and John Dewey taught at the University of Chicago, developing approaches to social thought that would have a significant impact on the Progressive movement. Mead often lectured to gatherings of the League on

such topics as industrial education, and Dewey, a strong advocate of trade unions, was closely tied to Hull House. Progressive education was born in Chicago, at the University's Lab School (under Dewey) and at the Francis Parker School. While educational and labor circles in other cities were quite separate, if not hostile, in Chicago they were closely united, with the Chicago Teachers' Federation affiliated with the Chicago Federation of Labor.[85] Chicago was also the unchallenged leader in humanistic architecture, with Frank Lloyd Wright and Louis Sullivan both active there in the early 1900s.

Finally, Chicago boasted a number of prominent female reformers. One of Raymond's friends, a Chicago reporter, claimed in 1906 that his city was run by "five maiden aunts"—Addams, Mary McDowell, Julia Lathrop, Cornelia DeBey and Margaret Haley—all members of the WTUL.[86] McDowell, known as "the Angel of the Stockyards," worked with slaughterhouse laborers; Lathrop and Grace Abbot championed the cause of children and later headed the Children's Bureau in the federal government; DeBey was active in health and educational reform; Haley led the aggressive Teachers' Federation; Dr. Alice Hamilton worked on industrial diseases and went on to hold the first position in that subject at Harvard; Sophonisba Breckenridge was a professor of social economy at the University of Chicago; and Florence Kelley had led the fight for a state factory inspection law in Illinois before moving on to New York to work for the National Consumers' League. Of course, at the center of this galaxy of reformers was Jane Addams, referred to by her colleagues as "Saint Jane." As Margaret later recounted, upon arriving in Chicago she experienced a religious exhilaration at walking the very streets hallowed by Addams.[87] In short, when Margaret followed her husband from New York to Chicago, she was not suffering exile in the benighted Midwest.

Raymond Robins made a striking impression upon his contemporaries. Handsome and eloquent, he carved out a career in reform by sheer force of personality and relentless energy. In 1901 he and Addams successfully intervened to halt police arrests of foreign radicals after President William McKinley's assassination. He was largely responsible in 1906 for the election of a reform candidate, John Fitzpatrick, as president of the Chicago Federation of Labor, inasmuch as he financed the printing of an article detailing

the corruption of the incumbent.[88] One of the most important crusaders for the single tax, as well as for retaining the Prohibition amendment, Raymond played a leading role in the Progressive party, serving on its national committee and running (albeit a poor third) as its Senate candidate in Illinois in 1914. As the acting head of the Red Cross Commission to the Soviet Union in 1917, Raymond became the unofficial liaison between the United States and the USSR. He subsequently considered himself a personal friend of Lenin, and at his Florida estate later in life, he planted an oak tree in honor of the Russian revolutionary. Raymond certainly was a friend of Jane Addams, Harold Ickes, Senator George Norris of Nebraska, Senator William Borah of Idaho, William Jennings Bryan, and Herbert Hoover. Theodore Roosevelt wrote to Raymond in 1915:

> As by this time you must surely know, you are one of the three or four men for whom the result of the last three years has given me the greatest regard and feeling, one of the half-dozen men with whom it has been a peculiar pleasure to be associated and whose friendship I regard as an honor of which all my life I shall be proud. Indeed, I am tempted to say that of all the men whom I have been associated with in this [Progressive] movement you are the man with whom I have been in closest sympathy as regards what seems to me the most momentous issues among all the issues that we raised.[89]

Raymond had first come to Roosevelt's attention more than a decade before when as a card-carrying union man and lawyer he was the principal negotiator for the United Mine Workers during the great anthracite coal strike in 1902.[90] The Robinses promised each other "unhampered freedom to serve," so as "to be free to work untrammeled for the growing good of the world."[91] While retaining her independence, Margaret also clearly benefited from her husband's respected position, for she was accorded trust and status, especially by Chicago union leaders, rarely given a female reformer in labor circles. When in 1907 the Illinois State Federation of Labor first asked her to speak before their convention, she attributed the opportunity to Raymond, to whom she wrote thanking him "for giving me my work." The Robinses shared the same interests, at times worked for identical causes, and saw themselves as a team laboring for reform. Particularly in the early years, Raymond

advised his wife on legal problems, looked after League business when she was away, frequently spoke at League meetings, and counseled young women in the organization.[92] At all times, he encouraged Margaret's public involvement and sought ways to expand her influence. He received considerable satisfaction from being married to a prominent reformer.

The relationship between Raymond and Margaret, however, was not like that between Sidney and Beatrice Webb, in which private passion was sacrificed on the altar of social reform. Rather, the private and public lives of the Robinses nurtured each other to a remarkable extent. Their mutual passion was clear from the start and no doubt accounts for their sudden decision to marry. Just after their engagement, Raymond feared that "the world, the flesh and the devil" might prove too strong for them if he stayed overnight in his fiancee's home.[93] In 1933, when Margaret was sixty-five, Raymond returned from the Soviet Union and soon after wrote to his wife that he hoped the pain in her side caused by "my too great ardor" had diminished; she replied that she felt wonderful, "now that you have made me whole again." Three years later, she wrote to Raymond that he always brought "healing to my spirit as well as to my body."[94]

In fact, that was not invariably the case. Prone to moodiness and insomnia, Raymond suffered three emotional breakdowns, the last and most serious of which (in 1932) destroyed his reputation and humiliated his wife.[95] Still, there is no evidence of serious marital discord between the two. Their happiness together even survived Mary Dreier's passion for Raymond, expressed in a clandestine correspondence with Raymond throughout the Robinses' marriage. Raymond persuaded Mary to sacrifice her passion to the cause of reform, and Margaret probably never knew of the compact between her husband and her sister. Indeed, she always hoped that if she died before Raymond, he would wed Mary. Raymond was aware, however, that his wife was essential to his stability and contentment: "You are," he wrote to her, "the *anchor* of my stormy driven life." For her part, Margaret felt that her husband was the only person who fully belonged to "my two worlds,—the great and blessed reality,—and the world of dreams!"[96]

Reality and dreams—an individual's stability and health may be seen as dependent on the proper equilibrium between the two,

on the balance achieved between one's acceptance of the objective world and one's highest expectations within it, for reality can be "great and blessed" only if it is seen to conform to one's hopes and desires. Margaret's equilibrium was destroyed in her teens when she had to face the question of what to do with her life. So much a creation of her own will, her world of childhood vanished, and her "dark hours" began, bringing indecision, turmoil, and illness. Her equilibrium was restored fully in the space of six months, from December 1904 to June 1905, by involvement with the League and by marriage to Raymond. Her "all pervading slowness" disappeared, as did her ill health; there were no more complaints of migraines, neuralgia, or "strained heart." She stopped taking her medicine, and, as she assured Mary, she could not "remember ever having been so well before." In 1923, she looked back to the spring of her transformation and told her sister that "I don't feel nearly as old as I did eighteen years ago."[97] In other words, Margaret felt that in recovering her health and certainty, she had regained something of her childhood. Certainly she had discovered a new foundation for the optimism and willfulness that had characterized her as a child. As in the Dreier home, she was once more in control and loved by the man of the house. In reestablishing an affection and authority similar to that she had experienced as a child, Margaret realized for herself the promise of liberation that she had discovered in Emerson.

Margaret's work in Brooklyn Hospital and in the Women's Municipal League had dealt essentially with paupers and prostitutes, victims of the economic and social system. She was dissatisfied with that because it did not attack problems at their source. The WTUL was attractive to her because it aimed at organizing trade unions that would give power to workers and thereby might eventually destroy the root causes of poverty and prostitution. But the League in December 1904 also was attractive to Margaret precisely because it was a new, unformed organization; there was room there for the shaping touch of a masterhand. By taking on the newly created office of treasurer of the New York League (and soon after, that of treasurer of the national WTUL), Margaret both saved the infant organization from a probable demise and gained the right to form it in her own image. Of course, she had the wherewithal to pay for that privilege. She became president of the na-

tional WTUL and of the Chicago branch in 1907—Mary succeeded her as president of the New York League—and during her first years in office, when the budget ran between $4,000 and $10,000, she bore "practically the entire expense of the National League."[98] In addition, she paid her own traveling expenses as president, conducted the League's business out of an office in her Chicago home, and paid the salaries of two employees of the League; later she underwrote payments to union organizers and provided the seed money for *Life and Labor*, the journal of the WTUL. Margaret was uneasily aware of the source of the League's achievements: "There are times when it makes me quite heart sick," she wrote to Mary Dreier in 1908, "to realize that it is my money which alone enables me to carry out the plans [of the League], and that whatever character or intelligence I have would be utterly useless were it not for the fact that I have the money."[99] Margaret's declaration of inadequacy was no doubt entirely sincere; she was overgenerous by nature. As in the Dreier home, however, the line for her between aggrandizement and abnegation was well-nigh invisible.

In all but its inception, the League was the creation of Margaret Dreier Robins; she rescued it, established its operations, and declared its principles. It was, Raymond told her, "one of your children that *you* raised from feeble infancy into maturity and power."[100] That was perhaps psychologically truer than he knew. The League functioned for Robins very much as a surrogate for the childhood home where she had wielded the gentle authority of a parent over her sisters and brother. It is not surprising that at the 1915 League convention, presided over by Robins, one participant thought that in tone and atmosphere the assembly was like a "jolly family gathering." "You know how I love pageants," Robins wrote to a League member, "and how eager I have always been to have the Labor movement express itself through pageants." Why should not all League members "turn into Playwrights?" she asked her husband.[101] When Robins encouraged League members to put on plays and celebrate anniversaries with pageants—September 6, Jane Addams's birthday as well as Robins's, was especially popular—she was harkening back to the days when she had staged dramas for her parents' anniversaries, as well as to when her parents told her of her great-grandmother directing Bremen weavers in the plays of Schiller.

Certainly, the League cannot be reduced to a mere reflection of Robins's psychic needs. However important Robins was as the financier, director, and ideologist of the organization, its accomplishments were the product of collaboration of strong-minded, independent women. At the same time, it is clear that the League offered Robins a unique opportunity, perhaps more critical than that of her marriage, to resolve her personal difficulties. The way in which she grasped that opportunity determined that the League would be to some extent, in its strengths as well as its shortcomings, an expression of her personality.[102] In reflecting upon her own experience, Jane Addams stressed that there were both subjective and objective motives for founding the social settlements: subjectively, there were many persons, such as herself, who longed for a vocation and spiritual commitment; objectively, there was a great deal of poverty and oppression that cried out for reform.[103] Just as Addams resolved her conflicts by establishing Hull House, so did Robins work out her problems by dedicating herself to the League. In so doing, she found a creative solution for more than her own needs and frustrations, for she shaped the League into a vehicle for realizing a vocation as well as for reforming society. Young women facing the same troubling questions of identity and purpose that she had struggled through laboriously could find a sustaining abode in the League. Robins molded it into an institution with a pronounced domestic aspect, a sort of home for reformers, in which young women could find themselves in a commitment to serving others.[104] The League thus became for its members what Robins had made of it for herself, a promise of reconciling reality with the world of dreams.

## Notes

1. Mary G. Peck to Mary Elisabeth Dreier (MED), June 2, 1950, copy, MED Papers, Schlesinger Library, Radcliffe College, Cambridge, Mass.

2. Except for the Peabodys of Massachusetts, only the Dreiers produced at least three daughters whose lives merited coverage in *Notable American Women, 1607–1950: A Biographical Dictionary*, 3 vols., ed. Edward T. James (Cambridge, Mass.: The Belknap Press of Harvard University, 1971) and *Notable American Women: The Modern Period*, ed. Barbara Sicherman and Carol Hurd Green (Cambridge, Mass.: Belknap Press of Harvard University, 1980). I owe this observation to Edward T. James.

3. *Notable American Women: The Modern Period,* pp. 204–6; also see Aline B. Saarinen, *The Proud Possessors* (New York: Random House, 1959), pp. 238–49.

4. Margaret Dreier Robins (MDR), "Dreier," n.d., p. 1, box 1, MDR Papers, Manuscript Collection, University of Florida Library, Gainesville, Fla.; Edward Dreier to MDR, July 30, 1914, box 60, MDR Papers.

5. MED, *Margaret Dreier Robins: Her Life, Letters and Work* (New York: Island Press, 1950), p. 3; MDR, excerpt from "Dreier Family Chronicle," n.d., p. 135, box 1, MDR Papers.

6. *The Boroughs of Brooklyn and Queens, Counties of Nassau and Suffolk, Long Island, New York, 1609–1924,* vol. 6, ed. Henry Isham Hazelton (New York: Lewis Historical Publishing Co., 1925), p. 33; MDR, personal notes, n.d., box 1, MDR Papers.

7. MDR to Raymond Robins (RR), July 18, 1936, box 73, MDR Papers; MDR to Carrie [Read], [July?], 1907, copy, box 2, RR Papers, Archives Division, Wisconsin State Historical Society, Madison, Wisc.

8. MDR to Carrie [Read], [July?] 1907, box 2, RR Papers.

9. MED to MDR, Jan. 18, 1917, box 30, MDR Papers.

10. MED to Edward Dreier, Apr. 30, 1947, MED Papers.

11. MDR, "Dorothea Adelheid Dreier," in *In Memory of the One Hundredth Anniversary of the Birth of Dorothea Adelheid Dreier,* ed. MDR (New York, 1940), p. 53. (Theodore Dreier graciously allowed the author access to this privately printed book.)

12. James H. Callender, *Yesterdays on Brooklyn Heights* (New York: Dorland Press, 1927), p. 243.

13. MDR to Christine, Feb. 7, 1914, copy, box 29, MDR Papers. On the heightened significance given to a child born after a sibling's death, see Albert J. Lubin, *Stranger on the Earth: A Psychological Biography of Vincent Van Gogh* (New York: Holt, Rinehart and Winston, 1972), pp. 88–90.

14. Emily E. Ford Skeel, "An American," *Letter* 3 (Summer 1945): 67.

15. MED, typed draft of *Margaret Dreier Robins,* p. 7, MED Papers.

16. "Life's Course Set by Cobbler's Shop," July 20, 1911, unidentified news clipping from Cleveland, Ohio, box 20, MDR Papers.

17. MDR, "Johann Caspar Theodor Dreier: February 6, 1828–February 16, 1928," box 1, MDR Papers; Theodor Dreier to MDR, Apr. 23, 1878, box 1, RR Papers.

18. MDR, "Dorothea Adelheid Dreier," in *In Memory,* pp. 54–55; MDR to MED, Nov. 20, 1943, MED Papers; MED, typed script, "The Block," dictated 1963, p. 4, MED Papers.

19. MED, typed draft of *Margaret Dreier Robins,* p. 18; MED, *Robins,* p. 8.

20. *Notable American Women*, 1, 217–18; MDR to MED, Apr. 16, 1914, MED Papers.

21. Edward Dreier, "My Mother," in *In Memory*, p. 62; MED to MDR, [c. 1897], box 25, MDR papers; Katherine S. Dreier, "Mother," in *In Memory*, p. 75.

22. MED, *Robins*, p. 2.

23. "Statement by Mrs. Raymond Robins to NWTUL," Oct. 1913, reel 10, MDR Papers; cf. MDR to MED, Jan. 17, 1931, box 35, MDR Papers.

24. See Sydney E. Ahlstrom, *A Religious History of the American People* (New Haven: Yale University Press, 1972), pp. 439–41.

25. Emily E. Ford to MDR, Mar. 18, 1881, box 25, MDR Papers; MED to Edward Dreier, July 11, 1939, MED Papers.

26. MED to MDR, May 7, 1913, box 29, MDR Papers; Theodor Dreier, Sr., to the author, July 18, 1977.

27. Edward Dreier to MDR, Oct. 22, 1941, box 43, MDR Papers; Callender, *Yesterdays on Brooklyn Heights*, pp. 206, 208.

28. See Steven L. Schlossman, *Love and the American Delinquent: The Theory & Practice of "Progressive" Juvenile Justice, 1825–1920* (Chicago: University of Chicago Press, 1977), pp. 131–36.

29. Emily E. Ford to MDR, Aug. 13, 1880; June 21, 1885, box 25, MDR Papers; MED, typed draft of *Margaret Dreier Robins*, p. 17.

30. MED, *Robins*, p. 6.

31. Quoted in Nathan G. Hale, Jr., *Freud and the Americans: The Beginnings of Psychoanalysis in the United States, 1876–1917* (New York: Oxford University Press, 1971), p. 65.

32. Katharine S. Dreier to MDR, Sept. 17, 1934, box 46; Emily E. Ford to MDR, June 23, 1889, box 25, MDR Papers.

33. M. L. Chanler to MDR, Jan. 8, 1904; MDR to MED, Aug. 24, 1899; MDR to RR, June 1, 1905, box 25; MDR to RR, May 20 and June 1, 1905, box 59, MDR Papers.

34. MED, *Robins*, pp. 6–7.

35. Thus she does not mention the disappearance of MDR's husband in 1932, an episode that attracted national attention; nor does she indicate MDR's disappointment with the League and her disapproval of the New Deal in the 1930s (on these, see chapter 5).

36. For the following, see MED, *Robins*, pp. 6–8.

37. Charles E. Rosenberg, "The Place of George M. Beard in Nineteenth-Century Psychiatry," *Bulletin of the History of Medicine* 36 (1962): 248; Barbara Sicherman, "The Uses of Diagnosis: Doctors, Patients, and Neurasthenia," *Journal of the History of Medicine and Allied Sciences* 32 (Jan. 1977): 35.

38. Hale, *Freud and the Americans*, p. 63; Francis Schiller, "The Mi-

graine Tradition," *Bulletin of the History of Medicine* 49 (Spring 1975): 1–19; cf. A. Stenbäk, *Headaches and Life Stress: A Psychosomatic Study of Headache* (Copenhagen: Munskgaard, 1954), pp. 84–85.

39. Hale, *Freud and the Americans*, pp. 64–65; Sicherman, "The Uses of Diagnosis," p. 47.

40. Hamilton Holt to MED, Aug. 11, 1950, MED Papers.

41. Barbara Loines Dreier to the author, July 18, 1977.

42. MDR to MED, Sept. 1, 1897, MED Papers.

43. "Psychosomatic" was coined by Smith Ely Jelliffe (1866–1945), and of course "psychoneurosis" did not enter medical language until Freudianism became popular in America after the turn of the century (see Hale, *Freud and the Americans*).

44. Sicherman, "The Uses of Diagnosis," p. 45; cf. Jean Strouse, *Alice James: A Biography* (New York: Bantam Books, 1982), pp. 113–14. On the concept of an identity crisis, see Erik H. Erikson, *Identity and the Life Cycle: Selected Papers by Erik H. Erikson* (New York: International Universities Press, 1959); see also Joseph F. Kett, *Rites of Passage: Adolescence in America, 1790 to the Present* (New York: Basic Books, 1977), pp. 38–50, 144–72, 245–72; Burton J. Bledstein, *The Culture of Professionalism: The Middle Class and the Development of Higher Education in America* (New York: W. W. Norton and Co., 1976), pp. 159–71.

45. Bledstein, *Culture of Professionalism*, p. 160.

46. Erikson, *Identity and the Life Cycle*, pp. 103–4, 116.

47. Quoted in Cushing Strout, "William James and the Twice-Born Sick Soul," *Philosophers and Kings: Studies in Leadership*, ed. Dankwart A. Rustow (New York: Braziller, 1970), pp. 497, 504.

48. Jane Addams, *Twenty Years at Hull House* (1910; reprint ed., New York: Macmillan Co., 1961), p. 59; Allen F. Davis, *American Heroine: The Life and Legend of Jane Addams* (New York: Oxford University Press, 1973), pp. 24–28.

49. Sicherman, "The Uses of Diagnosis," p. 47. For Gilman's own portrayal of her breakdown, see her short story "The Yellow Wall-paper," *New England Magazine* 5 (Jan. 1892): 647–59 (as Charlotte Perkins Stetson). Also see Mary A. Hill, *Charlotte Perkins Gilman: The Making of a Radical Feminist, 1860–1896* (Philadelphia: Temple University Press, 1980), pp. 128–64.

50. Quoted in Strouse, *Alice James*, pp. xi–xii.

51. Quoted in Leon Edel, *Henry James: The Conquest of London: 1870–1881* (New York: Avon Books, 1978), p. 49.

52. Quoted in Davis, *American Heroine*, pp. 41–42.

53. MDR to Jane Ickes, Aug. 12, 1939, copy, box 51, MDR Papers.

54. Ibid. On the significance of Emerson for young Americans, see Bledstein, *Culture of Professionalism*, p. 259.

55. MDR to Jane Ickes, Aug. 12, 1939, copy, box 51, MDR Papers.

56. On MDR's interest in James and her "healthy-mindedness," see chapter 5.

57. On the significance of Emerson for MDR late in life, see chapter 5.

58. Emily E. Ford to MDR, Apr., 1881, box 25; MDR to MED, Feb. 28, 1944, box 55, MDR Papers.

59. Ethel Dreier to MDR, June 20, 1911, box 28, MDR Papers.

60. On Storrs, see *Dictionary of American Biography*, 1963 ed., s.v. "Storrs, Richard Salter"; James Leiby, *Carroll Wright and Labor Reform: The Origin of Labor Statistics* (Cambridge, Mass.: Harvard University Press, 1960), pp. 40–41. On Runkle, see *Biographical Cyclopaedia of American Women*, ed. Erma Conkling Lee, vol. 2 (New York, 1925), p. 113 (I owe this citation to Edward T. James).

61. See, for example, MDR to Grace Dodge, June 23, 1915, copy, box 29, MDR Papers. On the importance of a community of sympathetic supporters for the formation of a young person's identity, see Erikson, *Identity and the Life Cycle*, p. 111; on the importance of extra institutional experiences for the vocational commitment of young women who did not attend college, see Ellen Condliffe Lagemann, *A Generation of Women: Education in the Lives of Progressive Reformers* (Cambridge, Mass.: Harvard University Press, 1979), p. 147.

62. MDR to MED, Nov. 5, 1923, box 19, RR Papers.

63. William Rhinelander Stewart, ed., *The Philanthropic Work of Josephine Shaw Lowell* (New York: Macmillan Co., 1911); *Notable American Women*, 2: 437–39.

64. Carroll Smith Rosenberg, "Beauty, the Beast and the Militant Woman: A Case Study in Sex Roles and Social Stress in Jacksonian America," *American Quarterly* 23 (Oct. 1971): 562–84; Israel Kugler, "The Trade Union Career of Susan B. Anthony," *Labor History* 2 (Winter 1961): 90–100.

65. Stewart, *Philanthropic Work*, pp. 334–35; Lagemann, *A Generation of Women*, pp. 95–96.

66. Quoted in Stewart, *Philanthropic Work*, p. 358.

67. Cf. Jane Addams, *A New Conscience and an Ancient Evil* (New York: Macmillan Co., 1914), pp. 65–68; *The Maimie Papers*, ed. Ruth Rosen (Old Westbury, N.Y.: Feminist Press, 1977), p. 193.

68. Stewart, *Philanthropic Work*, pp. 416–17; Vern L. Bullough, *The History of Prostitution* (New Hyde Park, N.Y.: University Books, 1964), pp.

180–82; also see Egal Feldman, "Prostitution, the Alien Woman and the Progressive Imagination, 1910–1915," *American Quarterly* 19 (Summer 1967): 192–206; John C. Burnham, "The Progressive Era Revolution in American Attitudes toward Sex," *Journal of American History* 59 (Spring 1973): 885–908.

69. Stewart, *Philanthropic Work*, p. 371.

70. On reform and prostitution, see Mark Thomas Connelly, *The Response to Prostitution in the Progressive Era* (Chapel Hill: University of North Carolina Press, 1980); Robert Riegel, "Changing American Attitudes toward Prostitution, 1800–1920," *Journal of the History of Ideas* 29 (July-Sept. 1968): 437–52; Blanche Glassman Hersh, *The Slavery of Sex: Female Abolitionists in America* (Urbana: University of Illinois Press, 1978).

71. MDR was acquainted with the crusade against prostitution by the 1890s, for she admired Emma Whittemore's reform work with prostitutes in New York City's tenderloin district (MDR to Alice O'Gorman, Oct. 25, 1938, box 39, MDR Papers). I owe the identification of Whittemore to Edward T. James.

72. Frances A. Kellor, *Out of Work: A Study of Employment Agencies, Their Treatment of the Unemployed, and Their Influence on Homes and Business* (New York: G. P. Putnam's Sons, Knickerbocker Press, 1905); cf. George J. Kneeland, *Commercialized Prostitution in New York City* (New York: Century Co., 1913), pp. 174–75; Nancy J. Weiss, *The National Urban League, 1910–1940* (New York: Oxford University Press, 1974), pp. 15–20. On Kellor, see *Notable American Women: The Modern Period*, pp. 391–93.

73. MDR, "The Employment Agency Bill," *Woman's Municipal League Bulletin* 2 (June 1904): 2.

74. Kellor, *Out of Work*, p. vi; MDR, "Statement before the Committee on Affairs of Cities, New York Assembly, Albany, New York," Mar. 24, 1904, box 3, MDR Papers; William Sheafe Chase to MDR, Mar. 14, 1904, box 25, MDR Papers.

75. Quoted in "Protection from Unfit Servants," *New York Herald*, Mar. 25, 1904.

76. Feldman, "Prostitution," pp. 200–206; Robert L. Buroker, "From Voluntary Association to Welfare State: The Illinois Immigrants' Protective League, 1908–1926," *Journal of American History* 58 (Dec. 1971): 643–69. Also see Jane Addams, forward to *Annual Report*, 1909–1910, League for the Protection of Immigrants, Papers of the Immigrants' Protective League, Midwest Women's Historical Collection, Preston Bradley Library, University of Illinois at Chicago, Chicago, Ill. Cf. Alice Henry, "A Forward Step in the Labor Movement," *Charities* 12 (August 1904): 62; S. P.

Breckenridge, "Tributes given at a Memorial Service in Honor of Margaret Dreier Robins under the Auspices of the WTUL of Chicago," *Bulletin of the WTUL of Chicago* 38 (Mar. 1945); Robert L. Buroker, "From Voluntary Association to Welfare State: Social Welfare Reform in Illinois, 1890–1920" (Ph.D. diss., University of Chicago, 1973).

77. See Feldman, "Prostitution"; Burnham, "Progressive Era"; Roy Lubove, "The Progressive and the Prostitute," *Historian* 24 (1962): 308–30; Davis, *American Heroine*, pp. 176–79.

78. Cf. MDR, untitled essay, [c. 1905], box 2, MDR Papers.

79. On the origins of the WTUL, see chapter 2.

80. William English Walling to MDR, Dec. 28, 1904, box 1, Papers of the National Women's Trade Union League (NWTUL), Library of Congress, Washington, D.C.

81. Dye, *As Equals*, p. 50.

82. MED, *Robins*, pp. 24–35; MED to MDR, June 21, 1936, box 49; May 25, 1944, box 55, MDR Papers; MDR to MED, May 9, 1906, box 26, MDR Papers.

83. For what follows on RR's life, see William A. Williams, "Raymond Robins and Russian-American Relations, 1917–1938" (Ph.D. diss., University of Wisconsin, 1951); Neil Victor Salzman, "Reform and Revolution: The Life Experience of Raymond Robins" (Ph.D. diss., New York University, 1973); Allen F. Davis, "Raymond Robins: The Settlement Worker as Municipal Reformer," *Social Service Review* 33 (June 1959): 131–41.

84. On RR's activity in Nome, see the memoir by his sister, Elizabeth Robins, with a foreword by Leonard Woolf, *Raymond and I* (New York: Macmillan Co., 1956). According to Woolf, RR had objected to this account being published in his lifetime.

85. On relations between the Chicago Teachers' Federation, the Chicago Federation of Labor, and the WTUL, see chapter 2.

86. On the statement regarding "five maiden aunts," see William Hard, "Chicago's Five Maiden Aunts," *American Magazine*, Sept. 1906, p. 489. On Chicago women reformers, see Rosalind Rosenberg, *Beyond Separate Spheres: Intellectual Roots of Modern Feminism* (New Haven: Yale University Press, 1982), pp. 32–36; Rebecca Louise Sherrick, "Private Visions, Public Lives: The Hull-House Women in the Progressive Era" (Ph.D. diss., Northwestern University, 1980); Lana Ruegman, "'The Paradise of Exceptional Women': Chicago Women Reformers, 1863–1893" (Ph.D. diss., Indiana University, 1982.)

87. MED, *Robins*, pp. 26–67. On relations between MDR and Addams, see chapter 2.

88. MDR to MED, May 9, 1906, box 26, MDR Papers.

89. Theodore Roosevelt to RR, June 3, 1915, box 6, RR Papers.

90. Salzman, "Reform and Revolution," pp. 132–34.

91. MDR to RR, May 31, 1905, box 59, MDR Papers; RR to Anita McCormick Blaine, Sept. 29, 1905, box 604, Anita McCormick Blaine Papers, Archives Division, Wisconsin State Historical Society, Madison, Wisc.

92. MDR to RR, Oct. 17, 1908; RR to MDR, Oct. 22, 1909, box 59; RR to MDR, Apr. 18, 1915, box 61, MDR Papers.

93. RR to MDR, May 29, 1905, box 2, RR papers.

94. RR to MDR, July 11, 1933, and MDR to RR, July 13, 1933, box 71; MDR to RR, July 19, 1936, box 73, MDR Papers.

95. See chapter 5.

96. In June 1907, two years after MDR and RR married, MED confessed her love for RR to him. Two years later, at his suggestion, RR and MED founded the "Order of the Flaming Cross," a covenant between the two in which her passion would be laid on the altar of divine will and social service. In their correspondence, RR became the "Knight of the Flaming Cross," and MED was the Lady of the same. There is no evidence that RR reciprocated his sister-in-law's love; rather he suggested the elaborate ritual as a way of affirming MED's work in social reform and preserving family harmony. At the same time, the "Order" commemorated RR's conversion in the Yukon and appealed to his romantic and sentimental nature. On the covenant, see MED's poems to RR of Aug. 13, 1939, and June 6, 1937, as well as her letter to RR of Aug. 14, 1940, MED Papers. For the quotations in the text, see RR to MDR, Mar. 12, 1923; and MDR to RR, Dec. 3, 1922, box 64, MDR Papers.

97. MDR to MED, June 25 and July 1, 1905, box 25; MDR to MED, June 3, 1923, box 34, MDR Papers.

98. "Report of Finance Committee," in "Minutes of the Eighth Biennial Convention of the NWTUL," June 5–10, 1922, Waukegan, Ill., p. 285, reel 22, NWTUL Papers, Library of Congress, Washington, D.C. For more on MDR's financial role in the League, see chapter 2.

99. MDR to MED, Sept. 18, 1908, box 26; MDR to MED, Jan. 12, 1909, box 27, MDR Papers.

100. RR to MDR, Apr. 30, 1929, box 67, MDR Papers.

101. MDR to Elisabeth Christman, Apr. 1, 1932, box 43; MDR to RR, Feb. 19, 1912, box 60, MDR Papers; Stella M. Franklin, "The Fifth Biennial Convention," *Life and Labor* 5 (July 1915): 116.

102. For further discussion, see chapter 5.

103. Jane Addams, "The Subjective Necessity for Social Settlements," and "The Objective Value of a Social Settlement," in *Philanthropy and Social Progress*, ed. Henry C. Adams (New York: T.Y. Crowell and Co., 1893), pp. 1–56; cf. Davis, *American Heroine*, pp. 38–39.

104. On the domestic aspects of the League, see chapter 4.

# 2

## "We Believe in You": Reformers, Workers, and the Bonds of Commitment

When Margaret and Raymond moved to Chicago after their marriage, they first stayed in what local reformers called "the honeymoon suite" at Hull House on Halsted Street. A few weeks later, they found permanent lodging in a third-floor, cold-water flat on West Ohio Street, about a mile north of Hull House and a few blocks from the Northwestern University Settlement; the other tenants were mostly Italian garment workers, and Robins would always associate her Chicago home with the smell of garlic and onions.[1] The Robinses lived for the next nineteen years in "the bloody seventeenth ward" on the West Side, a center of labor strife and election violence, as well as of the 1886 Haymarket riot. It was an area of ethnic variety and of extreme poverty, and for Robins, who had spent her life in comfortable and homogeneous surroundings, life in Chicago was unfamiliar and straitened. Forty years later, at the time of Robins's death, Raymond reflected that when he met his future wife in 1905, "she seemed to me bound by a narrower range than she was entitled to. . . . the bonds of custom and her social setting on the Heights of Brooklyn in her brownstone mansion still held. I knew that she would have [to] be taken *out* of that setting to find her true freedom and power, and believed that the 'bloody seventeenth' of Chicago's tenement district would do the job."[2]

It was appropriate that Robins began her Chicago career with a stay at Hull House, for the famous and influential settlement was

intimately linked with what was to be her primary concern, the Women's Trade Union League. William English Walling, the founder of the League, was a wealthy Kentuckian who graduated from the University of Chicago in 1897 and shortly after did graduate work there in economics and sociology.[3] The faculty of those departments was devoted to relating scholarship to public service, while George Herbert Mead and John Dewey in the philosophy department held similar ideas about civic reform.[4] Dewey was on Hull House's first board of trustees and admired the settlement's educational innovations. In particular, as Addams said in 1930, "Years ago, before trade unions had proved their social utility and when it was scarcely respectable to be identified with them, John Dewey made it easier for them and for all their Chicago friends."[5]

A convert to trade unionism, Walling by 1900 was working as a factory inspector in Chicago and living at Hull House. The factory inspection law was passed in Illinois in 1893 largely as a result of the investigations of Florence Kelley, a resident of Hull House, and the lobbying of the settlement's other residents; Hull House was subsequently criticized often as a center of trade-union agitation. "At Hull House," it was said, "one got into the labor movement as a matter of course, without realizing how or when."[6]

In 1901, Walling became a resident of University Settlement in New York City's garment district on the Lower East Side. While working there, he met Lillian Wald, the founder of nearby Henry Street Settlement. Walling and Wald had a mutual connection in Hull House and trade unions, for in the early 1890s Addams had corresponded with Wald about the necessity for organizing women workers. Walling also became acquainted with Florence Kelley, who had moved on from Hull House to become a resident at Henry Street and general secretary of the National Consumers' League, which urged the public to purchase goods manufactured under proper working conditions. Walling, Wald, and Kelley became interested in the British Women's Trade Union League, which had been founded in 1874 by labor reformers and middle-class sympathizers. In the summer of 1902, upon the urging of the two women, Walling went to England, where he talked to Mary Mac-Arthur, head of the British WTUL, about establishing a similar national organization in the United States.[7]

In November 1903 Walling attended the American Federation of Labor's annual convention in Boston, where, through Hull House connections, he met Mary Kenney O'Sullivan. The daughter of Irish immigrants, O'Sullivan had learned the trade of bookbinding in Hannibal, Missouri, where she grew up. While trying to unionize Chicago bindery workers in 1891, O'Sullivan was invited to Hull House, where she discovered what she called "a new world," a place where middle-class women "cared enough to help us and to help us in our own way." As she later recalled, "It was that word 'with' from Jane Addams that took the bitterness out of my life. For if she wanted to work with me and I could work with her, it gave my life new meaning and hope." Addams aided O'Sullivan in organizing the bindery workers and in establishing the Shirt Makers' Union. During her last year in Chicago, O'Sullivan lived at Hull House.[8]

O'Sullivan's activities on behalf of labor were acknowledged in 1892 when she was appointed as the AFL's first—and until 1908, only—female general organizer. It was while serving in that capacity that she met her future husband, John F. O'Sullivan, labor editor for the *Boston Globe* and a friend of Samuel Gompers. Married in 1894, the O'Sullivans settled in Boston, living for a time at Denison House, a settlement in the South End which, like Hull House, was associated with labor activism. When striking women garment workers wanted to form a union in 1894, they came to Denison House and O'Sullivan, not to the AFL, to ask for help.[9] Indeed, the strikers were typical of working women who had already learned that America's great labor federation did not welcome their affiliation. Although over five million women worked outside the home for wages in 1903, few belonged to labor unions, and only four women were included among the 496 voting members of the AFL's Boston convention in that year.[10] The established labor movement did not provide financial or moral support for the organization of women workers. That was left instead to the ad hoc activities of individual agitators and to the goodwill of the settlement houses. Given such a situation, it is not surprising that the Women's Trade Union League was not fathered by the AFL but was instead a distant offspring, a sort of grandchild, of Hull House. When Walling and O'Sullivan met in Boston in 1903, they decided that it was time for an organization that would be wholly dedicated to the cause of

working women, one that would bring the female wage-earner into the mainstream of the American labor movement.

The goal of the League, as stated in its constitution, was very general: "to assist in the organization of women wage-workers into trade unions." But the constitution was more specific about the membership of the executive board inasmuch as the League was to be a joint enterprise of wage-earners and social reformers: "The majority of the Executive Board shall be women who are, or have been, trade unionists in good standing, the minority of those well known to be earnest sympathizers and workers for the cause of trade unionism."[11] The first executive council accordingly consisted of four reformers, Mary Morton Kehew, Jane Addams, Mary McDowell, and Lillian Wald, as well as five trade unionists, including Mary Kenney O'Sullivan and Leonora O'Reilly.[12] Of the nine women on the original board, these six formed a network of personal relationships that dated back to the early 1890s. Kehew, a Boston reformer, was named president of the League at the urging of O'Sullivan; but Kehew never was more than a titular leader, and the national WTUL did not have an active president until Robins assumed the post in 1907.

Along with her place on the executive council of the national League, Mary McDowell was elected president of the Chicago WTUL, a post she held until succeeded by Robins in 1907. McDowell's reform career began at the age of sixteen when she helped her Methodist pastor distribute relief supplies to crowds fleeing the great Chicago fire of 1871.[13] In 1890, after serving as a national organizer for the Woman's Christian Temperance Union, she moved into Hull House as a kindergarten worker. The Hull House environment and the Pullman strike of 1894 brought the problems of workers to the center of her attention. Following Addams's recommendation, the University of Chicago in 1894 selected McDowell to head the new university settlement near the stockyards, an experiment that was to follow the philosophy of Hull House and to serve the research needs of the school's new department of sociology. Ten years later, shortly after the formation of the WTUL, McDowell sided with the packinghouse unions in their bitter strike for higher wages and recognition. Although she resigned the presidency of the Chicago League in 1907—princi-

pally because she knew that Robins would give the post her full attention—McDowell remained involved with the League until her death in 1936.

McDowell's role on the executive council reinforced the connection between Hull House and the League. But in terms of developing the strategy and ideology of the new organization in its first crucial years, Leonora O'Reilly, the council's leading "trade unionist in good standing," was more important.[14] The daughter of an Irish seamstress, O'Reilly began work in a garment factory at the age of eleven, and she joined the Knights of Labor at sixteen. O'Reilly was supported by Wald in her attempts to organize women workers, and through her involvement in the Working Women's Society, she became a friend of Josephine Shaw Lowell, Robins's mentor. Indeed, it may have been Lowell who brought O'Reilly into contact with the Dreier sisters. At any rate, shortly after the turn of the century, when O'Reilly was the head worker at Asacog House, a Brooklyn settlement, Margaret and Mary were serving on its board of directors. O'Reilly was one of Walling's first recruits to the League, although she at first feared that the new organization would be condescending to workers, having "the attitudes of a lady with something to give her sister."[15] She went on to persuade the Dreier sisters to join the League, and for all her later contributions to the WTUL, that may have been her most important, for Margaret Dreier Robins proved to be the salvation of the New York branch and later of the national organization itself.

Middle-class reformers such as Robins and McDowell who sympathized with the needs of workers and the aims of organized labor were known as "allies." The allies and their trade-union associates on the executive council guided the League through its initial growth by relying on contacts they had made and methods they had refined during the 1890s while organizing female wage earners. They quickly established local branches of the League in Chicago, New York, and Boston, where the settlement impulse had been the strongest. These cities were not only industrially mature and economically diverse, they also had a heavy concentration of garment factories, which employed large numbers of women. By 1915 the League had expanded to include branches in twenty-two cities. A few, like the Springfield, Illinois, branch, were paper organizations,

a mere warrant of good intentions. Some, like the Cleveland League, lay dormant until the national leadership resuscitated them during a passing labor crisis. The St. Louis branch had too few allies, hence it suffered from a lack of leadership and funds. The Boston branch never became truly self-sustaining because of a paucity of working-class reformers. The Leagues in Kansas City and Philadelphia had limited resources but nevertheless did effective work. In all cases, the national organization itself, as well as the strong Leagues of Chicago and New York City, provided essential support and money to the local branches, especially in times of labor strife. Such aid was dispersed mainly through the cities of the Northeast. The western states were too distant and too thinly spread with industry for the League to be effective there. The San Francisco branch was a lonely and weak outpost of female trade unionism. The League did not extend into the South until the 1920s, and then the expansion was not the result of the foundation of local branches but of the national league dispatching personnel and money to aid union organization. Yet however much the local branches of the League varied in effectiveness, they provided an institutional structure, a means of pooling diverse talents and experiences, that was needed to create trade unions for women workers. In addition, the League offered women a forum in which they could help shape discussion of industrialism's impact on the laborer, especially the female worker. As such, the League, in both its institutional framework and the network of personal relationships that informed it, allowed women to voice their own critiques of industrial capitalism and organized labor. By bringing together reformers and workers, women of different classes and backgrounds, the League was the institutional embodiment of new bonds of commitment among women, an expression of solidarity and sorority that carried with it hopes for female workers as well as for society at large.

Unlike Robins, most middle-class reformers and trade unionists did not regard work with the League as a lifelong commitment. Like the settlement house and the women's college, it served as a place of transition through which earnest young women moved on their way to roles as homemakers and mothers, research scholars, union organizers, or government appointees. Some reformers,

such as Jane Addams, backed the League in its infancy but never saw it as a major thrust of their work. Other allies, like Anne Morgan, daughter of financier J. P. Morgan, were supporters during a crisis—in her case, the "Uprising of Twenty Thousand" shirtwaist makers—but maintained little interest in the League afterwards.[16] In this respect, these wealthy women resembled scores of female trade unionists who surfaced during a strike or a labor crisis, only to sink back into anonymity, leaving no organizational ties or lasting influence. Other women of substantial means, such as Abby Aldrich Rockefeller and Dorothy Whitney Straight, provided important financial support but did not participate in League activities. Among wealthy allies in Chicago, Anna Wilmarth Ickes, Bertha Poole Weyl and Amy Walker Field married men with demanding careers and thereafter participated only occasionally, usually during times of strikes. After working for the League, Helen Marot became a researcher and writer for the Russell Sage Foundation. Bessie Abramowitz, a garment worker employed as an organizer by the League, became increasingly involved with her own union's affairs and then sharply curtailed her labor activities after marrying Sidney Hillman, president of the Amalgamated Clothing Workers.

Robins, Dreier, and McDowell were distinguished from most of their fellow allies in that they were full-time volunteers. Robins and Dreier never held salaried positions, while McDowell received only a modest stipend for her work at the University of Chicago Settlement. The three were also unlike most of the allies by virtue of coming from evangelical Protestant denominations. The Dreier sisters were born into the German Evangelical church. In a reversal of religious association for the socially comfortable, McDowell and her father bolted from the Episcopal church to worship in a Methodist congregation in Cincinnati's grimy industrial district. For all three women, social service was an expression of religious faith, which in part accounts for their enduring devotion to labor reform.

None of the three was a college woman, unlike most of the allies. Robins had taken private tutoring, and Dreier had studied briefly at the New York School of Civics and Philanthropy. McDowell had attended a training school for kindergarten teachers, but she felt that her real education had come "mostly in being the oldest daughter of a large family with an invalid mother."[17] Indeed, most

of the League's leaders had assumed heavy responsibilities for
their families in early adolescence, and half of them were the
oldest daughters in their homes. By caring for younger siblings,
substituting for their mothers when necessary, or by providing in-
come for their families, most had taken significant responsibility
for other family members by the time they were fifteen years old.

Fathers evidently played an important role for League women
in encouraging their ambition and self-development. Many leaders
of the League had enjoyed close relationships with their fathers,
often becoming the male parent's intellectual or social ally within
the family. McDowell shared her father's civic and religious inter-
ests, and, of course, Robins was her father's favorite child. Rose
Schneiderman claimed that her father rather than her mother "al-
ways encouraged me openly," and long after his death, she still felt
inspired by his applauding her ambition to be a teacher. So too,
Agnes Nestor was particularly close to her father, a member of the
Knights of Labor, who advised her on labor matters until his death.[18]

In general, the allies of the WTUL were daughters or wives of
men on the social and economic rise, men who identified with the
economic expansion of late nineteenth-century America. They did
not come from families losing out in the social race to agents of
great corporations, owners of franchises, or operators of political
machines. Neither were they mesmerized by a fading vision of so-
cial symmetry and tradition-minded leadership.[19] They instead
were committed to expanding social possibilities and to shaping a
more liberal culture. Robins and Dreier each inherited $600,000
from their father, an immigrant who became an iron merchant.
McDowell's father established a steel-rolling mill in Chicago and
patented the spiral springs that became standard on railway cars;
his legacy to Mary enabled her to devote herself to reform. Mary
Morton Kehew was the daughter of a wealthy Boston banker and
the wife of an oil merchant. Ellen Martin Henrotin, Kehew's suc-
cessor as president of the League, was the daughter of a financier,
and her husband became president of the Chicago Stock Exchange.
Anita McCormick Blaine's father was Cyrus McCormick, whose me-
chanical reaper revolutionized farming methods; her husband, a
lawyer and businessman, was the son of James G. Blaine, a presi-
dential candidate. Anna Wilmarth Ickes's father manufactured gas

fixtures, while her husband, Harold Ickes, emerged as one of Chi-
cago's leading attorneys, served as the League's legai counsel, and
became secretary of the interior under Franklin Roosevelt, whose
own wife had joined the WTUL in 1922. Amy Walker Field's father
was a prominent judge, and her husband was a professor of eco-
nomics at the University of Chicago.[20]

Naturally, most allies did not come from such publicly visible
and financially comfortable families as did the Dreiers, Kehew, and
Blaine. They nevertheless identified with the vitality they perceived
in industrial America and were far from feeling deprived of a privi-
leged status in society. Furthermore, most of the middle-class re-
formers of the League did not derive from villages or from an aris-
tocratic local gentry.[21] Rather, they grew up in cities and were
enthusiasts for urban life. Robins, Dreier, McDowell, Henrotin,
Kehew, Ickes, Field, and Weyl spent their formative years in major
cities. They did not nostalgically idealize rural, small-town Amer-
ica, but believed that a humane culture could flourish within an
urban technological society.

In general, allies came from families that had been in the
United States for several generations. The outstanding exceptions
to this were the Dreier sisters, whose ties to the land of their par-
ents were so strong. No other important allies were the daughters
of immigrants, and only two—Alice Henry and Stella Franklin—
were not born in the United States. Both were from Australia, and
both were special cases. The daughter of a seamstress and a failed
farmer, Henry became a journalist in Australia, came to America
at the age of forty-eight, and was hired by Robins in 1906 as of-
fice secretary of the Chicago WTUL. Franklin, the daughter of an
impoverished Australian farmer, had won transient fame by her
autobiographical novel, *My Brilliant Career* (1901). In the United
States, she worked for the League as a secretary and moved on to
edit *Life and Labor* with Henry and to serve as secretary-treasurer
of the Chicago WTUL.[22] Because of their vocation as writers, their
nonindustrial background, their foreign yet Anglo-Saxon origins,
and their dedication to labor reform, Henry and Franklin naturally
assumed the status of allies, even though neither was from a so-
cially prominent or moneyed family. In fact, a handful of trade-
union reformers came from more substantial backgrounds than

did the two allies from Australia—and, significantly, they too were immigrants. Thus Maud O'Farrell Swartz was the daughter of Irish landed gentry, and her wealthy relatives, one of whom became mayor of New York City, were eager to give her a continental education. She, however, migrated to the United States, took work as a well-paid typesetter, became a trade-union leader, eventually earned her livelihood as secretary of the New York League, and succeeded Robins as president of the National WTUL. Fannia Cohn was born to a prosperous, well-educated Russian family, but her identification with socialism led to the trade of a garment worker so that she could become a union leader.[23] Swartz and Cohn had the social and economic background to qualify them as allies, yet because of their foreign origins and their drive for independence, they entered the ranks of trade unionists, where, indeed, their education and cosmopolitanism impelled them toward leadership.

Except for blacks, a higher percentage of first and second generation American females worked than any other group of women.[24] Not surprisingly, then, most trade-union leaders were daughters of immigrants, though their ethnic backgrounds varied from city to city and from decade to decade as new workers entered the labor force. Over the years, however, Irish Catholic and Russian Jewish women, with a sprinkling of Britons, Germans, Scandinavians, and Poles, provided the basic leadership. Leonora O'Reilly, Agnes Nestor, Maud O'Farrell Swartz, and Elizabeth McErney were Irish Catholics who gave long years of service to the League. Among Russian Jews, Fannia Cohn, Rose Schneiderman, Pauline Newman, Lillian Herstein, and Bessie Abramowitz Hillman figured prominently. Melinda Scott, Myrtle Whitehead and Agnes Burns were wage earners with British Protestant roots. Louisa Mittelstadt and Elisabeth Christman were German-Americans, a group that were especially numerous among brewery and glove workers. Clara Massolitta, who was employed by the Chicago League to organize garment workers, was the only one of her ethnic origin to gain prominence in the organization, inasmuch as Italian mores and tenement-shop conditions inhibited the movement of her countrywomen into the ranks of labor activists. Irene Goins, a black woman and the president of the Federation of Colored Women's Clubs, served on the executive council of the Chicago League,

which hired her to work with McDowell in organizing black stock-yard workers in 1917. Although the League showed only sporadic concern for black workers, its activity on their behalf distinguished it from other contemporary labor and feminist groups. The Chicago League in particular took a leading role in advocating the admission of blacks into the established unions, but the restrictions placed upon blacks in industry meant that Goins was one of the few black women who emerged as a labor activist.[25]

In general, the parents of the trade-union reformers were not strictly proletarian. The League's activist workers, more commonly than its reformist allies, may be seen as having lost social and economic status. Most of the trade-union leaders had fathers with skills, men ambitious to gain a foothold in the entrepreneurial class as owners of small businesses. But because of various misfortunes, almost all of the future activists were at work by the age of fourteen. The case of Agnes Nestor's family was typical. Her father was from Ireland, and her mother, also Irish Catholic, worked in the cotton mills of Cohoes, New York. By the time Agnes was born in Grand Rapids, Michigan, however, Thomas Nestor was able to give up work as a machinist to manage the grocery store he had bought, an advance that eventually brought the family some respectability in Grand Rapids. Nestor entered politics, but after losing a bid for sheriff, he moved his family to Chicago and resumed his trade as a machinist. Since her father's wages were inadequate for a family of five, Agnes went to work at fourteen as a glove maker.[26]

John O'Reilly, the father of Leonora and a printer by trade, also aspired to own his own store. The children of Irish immigrants, he and his wife, a garment worker, established a grocery business on New York's East Side. But Leonora was doomed to a childhood of extreme poverty when the store failed and her father died before she was a year old. Her mother returned to the garment trade, and after only three years of schooling, Leonora went to work at eleven in a collar factory.[27]

The death of Rose Schneiderman's father also led to a life of poverty for his family. Jews from Russian Poland, the Schneidermans came in 1890 to the United States, where the father worked

as a tailor. After his death two years later, when Rose was ten, the family was thrown upon charity. When she turned thirteen, Rose became her family's principal breadwinner, beginning as an errand girl in a department store. For all her difficulties, however, Rose completed nine grades in four years of schooling.[28]

Mary Kenney O'Sullivan's experience was distressingly similar. Her parents came to America from Ireland and traveled west with a railroad gang for which her mother cooked and her father served as a foreman. The Kenney children were born in Hannibal, Missouri, where the father worked in the railroad machine shops. After completing the fourth grade, Mary became an apprentice dressmaker, and when her father died, leaving fourteen-year-old Mary responsible for her invalid mother, she took work at a printing and binding firm, where she learned every aspect of the trade.[29]

Mary Anderson's parents also fell onto hard times. She grew up on a prosperous farm in Sweden; but after a series of crop failures, her father could no longer pay his taxes and the family property was lost. Shortly thereafter, in 1889, sixteen-year-old Mary migrated to America and eventually moved to Chicago and a job as a boot and shoe worker.[30]

Clearly, the leadership of the League was drawn from groups of women from vastly different backgrounds. In education, economic status, and social origins, allies and trade unionists often came from different worlds. As a consequence, they came to the common realm of labor reform from diverse directions. The allies rarely were concerned with labor issues at the onset of their careers. Instead, they at first spent considerable time in various kinds of social service, such as charity relief, immigrant assistance, and hospital auxiliary work. Thus Robins came to the problems of labor by way of volunteer work in Brooklyn Hospital and antiprostitution work with the Women's Municipal League, while McDowell came to the WTUL from preoccupation with kindergarten education, the temperance crusade, and settlement work. In contrast, trade unionists were quickly and often brutally faced with the problems of unorganized women. Their commitment to labor reform arose from their immediate experience and was not the result of an abstract recognition of social injustice or of a lengthy evolution to-

ward concern for workers. As lower-class women, as the daughters
of immigrants, and as Catholics and Jews, they had faced forms of
discrimination and abuse that were wholly foreign to the allies.

Still, the middle-class reformers and trade-union activists had
important things in common beyond their mutual commitment to
labor reform. The highly independent, forceful personalities of
League women were in part the consequence of their assuming
heavy family responsibilities at an early age, whether voluntarily
like Robins and McDowell or from necessity like O'Sullivan and
Schneiderman. Moreover, the women of the League were strongly
influenced by their fathers, who instilled in them ambitions for per-
sonal achievement and social advancement. As one-time farmers,
foremen, and shop owners, the fathers of many of the trade union-
ists also gave their daughters a glimpse of a better life, a sense of a
social world beyond the tenement and the factory, a world that was
epitomized by the middle-class reformers of the WTUL. Finally,
both allies and activists were part of urban American society. Al-
though they came from rural Ireland and Sweden, from suburban
Evanston and small-town Missouri, they were formed in their early
adulthood by the great centers of Chicago and New York, a circum-
stance that gave them significant common ground when dealing
with problems of housing, health, and corruption in the city.

Allies and trade unionists were also brought together by a
consideration that sharply distinguished the two groups: on the
average, an ally when the League was founded was twelve years
older than a trade unionist.[31] This generational gap was a conse-
quence of the different careers of the two sets of women. Allies ap-
proached the WTUL by a leisurely route, often not arriving until
their late thirties or early forties; in 1903, the average age of the
allies was forty, and most allies were married and had children.
They usually joined the League with broad experience in running
organizations, raising funds, lobbying for causes, and establishing
useful civic connections. In contrast, trade-union leaders entered
the labor market in their mid-teens and joined the League in their
mid-twenties, at the same time that their sisters in industry were
quitting their jobs for marriage and a family; in 1903, the average
age of the trade unionists was twenty-eight, and most of them were
not married. While they had considerable experience of the work-

ing world, very few had been involved in administrative activity or in the broader difficulties of labor organization.

The contrast in age and experience between ally and trade unionist could be striking. McDowell, who at seventeen in 1872 was already heavily involved in directing relief assistance, worked with Nestor, who at the same age in 1897 was stitching gloves in a Chicago factory; they met in the League when McDowell was forty-nine and Nestor was twenty-one. Robins began her part-time volunteer work at Brooklyn Hospital in 1887 when she was nineteen; but at that age in 1901, Schneiderman had been the sole support of her family for six years, including three years sewing in a cap factory.

In the early twentieth century, the natural relationship between persons of such different ages was deference, a consideration that did much to ease accommodation between allies and trade unionists. Indeed, regardless of background, young women in the League addressed older members with respect, calling them "Miss" or "Sister." To all members, trade unionist Emma Steghagen, hired in her fifties as a secretary, was known as "Sister Emma." Women of the same age used each other's given names. Only on public occasions did Robins and O'Reilly, who were only three years apart in age, refer to each other as anything but "Gretchen" and "Leonora." Whatever their economic or social position, older women addressed the younger by their given names and naturally assumed a virtually maternal role toward them.

Since the line between the generations was all but identical with that between the classes, this insured the deference of the trade unionists toward the allies. That deference, along with commonly held opinions regarding labor reform, was a significant element in uniting women from very different environments. In effect, the courteous and obliging attitude of the young toward the old initially counteracted the leading role that the constitution of the League assigned to women from the working class. Of course, as time went by, the generational foundations of deference crumbled. New allies entering the League, principally young college women, were no longer necessarily senior to the trade unionists, while the original trade unionists gained years and organizational experience. By 1913 the average age of the original trade-union leaders

was thirty-eight. In that year thirty-three-year-old Nestor succeeded Robins as president of the Chicago League, only two years younger than Robins was when she joined the New York WTUL in 1903. Schneiderman became head of the New York branch at the age of thirty-five in 1917, and Swartz succeeded Robins as head of the national WTUL at the age of forty-five in 1922. In such turnovers of leadership, one of the original mandates of the League was fulfilled: the old generation yielded to the new, and middle-class reformers gave up their places to women from the working class.

Of course, as president of the League, one of Robins's chief goals was necessarily the replacement of allies with trade unionists in leadership positions. That, however, was also a policy dictated by common sense, for allies were involved in diverse civic and reform activities. Their many interests and busy schedules made them, in Robins's eyes, unreliable leaders for her own organization. According to Agnes Nestor, allies were usually involved with a "whole lot of other work and organizations and . . . taxed in everything." After a year as president, therefore, Robins decided that the future of the League lay with giving "the working girls every opportunity for a larger knowledge and experience—they must be intelligently *trained* to fight their own battles."[32]

Robins cultivated for leadership a group of young women who emerged into public visibility in garment strikes in Philadelphia, New York, and Chicago from 1909 through 1911. She insisted when she stepped down as president of the Chicago League in 1913 that she be succeeded by a trade-union reformer. Mary Dreier followed suit when she resigned the presidency of the New York branch in the next year. Within eight years after Robins assumed leadership of the national League, her program had led to the election of wage earners as presidents of all the local branches of the WTUL, an achievement for which she rightly took credit.[33]

The legacy of the allies endured, however, because the first years of the League were crucial for setting its tone, scope, and philosophy. Although leadership of the League passed from the hands of the allies, the organization retained the ideological complexion given to it by the middle-class reformers when they enjoyed a natural deference, based upon age and education, from the inexperienced trade unionists. The later leaders of the League con-

tinued to conceive of the policies and purposes of their institution in terms established by those who founded it, and they never questioned the ambitions and assumptions of the allies. Thus the high value that the middle-class reformers placed upon education, self-development, autonomy, and public performance found expression in 1914 in the creation of the Training School for Women Workers. As envisioned by Robins, the school was intended to encourage young women to assume responsibilities within labor organizations. It was one of the League's most notable pioneering ventures. The first residential college program for workers in America, it became the prototype of other institutes organized in the 1920s by colleges and labor organizations.[34] Yet the school was a substantial drain on the resources of the League, resources that might have been better spent on supporting strikes and organizing unions. As it was, only forty-four students were trained as labor organizers from 1914 to 1926, and by 1928, ten of them were no longer active in the labor movement. In fact, the school was probably most significant as an expression of the allies' commitment to education as an instrument of social change. It also demonstrated the allies' faith in the potential of young working women. As Leonora O'Reilly recorded in her diary, the essence of the League and trade unions was a matter of women saying to other women, "Go ahead . . . We believe in you."[35]

As an educational experiment, the training school reflected the success of the middle-class reformers in situating the League within a broad reform agenda. Given their own wide experience in reform work, the allies naturally defined the League not merely as an organization dedicated to improving the lot of working women but as part of a crusade against injustice and inhumanity. This was an exhilarating perspective for the young trade unionist who at first saw her difficulties as limited to unclean workshops and inadequate wages. Indeed, no small part of the devotion that trade unionists gave to the League stemmed from the success of the allies in linking the problems of working women to a tradition of reform that stretched back to antebellum days and that reached out to considerations of moral principle and social regeneration.

At the same time, this expansive definition of the League's purposes diffused the energies of the trade unionists even while it ex-

cited their imaginations. By assuming that the cause of women's trade unionism was intimately related to those of educational reform, suffrage, peace, temperance, and health, the middle-class reformers, long after retiring from leadership positions, were responsible for the League's inveterate habit of expending its resources on projects that were not immediately relevant to the task of union organization. In the best of worlds, the aspiration of the League to organize unskilled, immigrant working women into unions would have been difficult enough. Even without a broad reform agenda and a consequent inefficient use of resources, it is doubtful that the League could have realized its primary ambition in the face of seemingly intractable difficulties. Still, among the numerous obstacles before the League, one must also include the very reformist ideology that sustained it for so long.

Within the League, there was only sparing recourse to the language of class conflict, a consideration that implicitly recognized that discord within the organization could not be reduced to a matter of class struggle, with allies and wage earners putting forth coherent views congruent with their respective social and economic backgrounds. Members periodically debated the role that allies should play within the League, and on occasion they attacked allies for their overbearing leadership or for their lack of zeal. Yet the acrimony expressed toward allies came as often from other allies as from wage earners, and the criticism leveled by both groups was generally inconsistent and disjointed, without coalescence around particular issues over an extended time. To be sure, with women of different origins in the League, it was natural that members sometimes took sides on an issue according to their class background. Such divisions, however, generally represented expressions of passing anger and frustration, the outcome of conflicts centering on personalities or specific policies rather than the revelation of fundamental class tension.

While women in the League did identify themselves in terms of class, that was only one aspect of their self-perception, and by no means the most important. The identities of both allies and trade unionists as reformers and as feminists weakened the class tensions that would otherwise have been troublesome or debilitat-

ing. In accepting a broad reform agenda as articulated by the allies, the trade unionists saw the League as part of a movement whose ultimate goal was the transcendence of class conflict. In the meantime, the WTUL was regarded as a cross-class vehicle for bringing about reform, an institution ideally lacking in class conflict and thereby foreshadowing the society it was struggling to create.[36]

Although reformism and feminism muted class differences within the League, tension between middle-class reformers and trade unionists remained. They were dramatically revealed by a key event in the early history of the organization. In addition, the event illuminates the evolving nature of the League, as well as certain aspects of Robins's character and ambitions. In February 1908, the Chicago WTUL voted to discontinue meeting at Hull House in favor of gathering at the headquarters of the Chicago Federation of Labor (CFL). In the largest assembly in the history of the Chicago branch, every trade unionist voted for the move, while all but three of the allies—Robins and two colleagues—wanted to remain at Hull House.

The vote reflected different views regarding the role of the League rather than class antagonism per se. At all times, even while they pulled the League in slightly different directions, both the allies and trade unionists were concerned to preserve amity and unity. In brief, Robins and the trade unionists saw the League as the women's branch of the labor movement, while most of the allies saw it as the labor branch of the women's movement. The victory of Robins and the trade unionists was a limited and discreet declaration of independence from those middle-class reformers who had always looked to Jane Addams and Hull House for inspiration. Henceforth, Robins would provide the inspiration for the League—as well as its financial support. Insofar as the trade unionists of the WTUL gained a firmer place within the world of labor, it was by following the lead of a wealthy and dedicated ally; and insofar as Robins emerged from the conflict over Hull House as a spokesman for labor reform, it was by winning the support of the trade unionists against her fellow allies. The vote in February 1908 asserted that the League was prepared to strike out on its own in an attempt to find a place within the American labor movement.

When Robins moved to Chicago in August 1905, the Hull House circle welcomed her into reform work. Her husband's position certainly aided her reception, for Raymond, still head resident of nearby Northwestern Settlement, had ties with Hull House reformers that dated back to 1901 when he and Addams successfully intervened to halt the police dragnet of anarchists following President McKinley's assassination.[37] For her part, Robins's estimation of Addams grew immeasurably after she came to know the founder of Hull House. "Miss Addams is the greatest woman I know," she wrote to Mary Dreier in 1905, "large-minded, great-hearted, generous and forgiving!"[38] Despite their different temperaments, the women initially worked together admirably. Friends of Robins invariably remarked on her contagious enthusiasm, on her oratorical flourishes, and on her eyes, which seemingly reflected her passing emotions. By contrast, Addams appeared grave and wise, more than a bit formal and withdrawn. She preferred crisp, efficient meetings, while Robins was content to let colleagues ramble on, careless of time and coherence. Addams once cut off a WTUL meeting over which she was presiding when it was barely mid-evening. Robins, who reveled in labor meetings that wandered into the early morning hours, wrote in exasperation to her sister: "Who ever heard of unions stopping discussion at nine-thirty? Why they have only just begun!"[39] The difference in temperament between the two reformers was also evident in their writing styles, for while Addams wrote in dry, somber English, a spare expression of precise thought, Robins favored vivid verbs, copious superlatives, and frequent exclamation marks. While usually controlled in her public performances, Robins often became, as she put it, "hot mad" when provoked. On the other hand, even Addams's close friends rarely saw the mistress of Hull House angry.[40] As it happened, Robins's dealings with Addams were severely to test the latter's composure, and Robins's lowered estimation of "Saint Jane" was to lead to the League's retirement from Hull House.

Difficulties between Robins and Addams began when the latter, a member of the Chicago School Board, voted against a plan put forward by other reformers on the board (including Raymond Robins) regarding protecting teacher evaluation from the influence of politics. Robins and other reformers, such as Margaret Haley, the leader of the progressive Chicago Teachers' Federation, were

astonished and infuriated at what they saw as Addams's betrayal of reform. After Raymond and other reformers were dismissed from the board by a new mayor in April 1907, Addams refused to join in aiding the protests of the Teachers' Federation. Again, Robins was outraged, and Addams's explanations were of no avail:

> "There is only one thing, Miss Addams," I said, "in this story which has caused a strain and that is your position. Nothing else matters—but you have dealt us a blow and the very fact that you claim that you have the right to deal such a blow makes it all the harder. It was unexpected—it came as a complete surprise and neither of us have yet been able to catch our breath." . . . Something has snapped. Of course, it may just be her judgement that has gone awry but all the same it is the biggest puzzle that has ever come to me and the greatest blow Raymond had ever received in his public life.[41]

Although Robins was upset by what had happened to Raymond, she was also genuinely concerned about the issues at stake. As she saw it, action against the school board and the Teachers' Federation, an affiliate of the League, was evidence that "there is a growing effort to stamp out trade unionism absolutely and entirely in Chicago." The controversy was directly relevant to labor interests not only because the Teachers' Federation was an important part of the CFL but because better education for the children of the workers was the fundamental goal of the reformers.[42] In addition, the Teachers' Federation was fighting for what it termed a "democratic" educational system, one in which teachers controlled the schools and policy, as opposed to the ideal of "efficiency" put forth by those who wanted greater bureaucratic centralization. This gave the Federation an identity of interest with the WTUL inasmuch as a fundamental aim of the latter was worker control of the workplace, which League women considered an essential first step in the wider democratization of society. By her behavior on the school board, Addams seemed to many to be running counter to the principles of trade unionism.

"How is it possible, I ask over and over again," Mary Dreier wrote to Raymond, "it seems too dreadful to be true—there really could be no worse blow to the cause than she has given, and my heart aches for it and you." She likened the Chicago reformers to the beleaguered abolitionists of antebellum days, and she lamented

the "dreadful, backward step" that had been taken "because of St. Jane."[43] Robins could no longer regard Addams as she had in 1905, the "large-minded, great-hearted, generous and forgiving" leader of reform. Now, she was an opponent who could not be trusted, a divisive element within the League itself. "I cannot tell you how queer I feel," Robins wrote to her sister, "when I realize that I have to protect the interests of the League from Miss Addams and . . . at our League meetings we are practically divided now into two classes—the working group and allies." By the end of 1907, Robins had decided to sever the League from the settlement on Halsted Street. "Hull House is doomed," she wrote to Mary, "and I am going about very quietly to hold our meetings elsewhere."[44]

The obvious alternative was the Chicago Federation of Labor building on La Salle Street. The Chicago WTUL already had a nominal headquarters there, a single desk in the corner of a room reserved for the CFL's newspaper; the working headquarters of the League was in Robins's apartment on West Ohio Street. Robins's conviction that Hull House was doomed and her determination to save her own organization from the same fate led her to forge more significant relations between the League and the CFL. Her intentions were aided considerably by the close association she enjoyed with John Fitzpatrick, president of the CFL. In 1906, impressed by his commitment to unorganized and immigrant workers, the Robinses helped Fitzpatrick become president by rallying support among teachers and reformers. Unorthodox and progressive, even considered something of a radical by the national unions and other city centrals, Fitzpatrick was a leading proponent of unionizing working women.[45] As a first step in what Robins hoped would be a quiet break with Hull House, she began scheduling League committee meetings at the CFL building.

The transfer of the League from Hull House to the CFL must be seen in part within the context of Robins's very dissimilar experiences in New York and Chicago. In the former, the League was barely existing when Robins took charge and gave it vitality. When she arrived in Chicago, however, the League was thriving, with McDowell as president, Addams as vice president, Hull House as a focus, and with extensive ties to an influential network of labor, academic, and reform organizations. In her native city, Robins had

rescued the League, but in her new home, the center of an unusually cohesive and effective reform movement, it seemed initially that she could do no more than join the League in progress, another middle-class volunteer, albeit wealthier than most. In Chicago, above all, there was Addams, heroine of reform, priestess and sage, moral leader and celebrity, foremost woman of America, "mother Emancipator of Illinois," within whose Hull House the idea of organizing working women was first nurtured and within which the League still held its animated gatherings. As a resident of the settlement said, "The essential fact of Hull House was the presence of Miss Addams. . . . [Hull House] was not an institution over which Miss Addams presided; it was Miss Addams around whom an institution insisted on clustering."[46] The actions of Robins after she became president of the National WTUL make it clear that she was not content to have either the League or herself be adjuncts of Hull House, satellites bound by the gravity of Addams. In New York, having ended her apprenticeship to reform and seeking an institution to shape as she wished, Robins had appointed herself to save the League from a silent, ineffectual demise. In Chicago, as she came to see it, she was forced to rescue the League from none other than Jane Addams, for only by doing so could she achieve the independence and mastery that had brought her to the League in the first place.

On the afternoon of February 9, 1908, seventy-one women of the Chicago League, most of the active membership in the city, gathered in Federation Hall on La Salle Street.[47] Perhaps in an attempt to reduce the influence of Addams over the assembly, Robins had taken the highly unusual step of shifting the meeting from Hull House to the very room that the women were to vote upon as a permanent gathering place. She had spent the weeks before the meeting lobbying the trade unionists on the virtues of the removal from Hull House, and there was a touch of arrogant self-confidence in her choice of Federation Hall as the scene of her triumph. Ellen Henrotin, the League's first president, was speaking for many of the allies when she told Addams later that the assembly was "one of the most prearranged meetings I ever attended."[48] The *Chicago Tribune* noted with relish that "Miss Addams, who is a member of the League and was a constant attendant at the meet-

ings in Bowen Hall [in Hull House] was 'visibly absent.'" Indeed, the entire assembly was characterized by visible absences. Concern over possible newspaper sensationalism and recognition of the likely will of the trade-union majority combined to produce a tense surface decorum, an almost ostentatious avoidance of what had brought the League to its moment of decision. "As the arguments proceeded," the *Chicago Examiner* reported, "it became more and more evident that the trade-union girls had united in opposition to the sociological settlement workers, but not a breath of the undercurrent was permitted to escape the lips of anyone." When questioned by a reporter about the vote implying a repudiation of Addams, Robins exclaimed, "O, no! Our relations with Hull House have been so lovely. We really regret the necessity to leave Bowen Hall!"

The motion to transfer League meetings from Hull House to Federation Hall was made by ally Corinne Brown, who added, "I favor Federation for the reason that here we feel at home, while in Bowen Hall we have been under restraint. Here we can speak freely." When McDowell instantly asserted that there was never a lack of freedom at Hull House, Brown replied that trade unionists felt like "guests" there, "not as in our own home." Alice Post, an ally, also spoke in favor of the motion: "I have always believed until recently the League was not the real thing. We are getting in closer touch with the labor movement, and that is what we want." Post's assertion did not please McDowell, who felt that her own stewardship of the WTUL was under attack. "This League has always been the real thing," she protested, adding that, "We were born there [at Hull House]. It was there I met my first union girl."

McDowell requested a month's postponement of the vote, but Robins, who was presiding, "smiled sweetly" and said that action was imperative immediately, in part because she had already taken an option on renting Federation Hall. She added that the move to the CFL was intended to bring the League "into closer touch with the labor movement." According to the newspapers, the "spirited discussion," which few trade unionists joined, came down to a contrast between the "labor atmosphere" of the CFL as opposed to the "artistic surroundings of Bowen Hall." Dr. Rachelle Yarros, a resident of Hull House, spoke for the latter, insisting that the

League should "convene amid attractive furnishings instead of facing walls covered with union labels and tobacco juice": "She waved her hands around the meeting hall to demonstrate that it had nothing beautiful to commend it. 'Why can't we meet in a beautiful hall?'" Yarros wondered. "'If the girls must work in dingy places, they ought to meet in a beautiful hall.'"

The vote was taken, and the motion passed by fifty-one to twenty. According to the *Chicago Herald*, "The union labels and tobacco juice won because they were pronounced the 'real' thing." Reporters noted that a number of allies who had opposed the transfer from Hull House immediately left the hall, accompanied on their way by singing from the headquarters of the steamfitter's union, where a party promoting opening saloons on Sunday was in progress.

The *Chicago Examiner*'s heading for its report on the League's meeting was "Women Unionists Quit Hull House in Revolt." In fact, the meeting did not witness a revolt so much as a coup d'état, a maneuver whereby Robins enlisted the support of one group within the League in order to counter other members and establish her own dominance. The notion of breaking with Hull House was not the product of dissension among trade unionists but arose from conflict among allies over an issue only indirectly related to the nature of the WTUL as a cross-class coalition of reformers. Robins deplored the division into two classes that had appeared at League meetings, but, more than anyone else, she was responsible for that split, however much she insisted on the necessity for the break with Addams and on the "doom" that awaited Hull House.

Having lobbied for the transfer to the CFL and having arranged the crucial meeting to suit her purposes, Robins was then concerned to minimize the class division that her own actions had exacerbated. She failed, however, to enlist support for the move to Federation Hall from the middle-class stalwarts of the League, such as McDowell and Henrotin, whose ties to Hull House went back long before Robins's arrival in Chicago. In the end, Robins could find only two allies who would, so to speak, vote against Jane Addams, and as reporters noted, the willingness of those women to join Robins and the trade unionists merely served to bring closer to the surface the undercurrents that swirled around

the assembly. As Henrotin complained, both allies were "strangers in the League," only very recently brought into active membership by Robins herself.[49] Henrotin was also aware that both were opposed to Addams on the issue of the school board. Corinne Brown, a worker's daughter, became a teacher and a principal in the Chicago school system and was a strong supporter of the Teachers' Federation. Married to a prominent banker, she was in 1901 one of the few women delegates at the founding meeting of the Socialist Party of America.[50] Alice Post was married to Louis F. Post, editor of the *Public*, the most influential single-tax publication in the Midwest. It was Post's plan for teacher evaluation that Addams failed to support in 1906.[51]

Still, the split between wage earners and allies over the move from Hull House was not simply a result of Robins's ambitions coupled with a fight over educational reform. Robins could rally support for the transfer to the CFL because of the different points of view held by the two classes of women within the League regarding the purpose of their organization. These different emphases were retailed in trivial fashion on February 9 when the "labor atmosphere" of Federation Hall was contrasted with the "artistic surroundings" of Bowen Hall. Leonora O'Reilly once confessed that she occasionally suffered from "an overdose of allies," and the trade-union reformers of the League may have felt something of the same, that their place within the labor movement would always be uncertain so long as their focus remained on the genteel environs of Hull House.[52] Moreover, Hull House was a home for women, a space defined by gender, where, as Beatrice Webb observed in 1898, "self-subordinating and mild-mannered men . . . slide from room to room apologetically."[53] In leaving Hull House, the trade unionists by no means wanted to abandon female culture; rather, they aspired to extend that culture into the male-dominated world of unionism.

That aspiration was at least congruent with a certain temper that the trade unionists and Robins had in common with the denizens of Federation Hall. Bossy and opinionated, Robins was also relaxed, exuberant, uncensorious, even a touch earthy. She delighted in staying late at the League headquarters on La Salle Street where Fitzpatrick and his cronies would "no more bother about me

than they would about a piece of furniture to which they have become accustomed," but would go on arguing and cursing "to their heart's content."[54] It was natural for Robins to cultivate an informal, spontaneous, and convivial atmosphere at League gatherings, one that presented no barriers of pretension or excessive refinement to young women from the working class. At Hull House, on the other hand, the tone was serious, respectful, and formal. In contrast to the League, even close friends at Hull House did not call one another by their given names, and a visitor would never mistake a meeting in the settlement for a "jolly family gathering," as a League assembly was once called.

In short, even if the trade unionists did not "quit Hull House in revolt," they were still taking a positive step toward defining the WTUL in their own terms. They were no more pawns of Robins in Federation Hall than the school board crisis was a mere pretext for Robins's self-aggrandizement. The move to the CFL gave the trade unionists a greater sense of involvement and solidarity with the labor movement, while it made Robins a leading figure in Chicago labor circles. She became the indispensable mediator between the wage earners and the allies within the League, as well as the primary link between the League and the wider labor movement. In the summer of 1908, she was elected to the executive board of the CFL, the only middle-class woman to be so honored by a city labor federation. Fitzpatrick would come to see her as "the very soul of the labor position."[55] It was only after the break with Hull House that Robins emerged as the dominant figure in the League, the "Great Mother" as she was once called, enjoying the same preeminence and respect in her own organization that Addams did in Hull House.

Both Robins and the League paid a certain price for that preeminence, however. For Robins, the cost was wholly financial, though she was pleased to have the opportunity to spend part of her fortune for a worthy cause. She had begun her career with the League in New York City by accepting the new office of treasurer. When she became president of the New York WTUL, she also was named treasurer of the national league. When she was elected president of the latter in 1907, she relinquished the office of treasurer, but it is significant that thereafter the post devolved to a mere

bookkeeping function. For all practical purposes, Robins continued to keep and maintain the treasury of the League.

Having inherited $600,000 from her father, Robins's income from investments during the years in which she heavily subsidized the League ran between $13,000 and $17,000 a year.[56] Much of that went toward the expenses of her organization. In addition, she used her home as a working headquarters and paid the salaries of some union organizers; after 1911, she financed *Life and Labor*.

As the League grew and took on more responsibilities, a sounder financial footing was clearly needed. Fund-raising, therefore, remained a preoccupation for Robins, although she sought converts to the labor movement, not simply willing benefactors. Despite her wishes, she probably won more of the latter than the former, for she was an exemplary instance of those female reformers who convinced the wealthy to support "many a venture that on its own merits would never have appealed to them."[57] She even persuaded Julius Rosenwald, head of Sears, Roebuck Company and an arch-opponent of trade unionism, to give $1,000 to the training school. Contributions also came from female relations of men with vehement antilabor opinions. Anne Morgan made donations, and Abby Aldrich Rockefeller gave $5,000 annually (and in secret) for several years.[58]

As late as 1924, the bulk of the contributions to the national league still came from what Robins termed "a personal understanding between me and my friends" from the time that she was elected president. Emily Ford Skeel asserted that she gave money to the WTUL for thirty years only because of her childhood friendship with the Dreier sisters. Miriam Shepherd, the League's financial officer in 1924, met with similar frankness from an underling of businessman Albert Lasker: "I can save you some time by telling you that Mr. Lasker is not interested in your work. He happens to be a devoted admirer of Mrs. Raymond Robins and if he feels he can do it, I am sure he will give Mrs. Robins a thousand dollars, but I am sure he would not care what Mrs. Robins did with it when she had it."[59]

"I feel as if I were nothing but a money machine!" Robins lamented to her sister in 1921.[60] For all her efforts, however, Robins failed to establish a sound financial basis for the League. Instead,

her own generous subsidies, supplemented from handsome dona-
tions by the wealthy, apparently persuaded Robins that her organi-
zation had taken on a vitality it in fact never possessed. She never
realized that the very conditions of her committed administration,
her willingness to act as a "money-machine," meant that she could
be replaced only at the cost of danger to the institution she had
fostered for so long. The rapid decline of the League after her re-
tirement bewildered and disenchanted her, for she reluctantly
came to believe that the trade unionists who took over the League
were unequal to the task for which they had been trained.[61]

Moreover, there were other and more subtle costs to the League
from Robins's domination of it. Only three years after Robins
brought about the break with Hull House, some trade unionists
perceived dangers in Robins's leadership, especially regarding her
financial role. In 1911, Pauline Newman wrote to Rose Schneider-
man from Chicago:

> The League is owned and controlled by one person . . . I find
> that Mrs. Robins pays everybody's salary, all other necessary
> expenses, and as consequence she has no opposition in the
> entire organization. Mrs. Robins means well, I am sure, but in
> the end it is bound to suffer. She does not give the girls a
> chance to use their brains . . . but wants them to agree with
> everything she does. And unfortunately they do; they have to;
> she pays their salaries . . . the girls here are not imbued with
> the spirit of Unionism—but philanthropy. What would become
> of the League as an organization were Mrs. Robins to leave
> them—is easy to imagine.[62]

To be sure, such views may have been in the minority, and most of
Robins's trade-union colleagues were voluble in their appreciation
for her dedication, imagination, and egalitarianism. Of course, it
was intrinsic to the nature of Robins's domination of the League,
accompanied as it was by liberality and good cheer, that criticisms
such as Newman's were rare. Nevertheless, Newman at least had
the merit of considering crucial questions that apparently never oc-
curred to Robins. Newman was also right to be concerned over the
future of the League, for the organization's decline in the 1930s to
the status of a minor Washington, D.C., lobbying group to some
extent followed naturally from Robins's move toward domination

in breaking with Hull House. Without the "Great Mother" to provide for them, the trade unionists of the League lacked the resources to sustain their organization.

Robins never recognized the full costs of her domination of the League. Accustomed to wielding gentle authority since her adolescence, genuinely concerned for the welfare of others, she could not appreciate that her abundant virtues might have deleterious consequences. Always generous with her wealth, she would have been bewildered by the suggestion that her use of it to sustain a worthy cause was an act of self-aggrandizement. In the last analysis, it was perhaps best for the cause of working women that Robins remained oblivious to such disturbing possibilities, for it is likely that the League would never have survived so long or enjoyed its measure of success without the unreserved and unreflecting devotion she brought to it.

## Notes

1. MED, *Robins*, pp. 26–27; MDR to RR, Oct. 9, 1925, box 59, MDR Papers.

2. RR to MED, Apr. 10, 1945, MED Papers. On the Haymarket riot, see Bessie Louise Pierce, *A History of Chicago: The Rise of a Modern City, 1871–1893* (Chicago: University of Chicago Press, 1957), pp. 274–80; Paul Avrich, *The Haymarket Tragedy* (Princeton: Princeton University Press, 1984). On conditions in the Seventeenth Ward, see Robert Hunter, *Tenement Conditions in Chicago* (Chicago: City Homes Association, 1901).

3. On Walling, see the *Dictionary of American Biography*, 1958 ed., s.v. "Walling, William English"; and Allen F. Davis, *Spearheads for Reform: The Social Settlements and the Progressive Movement, 1890–1914* (New York: Oxford University Press, 1967), pp. 99–101.

4. On the University and reform, see Steven J. Diner, *A City and Its Universities: Public Policy in Chicago, 1892–1919* (Chapel Hill: University of North Carolina Press, 1980); and his "Department and Discipline: The Department of Sociology at the University of Chicago, 1892–1920," *Minerva* 8 (1975): 514–53.

5. Jane Addams, "John Dewey and Social Welfare," in *John Dewey: The Man and His Philosophy* (Cambridge, Mass.: Harvard University Press, 1930), p. 147; cf. Mark Storr, "Organized Labor and the Dewey Philosophy," in *John Dewey: Philosopher of Science and Freedom*, ed.

Sidney Hook (New York: Barnes and Noble, 1950), pp. 184–93. Dewey was at the University of Chicago and associated with Hull House from 1894 to 1904: see George Dykhuizen, *The Life and Mind of John Dewey* (Carbondale: Southern Illinois University Press, 1973), pp. 104–6.

6. Addams, *Twenty Years at Hull House*, pp. 150–55; Allen F. Davis and Mary Lynn McCree, eds., *Eighty Years at Hull House* (Chicago: Quadrangle Books, 1969), pp. 108–9. The statement by Alice Hamilton is quoted in Daniel Levine's *Jane Addams and the Liberal Tradition* (Madison: State Historical Society of Wisconsin, 1971), p. 160, cf. pp. 163–65. On Hull House's role in founding women's unions, see Jane Addams to Henry Demarest Lloyd, Nov. 18, 1891, Dec. 15, 1891, and Jan. 2, 1893, in the Henry Demarest Lloyd Papers, Archives Division, Wisconsin State Historical Society, Madison, Wisc. Also see Abraham Bisno, *Union Pioneer* (Madison: University of Wisconsin Press, 1967), pp. 123–24.

7. See Davis, "The Women's Trade Union League"; Dye, *As Equals*, pp. 1–12; Boone, *Women's Trade Union Leagues*, pp. 43–63.

8. Mary Kenney O'Sullivan, unpublished autobiography, Schlesinger Library, Radcliffe College, Cambridge, Mass., pp. 33a, 64–65, 98; Davis, *Spearheads*, p. 139.

9. O'Sullivan, unpublished autobiography, pp. 159, 171.

10. William English Walling to MDR, Nov. 1, 1904, box 1, NWTUL Papers; Davis, *Spearheads*, p. 99.

11. "The Constitution of the Women's Trade Union League," adopted in Faneuil Hall, Boston, Mass., Nov. 17–19, 1903, box 13, MDR Papers.

12. "Reports of Meetings Held for the Purpose of Organizing the Women's Trade Union League," box 13, MDR Papers.

13. For what follows on McDowell, see Howard E. Wilson, *Mary E. McDowell, Neighbor* (Chicago: University of Chicago Press, 1928), pp. 14–24; and the entry in *Notable American Women*, 2: 462–64.

14. For what follows on O'Reilly, see Dye, *As Equals*, pp. 34–36; and the entry in *Notable American Women*, 2: 651–53.

15. *Notable American Women*, 2: 652.

16. MED, outline of speech for WTUL Ball, Dec. 5, 1913, MED papers; MED to MDR, Mar. 28, 1925, box 35; Mary Anderson to MDR, July 29, 1941, box 53, MDR Papers.

17. *Notable American Women*, 2: 462.

18. Rose Schneiderman, with Lucy Goldthwaite, *All for One* (New York: Paul S. Eriksson, 1967), p. 29; Agnes Nestor, *Woman's Labor Leader: An Autobiography of Agnes Nestor* (Rockford, Ill.: Bellevue Books Publishing Co., 1954), pp. 42, 44.

19. For the argument on a connection between a "status revolution"

and Progressivism, see Richard Hofstadter, *The Age of Reform: From Bryan to F.D.R.* (New York: Alfred A. Knopf, 1955), pp. 131–72; cf. Buroker, "Illinois Immigrants' Protective League," pp. 650–51.

20. *Notable American Women*, 2: 181, 251–52, 313, 462–63; *Notable American Women: The Modern Period*, pp. 80–82.

21. Cf. Hofstadter, *Age of Reform*, pp. 137–38.

22. *Notable American Women*, 2: 183–84; Stella Miles Franklin, *My Brilliant Career* (1901; reprint ed., New York: Simon and Schuster, 1980).

23. *Notable American Women*, 3: 413–15; *Notable American Women: The Modern Period*, pp. 183–84; Ricki Cohen, "Fannia Cohn and the International Ladies' Garment Workers' Union" (Ph.D. diss., University of Southern California, 1976).

24. U.S. Department of Commerce and Labor, Bureau of the Census, *Statistics of Women at Work: Based on Unpublished Information Derived from the Schedules of the Twelfth Census: 1900* (Washington, D.C.: Government Printing Office, 1907), p. 166.

25. Cf. MDR to RR, Aug. 26, 1917, box 55; Elisabeth Christman to MDR, Aug. 19, 1937, box 44; MDR to Florence Sims, Mar. 20, 1920, reel 8, MDR Papers; Elisabeth Christman to Maud Swartz, Apr. 12, 1923, reel 3, NWTUL Papers.

26. Nestor, *Woman's Labor Leader*, pp. 3, 13–14; also see *Notable American Women*, 2: 615–17.

27. Eric Lawrence Sandquist, "Leonora O'Reilly and the Progressive Movement" (Honors thesis, Harvard College, 1966), p. 1; *Notable American Women*, 2: 651.

28. Schneiderman, *All for One*, pp. 28–35.

29. O'Sullivan, unpublished autobiography, pp. 6, 16; *Notable American Women*, 2: 655.

30. Mary Anderson, as told to Mary N. Winslow, *Woman at Work: The Autobiography of Mary Anderson* (Minneapolis: University of Minnesota Press, 1951), pp. 4, 6, 9.

31. This generalization is based upon consideration of the ages of MDR, MED, McDowell, Addams, Wald, Kehew, Henrotin, Marot, Ickes, and Blaine among the allies; and of O'Reilly, O'Sullivan, Nestor, Schneiderman, Anderson, Christman, and Swartz among the trade unionists.

32. "Minutes of the 3rd Biennial Convention of the NWTUL," June 12–17, 1911, Boston, Mass., p. 778, reel 20, NWTUL Papers; MDR to RR, Apr. 18, 1908, box 59, MDR Papers.

33. MDR to the executive board, WTUL, Chicago, June 9, 1913, box 17, MDR Papers; "Minutes of the 5th Biennial Convention of the NWTUL," June 7–12, 1915, New York, N.Y., pp. 373–74, reel 21, NWTUL Papers.

34. On the training school as a pioneering effort, see Jacoby, "The

British and American Women's Trade Union League," pp. 125–52; also see Hilda W. Smith, *Women Workers at the Bryn Mawr Summer School* (New York: Affiliated Summer Schools for Women Workers in Industry and the American Association for Adult Education, 1929); "Minutes of the 9th Biennial Convention of the NWTUL," June 16–21, 1924, New York, N.Y., p. 189, reel 23, NWTUL Papers.

35. "The League's 1926 School Term," unidentified article, box 4, MDR Papers; "Minutes of the 11th Convention of the NWTUL," May 4–9, 1936, Washington, D.C., p. 269, reel 24, NWTUL Papers; Leonora O'Reilly, diary entry for Mar. 17, 1909, O'Reilly Papers.

36. For an interpretation of class conflict within the League, see William H. Chafe, *The American Woman: Her Changing Social, Economic, and Political Roles, 1920–1970* (New York: Oxford University Press, 1972), p. 71; Meredith Tax, *The Rising of the Women: Feminist Solidarity and Class Conflict, 1880–1917* (New York: Monthly Review, 1980), pp. 95–124.

37. Carl V. Wisner to RR, Sept. 27, 1943, box 33, RR Papers; Davis, *American Heroine*, p. 117.

38. MDR to MED, Sept. 30, 1905, box 25, MDR Papers.

39. MDR to MED, Nov. 4, 1907, box 26, MDR Papers.

40. On Addams's personality, see Davis, *American Heroine*, pp. 75–77, 91, 103.

41. MDR to MED, May 29, 1907, box 26, MDR Papers; Robert Louis Reid, "Professionalization of Public School Teachers: The Chicago Experience, 1895–1920" (Ph.D. diss., Northwestern University, 1968), pp. 102–29; Davis, *American Heroine*, pp. 131–33.

42. The quotation is from a Nov. 6, 1906, letter of MDR to MED in MED's *Robins*, p. 30. On education for workers' children, see MDR to MED, May 22, 1907, box 26, MDR Papers.

43. MED to RR, May 27, 1907, box 2, RR Papers.

44. MDR to MED, Nov. 4, 1907; cf. MDR to MED, June 11, 1907, box 26, MDR Papers.

45. On Fitzpatrick, see John Howard Keiser, "John Fitzpatrick and Progressive Unionism, 1915–1925" (Ph.D. diss., Northwestern University, 1965), pp. 18, 20–22; RR, "John Fitzpatrick: A Leader of Organized Labor in the West," *Life and Labor* 1 (Feb. 1911): 31–43.

46. The quotation is from Davis, *American Heroine*, p. 81. On the image of Addams, see Davis, *American Heroine*, pp. 102–5, 158–59; in 1911, a Boston newspaper likened Addams, the "mother Emancipator," to Lincoln, another fighter against moral darkness (Davis, *American Heroine*, p. 164).

47. The following account is based upon reports in the *Chicago Tri-*

*bune*, the *Chicago Record-Herald* and the *Chicago Examiner* for Feb. 10, 1908. In 1908 the nominal membership of the Chicago League was 400, not counting affiliated members; in 1911 membership was 900, with an affiliated membership of about 24,000.

48. Ellen Henrotin to Jane Addams, Feb. 10, 1908, Jane Addams Papers, Peace Collection, Swarthmore College, Swarthmore, Pa.

49. Ibid.

50. Mari Jo Buhle, *Women and American Socialism, 1870–1920* (Urbana: University of Illinois Press, 1983), pp. 71–72, 105; Alice Henry, "Corinne Brown," *Life and Labor* 6 (June 1914): 189.

51. On the Posts, see Reid, "Professionalism of Public School Teachers," pp. 112–13.

52. O'Reilly is quoted in Phillip S. Foner, *Women and the American Labor Movement*, 2 vols. (New York: Free Press, 1979–80), 1:310.

53. *Beatrice Webb's American Diary, 1898*, ed. David A. Shannon (Madison: University of Wisconsin Press, 1963), p. 108.

54. MDR to RR, Feb. 3, 1916, box 54, MDR Papers.

55. John Fitzpatrick to MDR, May 31, 1922, in album, "A Garland of Greetings to MDR," box 1, MDR Papers.

56. This estimate is derived from MED's ledger books, 1903–1911, MED Papers.

57. Robert H. Wiebe, *The Search for Order, 1877–1920* (New York: Hill and Wang, 1967), p. 175.

58. MDR to RR, Jan. 10, 1932, box 70; MED to MDR, Mar. 28, 1925, box 35; May 3, 1932, box 43, MDR Papers; MED, outline of speech for WTUL Ball, Dec. 5, 1912, MED Papers.

59. "Minutes of the 9th Biennial Convention of the NWTUL," June 16–21, 1924, New York, N.Y., p. 220, reel 23, NWTUL Papers; Emily E. F. Skeel to Elisabeth Christman, Jan. 16, 1938, MDR Papers. The quotation comes from Miriam Shepherd to MDR, Mar. 4, 1924, box 35, MDR Papers.

60. MDR to MED, May 27, 1921, box 32, MDR Papers.

61. See chapter 5.

62. Pauline Newman to Rose Schneiderman, Dec. 9, 1911, Rose Schneiderman Papers, Tamiment Library, New York University, New York, N.Y.

# 3

## "The Citizenship of Labor": Democracy and the Ideology of Reform Unionism

On May 19, 1907, in her first public action as president of the WTUL, Robins led 4,000 workers in a march through downtown Chicago in protest against a murder trial in Idaho of leaders of the Industrial Workers of the World (IWW).[1] Jane Addams had cautioned Robins against associating the League with so radical an organization, and Robins's role in the parade played a part in the split between the WTUL and Hull House nine months later.[2] More important, Robins's action had an enduring effect upon public perception of her. Soon after the parade, she was blackballed by the Chicago Woman's Club. Two days before the march, the *Chicago Daily Socialist* declared that there was "no more able advocate of trade unionism" than Robins; but after May 19 rumor spread even into labor circles that she was so fanatical about organizing women into unions that (as Mary Dreier recounted) "she even neglected her baby, who froze to death on the fire escape;—she who, to her unending sorrow, never had a baby." As late as 1928, Robins's part in the "red demonstration" was used to argue that she would be a dangerous choice for the position of secretary of labor in Herbert Hoover's administration.[3]

An American flag was carried at the head of the parade, followed by Robins in a carriage; a number of trade unionists were with her, but all the allies stayed home. Later, Robins would claim that "not a single red flag was carried in the parade," although newspapers were unanimous in describing the march as festooned

with red banners. According to the *Daily Inter-Ocean*, the protest
was a "trail of the red flag from start to finish," a scarlet "taint of
anarchy" smearing the marchers, from the League women at the
front to the drunken brewery workers at the rear. For hostile on-
lookers, the nature of the parade was epitomized by the presence
in it of Lucy Parsons, the widow of a man executed for his sup-
posed complicity in the Haymarket riot, a founder of the IWW, and
an advocate of revolutionary socialism.[4] Robins found the enthusi-
asm of the crowd contagious, and, according to the newspapers,
when a robust woman leaning from a second-story window dipped
her red flag in salute as Robins went by, the newly elected presi-
dent of the League replied by exuberantly waving her bouquet of
American Beauty roses.

It was fitting that Robins was unable or unwilling to see the
red banners behind her in the parade. Figuratively as well as physi-
cally, she was looking forward to the American flag. For her, the
protest march was in the name of traditional American values and
had nothing to do with those personified by the notorious Lucy Par-
sons. Like the IWW, the League represented "the great army of toil-
ers of the world" who derived their courage and spirit "from a line
of American ancestry going back to the Minute Men of the Revolu-
tion." Robins self-consciously looked back to the same revolution-
ary tradition, as well as to the heritage of those who "founded the
free cities of Germany."[5] Although she lacked sympathy for the pro-
gram of the IWW, she viewed labor militancy itself as an expres-
sion of American values, as a recasting of the American Revolution
into industrial terms. When the IWW outraged the American Feder-
ation of Labor (AFL) by its involvement in the Lawrence, Massa-
chusetts, textile-workers' strike in 1912, Robins sympathized with
the IWW because she considered the strike a genuine uprising of
workers. "Grim and terrible as a strike may be as an expression of
protest," she wrote about the Lawrence upheaval, "it is neverthe-
less the outward and visible sign of a miracle in the human soul."[6]

While Robins was convinced that labor militancy expressed
American ideals, her enthusiasm for an aggressive labor move-
ment also came from her belief that history recorded the "majestic
advance toward God's final idea" and told of a long struggle for a
"finer human life." Her perspective on labor reform was lengthy in-

deed, for the expected triumph of workers represented for her the principal contemporary expression of that progressive movement that had obliterated slavery, conquered disease, won religious freedom, and led to the liberation of women. "After all," she wrote to her niece, "the industrial struggle today is but a continuation of the struggle covering six thousand years of recorded history." Moreover, progress was cumulative and could not be lost; the "growing good" achieved by the courageous and the enlightened became a permanent possession of mankind.[7]

Robins's views on the relationship between American values and the labor movement were formed by a tradition that began with nascent labor organizations in the 1820s and 1830s, found expression in a free labor ideology in the 1840s and 1850s, and achieved institutional realization on a national scale in the decades after the Civil War.[8] She did not go to that tradition for sophisticated economic analysis, and for all the time she spent working with unions and dealing with matters of wages, prices, and hours, she remained naive about economics. Rather, she drew upon an American tradition of the labor theory of wealth in order to supply her moral arsenal and to develop a native vocabulary for her sense of the ethical dimension of work. Abraham Lincoln was a central figure in the tradition, and Robins was proud that placards in the May 19 march carried quotations from him (as well as from Emerson). Writers of the League frequently appealed to Lincoln's statements that government should "secure to each laborer the whole product of his labor" and that capital is "only the fruit of labor, and could never have existed if labor had not first existed."[9] For Robins, labor was all that and more: the maker of needed goods, a means of social mobility, a religious necessity, a path to self-realization, and a foundation of democracy. Like her predecessors in labor reform since the 1850s, Robins insisted that labor could never be merely a commodity or be equated with the commodities it produced. She was pleased that the well-known phrase "Labor is not a commodity" was incorporated into the Clayton Act of 1914, landmark legislation that spelled out the rights of laborers.[10]

Neither a commodity nor a commercial article, labor represented, as the Clayton Act said, "a portion of the life of the human being itself." Goods or services produced for "wages less than

living and by hours longer than health endurance" robbed laborers
of their strength, thereby claiming aspects of the person that could
not legitimately be offered in the daily struggle for a living.[11] Robins
believed that laborers must have a degree of power over their own
working conditions, for otherwise the energy they invested in work
would be entirely at another's mercy, leaving their lives irreparably
divided against themselves. She believed that labor was so woven
into the fabric of existence that it was all but equivalent with life
itself. After searching in 1910 for a title for the League's new jour-
nal, Robins finally settled on Robert La Follette's suggestion, *Life
and Labor*. And when League members memorialized one of their
own, it invariably was the "life and labor" of the individual that
were celebrated.[12]

The extent to which Robins and other League writers were
driven to expand the concept of labor, stretching it to encompass
the totality of human life, hints at the urgency and extent of the
problems they saw themselves confronting. As women and as la-
bor reformers, they thought that they were living at the dawn of a
new era, and they believed—naively, passionately, and gener-
ously—that they could provide something of the philosophy called
for by the times. Robins looked upon her time as a "Homeric age"
because it attested to "the worth of labor" and had given birth to
"the rise of women." For her, the public emergence of labor and
women was not merely one aspect of modern times; rather, it char-
acterized modernity, which she regarded as a permanent, evolu-
tionary advance from the dark days "when women were the chattel
of men, and labor in chains."[13]

Robins was convinced laborers and women were emerging
into the public realm together, even if their passage was uncertain
and troubled. Their appearance was called forth by the conditions
of a new industrial civilization, and female laborers in particular
faced exceptional difficulties and responsibilities in dealing with a
radically new way of life.[14] But it was appropriate that the new "Ho-
meric age" witnessed the emergence of laborers and women in-
asmuch as "it had been the woman and the worker [who had] al-
ways faced life and its burdens," as the editors of *Life and Labor*
wrote.[15] Women and workers belonged together because they were
"producers," as Robins called those who made useful contribu-

tions to society. She did not limit that category to those who earned a wage, for in 1919 she unsuccessfully urged the secretary of commerce to list mothers caring for children as "producers" in the forthcoming census.[16] Robins divided society into the producers, whom she described as the "toilers of the world," and the exploiters of labor. She always held to Josephine Shaw Lowell's conviction that workers "are the people—all the people. The few people that don't belong to the laboring classes don't amount to anything."[17]

According to Robins, "despotic workshops," that is, those without unions, denied laborers the power of influencing their material conditions and social relationships; hence, workers were deprived of feeling that they were active, responsible beings. Workplaces without unions "register[ed] permanent reactions of stolid submission and isolated personality in the minds of workers." "No place is this for any creative genius," Robins wrote of such workshops. "No need here of imagination, of ability to think, to develop in response to a desire for increasing knowledge and skill,—only an automaton, the last necessary adjunct, an essential part of the machinery."[18] In contrast, "The greatest value of the trade union movement is that it calls forth personality. It does this primarily by placing responsibility upon the worker in factory and shops." The self developed by assuming responsibility. It thereby exerted influence upon the world outside the workplace, insuring the survival and vitality of a free state and a free church. In an industrial society, a democracy was possible only if the worker was an active, responsible citizen. Thus the advance of trade unionism created the possibility of a new "citizenship idea of labor."[19]

Robins believed that the labor movement could become a potent force for transforming human relationships in a democracy. It was natural for her to regard issues such as collective bargaining, the closed shop, and union recognition in moral and social terms because she was concerned about the cultural significance of labor and the regeneration of society. Frances Squire Potter, a lecturer for the League and a professor of literature at the University of Minnesota, articulated Robins's sweeping ambitions when she said that the labor movement represented a new "ideal of associated life," which would "repudiate the froth and scum of our civiliza-

tion—thrones, armies, navies, moribund institutions, the para-
sites."[20] Union organization, by counteracting feelings of passivity
and dependence, challenged laborers to create new social values.
"The greatest asset of the union shop," Maud Swartz declared, "is
the opportunity it gives the worker for development in the interest
of all other workers." According to Mary Beard, a member of the
League in 1909 and later the author of *Woman as Force in History*,
the labor movement involved a "state of mind" that took visible
shape as "a great social force akin to titanic forces in the natural
world" and that worked to foster "ideals of peace and well-being in
society."[21]

From Robins's point of view, only a union could counteract
the alienation that stemmed from increasing specialization of
knowledge and subdivision of work; only a union could provide a
"sense of fellowship and self-respect." The union represented "the
great school of democracy, the great school and university of the
working people," which taught the meaning and social value of la-
bor power. As an organizer for the League expressed it, the union
existed to show the worker "that her life and how she lives it is of
consequence to more than just herself."[22]

Robins and her colleagues identified the aims of unionism
with those of education, and they viewed education as a matter of
moral development, since it pointed to the possibility of enlarging
an individual's consciousness. Joining a union meant beginning
a natural education, coming to see association instead of juxta-
position, common intent instead of isolated action. According to
women of the League, it meant learning to think. "Go into a group
of union women and non-union women meeting together," Maud
Swartz told the executive board of the WTUL: "They look alike. But
see them in action. The union women know how to think."[23] Mary
Anderson agreed that "it is the organized girl who is the thinking
girl. The unorganized people are not thinking." Working women
like Anderson often insisted that "the best part of the union is that
it makes you think!" Anna Rudnitsky, an immigrant seamstress, de-
clared, "That is the best thing in the Union, it makes us think. I
know the difference it makes to girls and that is the reason I believe
in the Union. . . . it makes us more interested in life and to be more
interested is, oh, a thousand times better than to be so dead that

one never sees anything. . . . That is terrible, that is like death."[24]
As League women saw it, nonunionized workers could never contribute to social betterment because they were unaware of their potential, and therefore without the imagination to envision a society based on communality and interdependence. Robins aspired "to win [them] over into fellowship," and she had no doubt that the League, which Mary Kenney O'Sullivan called the "first national body of thinking women," was the natural vehicle for the task.[25]

As much as possible, Robins wanted unionists to have access to an education that would orient them and their work in history and society. Of course, the League's Training School for Women Workers offered some general courses, but its program was designed primarily to provide skills for union organizers. The courses set up by the League itself were more for the worker's self-improvement. They were open without charge to all workers, female or male, union or nonunion; but since the courses were publicized through union meetings and journals, most of the enrollment came from unionists affiliated with the WTUL.

Under Robins's guidance, the Chicago League offered courses in parliamentary procedure and the philosophy of collective bargaining, as well as topics in political theory and economics. Opposed to a narrowly practical education, Robins also set up courses in art, literature, history, and science. She saw the study of history as especially important, so the history of parliamentary law received as much emphasis as parliamentary procedure. By providing courses such as the history of technology and the evolution of trade unions, Robins believed that the student worker would grasp the significance of her own role in contemporary society.[26]

The League pioneered in workers' education in America because Robins and her colleagues shared Leonora O'Reilly's view that education "is principally woman's work."[27] Of course, that was not a novel idea, but the League for the first time took practical steps to apply it to the nation's labor force. The local branch of the WTUL in Philadelphia assumed complete responsibility for the educational work of the labor community. In Chicago, members of the CFL routinely took places in the League's classrooms. By 1918 the CFL and the League formed what was called a "Workers' College," which offered numerous courses at night and during the

weekends. A year earlier, the Chicago League worked out a plan with the city's board of education whereby the League was permitted to use public school classrooms for teaching working women; the plan had the support of Robins's close friend and ally, Margaret Haley of the Teachers' Federation. As the head of the Illinois Committee on Women and Children in Industry during World War I, Robins convinced the board of education to provide any course desired by at least twenty adults. After the war, the national League became affiliated with and supported the independent Workers Education Bureau as soon as it was set up in 1921.[28]

As a member of the the AFL's and CFL's Committee on Industrial Education from 1909, Robins led opposition to establishing in the public schools an approach to vocational education that would have divorced it from general studies. She believed that industrial training should be taught in secondary school—her mother, she recalled, had promoted the subject—and she convinced the Chicago Board of Education in 1915 to employ a League member to teach glove making. As Robins wrote to a friend, that marked the first time in the history of Chicago that a trade-union woman had been engaged to teach a trade in the public schools."[29] She always encouraged children of both laborers and the privileged to take courses in manual training, no doubt recounting her own happy experience with the old cobbler in Neuenkirchen. But she also believed that a child given narrow vocational instruction would turn into a socially undeveloped laborer, unable to see beyond the confines of the workshop and shut off from the possibility of fellowship.

At the turn of the century, as the pace of industrialization outran the capacity of private institutes to supply trained laborers, business groups began a drive to have public schools assume the responsibility for vocational training. In 1913, the Commercial Club of Chicago, an association of leading manufacturers and businessmen, proposed to the board of education the adoption of a program whereby 90 percent of the city's children after the eighth grade would study only vocational subjects. The Commercial Club represented what was called the "efficiency" side of educational reform, the same alliance of administrators and businessmen that had defeated the "democratic" reformers, led by Louis F. Post and Raymond Robins, in 1907.[30] Robins's opposition to the proposal

was immediate and predictable, for it ran counter to her basic assumptions about the nature of education. Agnes Nestor, then president of the Chicago League, also opposed the plan, explaining that it would deny "all opportunity for cultural development." Robins advocated an industrial education that encompassed the "cultural training of the mind," instruction that included comprehension of the industrial world and its background. She always maintained that to make utility to industry the primary goal of education was to have workers collaborate in their own exploitation, thus insuring that they would be submissive and isolated.[31]

Robins discerned what she called "isolated personality" and an "isolated social ethic" in the greed of the capitalist, in the selfishness of upper-class women, and in the narrow craft orientation of the AFL. She also saw it in the inability of workers to speak a common language. While the League respected the ethnic variety of its members and often enlivened meetings with songs in different languages, it was clear that lack of a common tongue was a serious drawback to both worker welfare and union organization. A Chicago meat-packing concern deliberately put together workers with different languages with the aim of forestalling union activity: "It prevents them from getting together," the firms' employment agency told an investigator. A Chicago sweatshop manager said that he always recruited uneducated immigrants: "I want no experienced girls. They know the pay to get. I got to pay them good wages and they make me less work, but these greenhorns, Italian people, Jewish people, all nationalities, they cannot speak English and they don't know where to go and they just come from the old country, and I let them work hard, like the devil, and these I get for less wages." The view shared by many League reformers that unions gave birth to thought and that knowledge led to fellowship found considerable warrant in their dealings with immigrant workers. As a League woman reported, "We have a large constituency who cannot read English, who have not learned to think."[32]

In part because of her stress upon the importance of communication, Robins identified learning the English language with becoming an American, an act that, according to a League writer, transformed the immigrant from a "bewildered outsider" to a "citizen whose welfare concerns a nation." Mary Anderson recalled

that it was not until she had learned to speak English that she felt like a human being in America.[33] After the garment strikes from 1909 to 1911, in which problems of communication among ethnic groups seriously hampered the League's activity, the WTUL began an extensive program of teaching English to immigrant working women. League members emphasized that the immigrant's first experience with the language should be related to the daily life of the worker. The League opposed the teaching of English by private agencies funded by businessmen because textbooks in such courses did not "tell the girl worker the things she really wants to know. They do not suggest that $5.00 a week is not a living wage. They tell her to be respectful and obedient to her employer."[34] The League did not approve of that message, and in 1912 it published "New World Lessons for Old World Peoples" in *Life and Labor* and as a pamphlet. Violet Pike's vivid, unpatronizing text presented immigrant workers with translation exercises that carried a moral about the role of the union in their lives:

> A Union girl takes me into the Union.
> The Union girls are glad to see me.
> They call me sister.
> I will work hard for our Union.
> I will come to all the Union meetings.[35]

And at those meetings, Robins hoped, the union girl would learn about ideals, about labor and citizenship, about how to be an American, militant in her own and her sister's cause.

Annie Shapiro, the oldest daughter of Russian immigrants, went to work at thirteen making bow ties, and by the time she was eighteen, she was operating a pocket-cutting machine at Hart, Schaffner and Marx, Chicago's largest manufacturer of men's clothing. On September 22, 1910, her wages were cut when the piece rate for seaming pockets was dropped from four cents to three and three-fourths cents. A quarter of a penny added up to a lot for a worker receiving only seven dollars a week, for it came to around fifteen cents a day, eighty cents a week, or a 12 1/2 percent reduction in wages.

Shapiro and sixteen other young girls walked out of Hart, Schaffner, thereby launching a protest that would bring out about 40,000 garment workers, virtually shut down the Chicago factory clothing industry, cause almost five months of bitter strife, and result in the first successful experiment in collective bargaining for the settlement of industrial disputes. Within nine years of Annie Shapiro's walkout, the garment workers of Chicago would be completely unionized. As early labor historians saw it, the agreement worked out with Hart, Schaffner marked "the beginning of the most highly elaborated industrial government in America based on equal participation of employer and union." Indeed, it did serve as a catalyst for the organization of other workers and as the model for over 4,000 new union contracts in the decade after 1910. Moreover, a new union eventually emerged from the 1910 struggle, Sidney Hillman's Amalgamated Clothing Workers of America (1914), which Robins regarded as the embodiment of reform unionism, a model of what a labor organization should be. Robins and the League were instrumental to the success of the Hart, Schaffner agreement, and in later years Robins would look back upon it as the work of which she was proudest.[36] At the same time, her connection with the Amalgamated plagued her efforts to establish closer and more useful ties between the League and the AFL because the Amalgamated would ultimately leave the AFL in protest over the Federation's rigidity and lack of commitment to unskilled workers.

Walkouts were not uncommon in the garment industry, hence they were not always taken seriously—especially when women were involved. At first, Thomas Rickert, national president of the United Garment Workers' Association (UGW), an affiliate of the AFL, thought that the September 22 action was "just an over-night" strike, and Hillman, a young cutter at Hart, Schaffner, later confessed that the men in his shop regarded the protest as a joke. But the women continued walking out, and the revolt spread. As *Life and Labor* described it, "They poured out of the shops, threw down their needles, and in nine different languages demanded a better condition of affairs in the industry of garment making in Chicago."[37] Finally, Rickert was forced to call a general strike on October 27 because the *Chicago Daily Socialist* was threatening to do

so on its own. As one young woman said: "Then the great strike came—not just the separate little strikes, but one whole strike. When the foreman heard us all talking about it, he said, 'Girls, you can have your pockets and your cent again if you'll stay.' But just then there was a big noise outside and we all rushed to the windows and there we saw the police beating the strikers on our account, and when we saw that we went out."[38] In all, some 40,000 workers went out in the end, about 10 percent of the working population of Chicago and the entire work force of the clothing industry, the city's largest employer. About half of the strikers were women.

Sixty-six years after her walkout, when Annie Shapiro Glick was asked what had caused the strike, she said, "We had to be recognized as people."[39] Indeed, if poor working conditions were enough to cause the revolt, it would have happened long before September 22. Poor sanitation, inadequate ventilation, seasonal employment, irregular and long hours, and low wages were commonplace in the industry. But the workers were pushed to the breaking point by other considerations. The garment industry in 1910 was still carrying through a transformation in its methods of production and marketing that had begun in the 1890s, when the manufacture of garments became a major industry. As the industry grew, it also moved to subdivide and speed up the work. In 1893, Mary Kenney made entire cloaks herself in a small Chicago shop where she had gone to organize workers. Ten years later, the making of a cloak or a coat could take up to eighty-five different workers, each making a snip or a cut that required little skill. At the same time, in the year that the League was formed, Hart, Schaffner moved "inside," assembling into a series of larger shops all its work previously done in pieces by tenement workers. Such moves, which were occurring across the country, were usually accompanied by the introduction of power-driven sewing machines that worked up to ten needles simultaneously. By 1910, there were still about 600 garment shops in Chicago, but half of the clothing produced came from the new factories.[40]

Having decided to consolidate their production, the most important manufacturers took steps to ensure that workers did not take advantage of their greater concentration to coalesce into unions. The Wholesale Clothiers' Association had been formed in

Chicago in 1890 to aid large manufacturers in their competition with small shops or contractors. Soon after the turn of the century, however, it became concerned about the spread of the closed shop. In affiliation with the National Association of Clothiers and the National Association of Manufacturers, it began a campaign against unions. It formed its labor bureau in July 1904, which consolidated all small labor exchanges and at which skilled workers had to register before being employed by either a member of the Wholesale Clothiers' Association or by the Wholesale Tailors' Association (representing the special-order branch of the industry). In August 1904, members of the Wholesale Clothiers' Association broke their union contracts by proclaiming the open shop in their establishments. Union workers walked off the job, and the subsequent lockout smashed the United Garment Workers and led to massive setbacks for unions throughout Chicago.[41] They vanished in sixteen of twenty-five industries. A tailors' local of the UGW, one of the few left in operation, reported that its membership had fallen from 500 to 32 as the Labor Bureau blacklisted unionists. By 1910, the UGW still had only about 1,000 members, and most of those were cutters, the most skilled workers in the garment industry. Women's unions were particularly hard hit because the antiunion drive coincided with the influx of large numbers of immigrants from eastern Europe, women eager for any employment. In 1903, there were just over 31,000 trade-union women in Chicago, more than in any other city in the nation; by 1909, according to Robins, there were fewer than 10,000. The UGW had 8,000 women enrolled in 1903 and almost none by 1910. A union of waitresses numbered 1,600 in 1903 but had vanished by 1910. The same thing happened to laundry workers, whose union had grown to 2,000 by 1902 and had ceased to exist by 1909.[42]

In short, when Annie Shapiro began making bow ties in 1905, she was entering an industry that had been radically changed during the last few years. Taking advantage of the open shop and a plentiful supply of immigrant labor, the large manufacturers further subdivided and speeded up production while trying to drive down wages by the sort of expedient that made Annie Shapiro walk off the job in 1910. The 40,000 workers who struck at that time—and only 7,500 were from Hart, Shaffner—indeed did so because they

"had to be recognized as people." They were not so much protest-
ing low wages and filthy work conditions as they were insisting that
they be treated humanely. Their first and most insistent demand
was for the closed shop, although many strikers were vague about
what that meant. At least it is clear that the closed shop had come
to represent for workers a crucial measure of control over their
lives. That is how Robins saw the strikers' demand and why she felt
that she was not speaking in mere abstractions when she equated
unionism with self-respect and solidarity. She was later fond of tell-
ing of an Italian woman who said to her during the strike, "We do
not live only on bread. If I cannot give my children bread, I *can* give
them liberty."[43]

The League, along with the CFL and (reluctantly) the UGW, di-
rected the strike and provided relief assistance. As a member of the
strike board, Robins directed the relief work, an enormous task,
since it included caring for 40,000 strikers and their families during
a very bitter winter. She also had to coordinate matters of picket-
ing, publicity, medical care, housing, strikers' grievances, and co-
operation with other groups (such as charities and churches). She
helped set up the most extensive commissary system in the history
of an American strike, with six stores distributing food, milk, coal,
and other necessities.[44] In all this, Robins was greatly aided by the
experience of Mary Dreier and the New York League in the "Upris-
ing of Twenty Thousand" shirtwaist makers in 1909, as well as by
her own experience in the related strike of garment workers in Phil-
adelphia in 1910.[45]

In the four and a half months of the strike, $100,000 was raised
to support the workers, with $70,000 coming from the League's
own efforts. Robins organized a citizen's committee through which
she and other League members took "girl strikers" like Bessie
Abramowitz and Annie Shapiro to the homes of wealthy women to
explain their problems. Such get-togethers not only garnered dona-
tions but publicity as well, for the newspapers took to writing
stories on how the strikers were gaining "social recognition" by
reaching influential Chicagoans.[46] Some of the latter came to be
called "Aristocratic Pickets" when they joined the lines outside the
factories. Robins arranged for the women's clubs to make a house-
to-house canvass of the wealthier neighborhoods of the city to

raise money on what she called "Sweatshop Sunday" (January 22, 1911). The money raised by all these endeavors went for relief supplies but also for entertainment and publicity for the strikers. As it developed, winning sympathy from middle-class women and from the newspapers was crucial in bringing about a relatively successful end to the strike. Carl Sandburg, a labor reporter for the *Daily News*, was only one of the writers whose favorable stories about the protesters won support from an audience who otherwise would never have countenanced the notion of a closed shop. Moreover, Sandburg also cheered on the strikers by appearing at small gatherings to sing and play his banjo.[47]

As one of four persons representing the strikers, Robins helped draft the agreement finally signed by Hart, Schaffner and Marx on January 14, 1911. The agreement called for the return of all strikers without regard to membership in the UGW, the creation of an arbitration committee, and the establishment of a method for handling grievances by that committee. The workers were not granted a closed shop, and the agreement did not extend beyond Hart, Schaffner. Rickert's UGW officers unilaterally shut down the commissary stores, and the remaining strikers were forced back to work on February 3, "starved into submission," as a social-work journal put it.[48]

Although the great strike thus ended on a note of betrayal, the garment workers could be proud of their achievement. A reporter noted that "considered for years to be the weakest link in the labor world, the spurned tailors turned and exhibited a class solidarity that has astounded the old labor leaders."[49] Furthermore, unionism had made great strides during the strike, for by the time it was over, significant numbers of Chicago's garment workers were in unions. But the walkout of 1910 would be little more than a footnote in labor history if it were not for the clause in the Hart, Schaffner agreement calling for the arbitration of disputes. Although the workers were chagrined at not winning acceptance of the closed shop, the arbitration clause proved to be the next best thing. As it developed, the creation of arbitration procedures between management and workers laid the foundation for the introduction of the preferential shop in 1913 and the closed shop soon thereafter. Such a development, however, was by no means inevitable in

1911, and as important as Robins and the League had been in sustaining the strikers for months, they were even more significant in ensuring the eventual success of the Hart, Schaffner agreement in the years after the strike.

Robins was crucial to the development of the arbitration machinery. She saw with clarity that the promise of arbitration offered unionism a powerful role in the garment industry. She personally paid the salaries of Mary Anderson and Bessie Abramowitz and sent them into the shops to explain the agreement to workers, many of whom could not speak English. When Clarence Darrow, the workers' representative on the arbitration committee, found himself overwhelmed with grievances, Robins took over some of his tasks. Eight months after the settlement, Robins wrote to Mary Dreier that "the business agent [Sidney Hillman] for the Hart, Schaffner and Marx workers, through whom all grievances reach the arbitration committee, has had to go away as he is pretty well exhausted . . . and all the work has been left in my hands."[50] Much of that work involved trying to end spontaneous walkouts and threats of strikes, for it was difficult to get such a diverse group of workers to understand the new procedures. As Robins wrote to her husband a little more than a year after the agreement, "There is no use giving you the details of the endless sessions, the hour long talks, the wild harrangues [of the workers]. . . . We are still gripping that trade agreement like a bulldog and every day that we hang onto it, it is more difficult to destroy. . . . the firm is egging the people on to strike with taunts and asking, 'Can't you strike now that you are unionists?' . . . this egging on is supplemented by the representatives of the National Garment Workers officers."[51] The supervisors at Hart, Schaffner wanted workers to strike so as to discredit the arbitration procedures, which limited their authority. At the same time, the national officers of the UGW wanted to be able to wrest control of a strike from the city union, thereby discrediting the new officials of the Chicago UGW who, like Hillman, had been impelled to leadership by the 1910 strike and kept there in part by their role in the arbitration procedures.

From the end of the strike to March 1912, Robins, Hillman, Darrow, and others tried to settle grievances, forestall strikes, and keep both the Hart, Schaffner bosses and the national UGW officials at bay. But after a year of such efforts, Robins decided that the

ad hoc efforts of union sympathizers were not working. She there-
fore called a meeting in March 1912 to work out more effective pro-
cedures. The result was the Trade Board, which finally set the Hart,
Schaffner agreement on a solid footing by instituting an appeals
process and weekly meetings of deputies from both management
and labor. Robins helped assure the success of the Trade Board
when she had James Mullenbach, a social gospel minister with ex-
tensive reform connections, appointed chairman. He was Raymond
Robins's closest friend, and Raymond secretly paid his salary for
the first year of the new position.[52]

At every stage in the development of the Hart, Schaffner agree-
ment, Robins played a critical role. Without her devotion to work-
ing out adequate arbitration procedures, it is likely that the Hart,
Schaffner agreement would never have become a landmark in la-
bor history. She was the only nonunion person on the strike board
during the walkout, and she was the only nonunion and non-
management individual who was a signatory to the Hart, Schaffner
agreement. Feeling that the agreement would otherwise not work,
Joseph Schaffner, the partner in the firm most involved with it, in-
sisted on Robins's signing it at its various stages. Sidney Hillman
and John Fitzpatrick likewise insisted that Robins help negotiate a
new contract in 1913, the one that established the preferential
shop at Hart, Schaffner.[53]

Robins could indeed be proud of her part in the strike of 1910
and in the development of industrial government at Hart, Schaffner.
She was also proud that the League's work helped lay the founda-
tions for what would become the Amalgamated Clothing Workers
of America. She regarded Hillman, the Amalgamated's president,
as a labor leader with the same vision and stature as Fitzpatrick.
"We saw things alike," she said about Hillman, "especially in re-
gard to the Labor Movement." In 1916, Hillman married Bessie
Abramowitz, the young striker whom Robins sent into the shops as
an organizer in 1911 and who was a founding member of the Amal-
gamated in 1914. The Hillmans reciprocated Robins's regard and
affection, and when Robins died, Bessie wrote of her that she "en-
abled me to become what I am today."[54]

The events of the strike and its aftermath, however, bore seeds
of trouble for Robins and the League. The problems that the League
had encountered with national officials of the United Garment

Workers were a forewarning of the difficulties it would continue to have with Samuel Gompers and the American Federation of Labor. Before the strike, the Chicago UGW was a small union of skilled craftsmen, mainly special-order tailors and cutters, headed by men of German, Irish, and Swedish descent. During the strike, UGW officials tried peremptorily to end the walkout, impeded the work of the strike board, and stingily disbursed funds even though the UGW treasury was swelling with dues paid by new members. After the strike, the Chicago UGW was swiftly transformed into a large industrial union—that is, an organization of workers throughout an industry without regard to craft specialization or skill—dominated by Jewish, Polish, and Italian immigrants. Other garment workers rejected the leadership of the UGW because of its conduct during the strike, while the remaining stronghold of the UGW in Chicago, the newly enlarged union at the Hart, Schaffner firm, became virtually independent of the national UGW organization.[55]

In 1914, the Hart, Schaffner workers and dissident members of the UGW in New York City bolted from the United Garment Workers of the AFL to form the Amalgamated. Hillman stated to reporters at the time that his new union would be concerned with "ultimate aims" and would have a "social service" aspect, in contrast to the "business-union" that dominated the labor movement. He also declared that he aspired to extend the Hart, Schaffner plan throughout industry. He conceived of the Amalgamated as a "vertical" organization, bringing together the craft specialties and weak locals of the garment industry in order to confront the new mass-production factories. Gompers, on the other hand, saw the Amalgamated as a betrayal of the labor movement, an act of secession that made for "dual unionism." Furthermore, he opposed industrial unionism because it weakened or eliminated the craft jurisdictions that he saw as giving stability to the labor movement. Above all, he believed that labor must speak with a single voice to be effective, and he reportedly said regarding the Amalgamated, "Right or wrong—no act of secession will be tolerated."[56]

Robins was entirely sympathetic with Hillman and was bitter that the AFL's lack of commitment to unskilled workers compelled an independent course for her model union. After the creation of the Amalgamated, Robins wrote to her husband that "the Sidney

Hillman group of garment workers have quietly 'withdrawn' from the Chicago Federation and our League, so that we may have clear sailing with the A.F. of L.! How I resent it!" The national officers of the UGW held Robins and the League responsible for the secession of the Amalgamated, however, and there was to be no clear sailing. At the 1915 convention of the League, Robins reported that national officials of the UGW were "going from city to city attacking the National Women's Trade Union League and claiming that the Chicago League organized this group of unorganized people for the purpose of fomenting secession." Nine years later, shortly before the death of Gompers, Robins informed a meeting of the WTUL that the president of the AFL had told her that the League had "very influential enemies, and those enemies were the international officers of the [United] Textile Workers and the United Garment Workers. He intimated that we might have other enemies."[57]

Indeed, as Robins was well aware, one of those other enemies was Samuel Gompers himself. He was never to forget the role played by Robins in the strike of 1910 and in the rise of the Amalgamated, and even if he wished to, the men of the UGW were always prompt to remind him that the League had sown dissension within the ranks of labor. In addition, Robins's affection for Hillman and her admiration for the reform unionism of the Amalgamated were well known. Of course, the League was certain to encounter resistance from the AFL in any event, since the Federation did not support unionizing women. Nevertheless, it was unfortunate that the work of which Robins was proudest, the single most substantial and enduring achievement of her organization, served to remove the League even further from the mainstream of the American labor movement. Robins's temperament, however, was not such that she was adept at dealing with that sort of consideration. To the end of her days with the League, she remained puzzled by the inability of the Federation to honor the devotion to unionism that she and her colleagues so signally displayed after the great walkout in 1910.

In November 1907, Robins attended her first convention of the American Federation of Labor. It was six months since she had led the protest march through Chicago, and she was in the middle of her discreet campaign to have the meeting place of the League

moved from Hull House to the CFL headquarters. She was anxious to establish closer ties with the labor movement, especially by having the Federation appoint an organizer to help establish women's trade unions. Even though Gompers had greeted the creation of the League with applause, the members of his Federation still believed that working women were unsuitable for organization because they were unskilled and only briefly in the work force. In 1907 there were no more female delegates at the Federation's convention in Norfolk, Virginia, than there had been four years earlier at Boston when the League was founded.

Robins wrote to her husband from Norfolk that "we are *not wanted* by the President and the majority of the Executive Council! I have not yet fathomed what the trouble is, but the discourtesy is very marked and apparent. . . . Those in authority are resentful or afraid and I can't tell which!" A few days later, the courtesy had improved but Robins remained perplexed: "Last night Mr. Gompers gave a grand banquet to the members of the Executive Council and their wives and I was included and sat to the right of the G.O.M., as he likes to be called. This is, of course, a great distinction, but I am not sure but it was done just to jolly me." There can be little doubt that Robins was right, for Gompers was apparently taken with her charm and social position. A month earlier in Chicago, he had been gracious to Robins, saying that if he had seen her at a CFL assembly, he would have asked her to the platform. "I felt like telling him," Robins wrote to her husband, "that possibly the Chicago Federation of Labor would think that I had a right to ask him to that platform."[58]

The mix of discourtesy and distinction that greeted Robins at the convention reflected the ambiguous position that the League had in the eyes of the Federation's leaders. On the one hand, Gompers and his colleagues looked upon the League with suspicion because it was founded and dominated by middle-class women who presumed to lecture the leaders of labor on the needs of female wage earners. On the other hand, the Federation's own resolutions, including one made at the 1907 assembly, asserted that the AFL was dedicated to the unionizing of women, a task in which the WTUL could be of assistance, for (as Mary Dreier noted) "some of those [union] men . . . think the whole purpose of the League is to fork out money when they want it."[59]

In the eyes of the Federation's leaders, the League never lost its philanthropic cast. Nor did the League's connections with Hull House serve Robins well in dealing with Gompers, for he distrusted upper-class social workers, declaring that "the workers are not bugs to be examined under the lens of a microscope, by intellectuals on a sociological slumming tour."[60] The converse of this disdain was conveyed in Gompers's words of appreciation at the 1911 AFL convention for the "many kind-hearted, noble and philanthropic ladies [who] helped in the Shirt Waist strike"—condescension that infuriated Robins even more because Gompers said nothing about the crucial role that the League had played in the recent garment workers' strike in Chicago.[61]

At times, trade unionists of the League would defend the position of the allies, as when Melinda Scott told Gompers in 1915 that "we hear a great deal of criticism of the Women's Trade Union League because we have people in it who are not trade workers. . . . Mrs. Robins is doing a work that no trade union woman I know of could do. She is reaching the people we could not reach. It may be at some future time . . . we will be able to find a trade union woman . . . to fill her place as president; but the work she is doing . . . could not be duplicated." Later in the same year, Robins herself confronted the executive council of the Federation during a meeting in Chicago:

> Something was said about the fact that it was not especially great credit to the movement that people who were not workers should be within the movement. I said: "Gentlemen, it is not so very long ago that the men's organizations of American labor had men like Wendell Phillips and Horace Greeley working with them. . . . It is quite natural that at this moment, with immigrant women pouring into the new country, there should be women standing for fair play, even though they are not workers. . . . If you feel that to turn the League into a federation of women trade unionists will make it easier to get the cooperation of the American Federation of Labor, I will say for myself and the rest of us who call ourselves allies that we will withdraw. Our desire is to see this a women's trade union movement." . . . Then these gentlemen said, "Why, no, they had not meant anything like that." They were not at all sure it might not be easier to have a Women's Trade Union League than to have a federation of women trade unionists.[62]

In calling the bluff of the executive council, Robins revealed that the Federation was not fundamentally concerned with the middle-class aspect of the League. As the men on the council intimated, it was easier for them to deal with the League, even if workers were not in charge, than to contemplate working with a nationwide federation of women trade unionists. Robins would always be distrusted by Gompers because of her middle-class background— "my position as ally forecloses value [of] my judgment," she telegrammed supporters at a Federation convention in 1924—but as trade unionists took over leadership of the League, they found that the Federation's attitude toward their organization remained hostile and unyielding.[63] Agnes Nestor, Maud Swartz, and Fannia Cohn were treated no more congenially or cooperatively than Robins, Mary Dreier, or Mary McDowell had been—indeed, perhaps even less so, for they lacked the refinement and social grace that Gompers found attractive in Robins. Mary Kenney O'Sullivan and Leonora O'Reilly, who had impeccable credentials as workers and trade unionists, both eventually left the League in part because of their anger at the Federation's policies regarding the WTUL and women workers. In 1918, three years after wage earners had been installed as presidents of all the League's local branches, Gompers refused to appoint a trade-union woman to the chairmanship of the Committee on Women in Industry "because a trade union woman would be too poor to hold such a position."[64] Naturally, a middle-class ally of the League, who could afford the position, could not be appointed because she was not a trade-union woman.

The Federation never lacked a reason for denigrating the League and its goals. Women were not competent to decide which trade to enter, Gompers asserted in 1916, because they followed their emotions too readily. Women were not qualified to organize women, he said in 1915, because women were difficult to organize, because "women organizers were rarely worth anything," and because "they had a way of making serious mistakes." Anyway, the heads of the national unions suggested in 1924, there were not all that many women workers to organize, only about 150,000 by their count. Mary Anderson told Gompers that in fact there were some 3,000,000 women eligible for membership in the Federation, and Robins wrote to Mary Dreier that "these men died twenty years ago and are just walking around dead!"[65]

Gompers's most serious charge against the League was that it was not committed to the tedious business of union organization but instead turned to educational projects, which he saw as a waste of time and money, and to securing protective legislation, which he thought allowed the government to intrude upon the independence of the worker. The New York League was a case in point for Gompers (as well as for later students of the subject), since that branch of the WTUL displayed its supposed ambivalence toward union organization after 1913 by pouring energy into a campaign for protective legislation. That view, however, fails to account for the League as a whole or to recognize the special circumstances of the New York League. The latter turned to protective legislation as a result of disasters in the garment industry, especially the Triangle Shirtwaist fire, which left 146 young women dead and shocked the nation. The New York League threw itself into a crusade for protective legislation, deeming that it did little good to urge women into unions if they were then to be slaughtered on the job. The New York branch worked closely with the New York State Factory Investigating Commission, on which Mary Dreier sat as one of the nine commissioners.[66]

Neither the Chicago League nor the national organization was impelled to shift its resources from union organization to protective legislation by the calamities that affected the New York League. Even while maintaining its legislative activity, the Chicago League undertook some of its most important organizational drives after 1913. From 1914 to 1925, it helped the International Ladies' Garment Workers' Union (ILGWU) successfully unionize shops in Chicago. Dressmakers, waitresses, bookbinders, glove makers, Pullman-car cleaners, broom makers, state hospital workers, and stockyard workers were all organized from 1913 to 1918. On the national level, the League in some years after 1913 employed as many as twenty organizers, who were dispatched on projects such as unionizing candy makers and dressmakers in Philadelphia, telephone operators in Boston, cigar makers and printers in Washington, D.C., and textile workers in the South.[67]

In her presidential address to the League in 1917, Robins again insisted that "organization is the heart of it all. . . . Industrial freedom requires the trade agreement and the trade agreement requires the organization of workers."[68] Yet the League's dedication

to organizing trade unions did not survive Robins's resignation as president of the WTUL in 1922. Well into the 1930s, Elisabeth Christman often incorporated letters from Robins on the need for organization into her own appeals to the executive council; but without Robins, the League lacked the resources (and perhaps the inspiration) for such campaigns. The movement away from unionizing, then, took place in the mid-1920s and not more than a decade earlier. Gompers's rejection of the League for its desultory approach to union organization was at best based upon a very partial view of its activity, and it entirely overlooked the League's achievements in the upheavals of the garment industry from 1909 to 1912.

The problem that the League posed for the Federation did not stem from either the middle-class complexion of the League or the League's supposed negligence toward union organizing. The tensions between the two labor organizations also had little to do with the perceived emotionalism of women, the incompetence of female organizers, or a paucity of women workers. The men of the Federation were not hypocrites in putting forward such objections, for there is every indication they believed them to be valid; but none of them went to the root of the difficulty. So too delegates to the Federation's conventions periodically approved resolutions calling for the unionization of working women while also voting for declarations asserting that women properly belonged in the home, not endangering their health and (the AFL assumed) lowering men's wages by venturing into industry. The clash between the League and the Federation, however, cannot be reduced to one of gender, although members of the AFL certainly regarded women, whether middle-class or laborers, as their inferiors. Working women were members of the Federation, while in two decades of activity, the League assisted about 100 trades in some fashion, most of which included men. The League was quick to aid any strikers, whatever their sex.[69]

To be sure, each side often criticized the other in terms of sexual stereotypes, with Gompers muttering about meddling women who were ignorant of the working world and Robins complaining about the "miserable men" who failed to nurture unions founded by the League.[70] In general, this was rhetoric to which both parties had access, an accentuation of obvious points of contrast between

the leaders of the two organizations. It did not reach to the deepest differences between the League and the Federation. Indeed, both sides were careful not to explore those differences. The terms of abuse used by them, along with the debating points that arose from the Federation's various criticisms of the League, allowed the leaders of the two groups to avoid spelling out the fundamental causes of their conflict, for the assumptions that each brought to the labor movement required that they preserve a semblance of working together.

From the League's perspective, the Federation had so narrowly defined the nature of the labor movement in terms of skilled craftsmen and material gains that it had become part of the established order, hence unresponsive to those outside it, those who most needed the protection of unions—the unskilled, the immigrants, the women. Alice Henry noted that since "trade qualifications and trade autonomy were essential articles of faith" for the AFL, "the inferior position held by women in the industrial world was therefore reflected in the Federation."[71] Robins was committed to the idea of industrial unionism—indeed, the constituency to which she appealed required some such redefinition of the structure of labor—and she saw unions within a context of self-development, citizenship, democratic culture, and social regeneration. In her eyes, the Federation had abandoned the reform values that were integral to the American tradition of labor and democracy, and far from being an institution of reform, it had become a bulwark of the status quo, as calloused and selfish as the manufacturers who exploited immigrant laborers.

At the same time, Robins concluded that the fate of the League and of working women was inalterably bound to the Federation. Labor was still struggling for its rights, and as recently as 1904 the established craft unions of the AFL had suffered severe setbacks across the country; conservative forces seemed poised to attack the labor movement at any moment. In short, Robins entirely accepted Gompers's dictum that labor must speak with one voice. In her early years with the League, she considered alternatives to the established labor movement, such as a national federation of female trade unions or a labor party like England's, yet she rejected them as impractical or a threat to labor as a whole. It was unbear-

ably frustrating to see the Amalgamated leave the Federation and the League, but she evidently never considered aligning her organization with Hillman's 38,000 followers in sixty-eight locals instead of with Gompers's 4,000,000 workers in 40,000 unions. She would not have seen that as best serving the cause of working women. She always concluded that the League must stay within the Federation, for only by doing so would female wage earners be able "to make self-respecting demands upon labor leaders." In 1913, Raymond's strictures probably kept Mary Dreier from wavering on this point: "With all its short comings . . . [the AFL] is none the less the true representative body of organized labor in this country. . . . As a matter of expediency, you must cooperate with the policy of the American Federation of Labor." Twenty-one more years of dealing with the Federation made Mary no more enthusiastic for the same conclusion: "There are times," she wrote to her sister, "when it is all I can stand to accept the limitations put upon us by our relation with the AFL, though of course I know that is the only way to work."[72]

From the Federation's point of view, the League was dedicated to organizing the wrong kind of worker into the wrong kind of union—and, up through 1911, enjoying some success in doing so. Gompers did not see unskilled, immigrant working women (or men) as assimilable to the craft divisions and trade discipline of the Federation; nor did he believe that the Federation, as a practical matter, could do much for them. To bring them into the AFL would result in driving down the prestige of artisan skills, the stature of the American workman, and the wages of the union craftsman. It would explode the craft jurisdictions that gave security and solidity to the labor movement, thereby once more exposing workers to the rapacity of employers. Gompers never came to terms with the new force of industrial unionism, and it is not surprising that the United Mine Workers, the only major industrial union within the AFL, were restive under his leadership. On the other hand, Robins admired John Mitchell, the head of the United Mine Workers, because "he is the one man who understands the industrial struggle of our day and understands and sympathizes with the unskilled worker. He therefore has the vision of what our woman's movement needs and the handicaps [we] are under."[73]

The League made industrial unionism even more unattractive to Gompers by enveloping it in reformist rhetoric and missionary sentiment, the sort of language that Hillman used when he described the Amalgamated in terms of "ultimate aims" and "social service." According to Gompers, the strength of the Federation came from its rejection of a broad reform agenda in favor of concern for work rules, membership standards, and wage policies. In its dedication to reform unionism, the League threatened the Federation's conception of itself as a consortium binding together the steadiest of the union men from the most skilled crafts in pursuit of purely economic ends. In so defining the purpose of the Federation, the established national unions had made their peace with an acquisitive and mobile industrial society, and the sort of trade unionism that Robins had in mind for working women could only disrupt that self-interested compact.

It was clear to Gompers in 1914 that the League did not represent an idle threat when the Amalgamated seceded from the UGW and the AFL, thereby proving to his satisfaction that when Robins's conception of unionism found institutional realization, an impetus to reform destroyed labor solidarity. With all that Gompers disliked and distrusted about the League, however, he could not repudiate it or cut it off from the Federation. The AFL had formally and repeatedly committed itself to the unionization of the entire wage-earning class, "without regard to color, sex, nationality or creed." In 1890 Gompers declared, "I have always maintained that a trade union could be organized from all classes or wage-workers of any particular trade or calling whether skilled or unskilled."[74] He could not turn his back on women who claimed only to be accepting his statements of principle and intent at face value. To reject the organizational aspirations of the League would be to run counter to his conception of the Federation as an organization that drew its strength from the union of all workers. In effect, Gompers was stymied by the principles of his Federation in the same way that Robins was by her commitment to labor solidarity. Drawn together by principles that they formally and very reluctantly shared, however, they had insufficient common ground to insure harmony. They were forced to deal with each other, and for the most part, they did so superficially and spitefully. There was nothing grand

about their struggle, no declaration of fundamental issues, no articulation of the relationship between reform, unionism, and society, for it was in the very nature of their wary accommodation that they could not permit the extent of their differences to be illuminated fully.

Nevertheless, the members of the League were proud that as they saw it, they were part of a tradition that had been abandoned by the Federation. In 1924, Rose Schneiderman, the new president of the national League, lamented that her organization continued to encounter resistance from the Federation, which had recently proposed that it be absorbed by a women's department of the AFL. "We are not popular with some folks," she told a League convention. "I don't know why. I know we uphold the old idealism of the movement, and perhaps some people think we are radical or 'red' because of our insistence that idealism shall be maintained."[75] It was a sign of the times that the "old idealism" had come to seem radical in the 1920s. In fact, it derived from a tradition of reform unionism that held sway in the American labor movement through most of the nineteenth century and enjoyed its last great efflorescence in the Noble and Holy Order of the Knights of Labor from the early 1870s to the mid-1890s. In its reform values and organizational goals, the League represented a last expression of that tradition. Whatever the differences of time and place, the clash between the League and the Federation was a recapitulation, on a small scale and in attenuated fashion, of the ideological conflict within the Knights of reform unionism and practical craft unionism.[76]

The Knights had been an unwieldy collection of local assemblies, both trade (from the same craft or occupation) and mixed (from all trades and callings). The different kinds of locals had varying aims, and the trade-union contingent was particularly opposed to a program of social reform. Until 1881, Gompers was a leader of the craft unionists within the Knights. From the foundation of the AFL in 1886, his insistence on labor solidarity, economic ends, and craft unionism was in part a reaction to the Knights, who espoused a cross-class coalition and an early form of industrial unionism in the name of social renewal. He was motivated by the fear that skilled workers would be subordinated to the interests of the unskilled and that craftsmen would lose their chance

for material betterment in a distracting drive for social transformation.[77] Twenty years later, when Robins preached the virtues of industrial unionism, social regeneration, cross-class solidarity, and unskilled workers, Gompers could hardly avoid seeing the League in terms of what the Federation had been established to combat in the labor movement.

Robins was linked to the Knights in her association with Leonora O'Reilly, who had joined the organization in 1886. Agnes Nestor had learned about trade unions from her father, a member of the Knights. Alzina Parsons Stevens had brought the ethos of the Knights into Hull House in 1892 after extensive service as an officer of the order in Ohio.[78] These connections, however, were probably not as crucial to Robins's embrace of reform unionism as was the influence upon her of her tutor in Brooklyn Heights, Dr. Richard Salter Storrs; her teacher of rhetoric, Lucia Gilbert Runkle; and her mentor in labor matters, Josephine Shaw Lowell. These persons pointed Robins to the tradition of American labor reform of which the Knights were only the fullest and most recent expression, back past the Gilded Age to Wendell Phillips, Horace Greeley, and the humanitarian crusades of antebellum America, and past them as well to a Jacksonian labor movement that promoted reform unionism, communitarianism, and democracy.

Whatever the sources of her inspiration, Robins shaped the League into an institution that bore a remarkable ideological resemblance to the Knights of Labor. Like the Knights, League members were concerned for self-improvement and educational development; committed to an alliance of the middle class and the working population; intent on creating a transformed, expansive society in which the worker would be self-governing as well as socially conscious; devoted to winning equal rights and suffrage; in favor of industry-wide organization of workers and against craft divisions; dedicated to the unionization of unskilled, immigrant laborers; and in favor of unions as agents of reform rather than economic pressure groups. Like the Knights, which had some 65,000 women members in 1886, the League offered women the opportunity to envision female values and female culture, the nurturing forces of motherhood and domesticity, reforming the workplace and society.[79]

As part of a long tradition of reform unionism, the League could not accommodate itself to the policies of the Federation without betraying its convictions. In their devotion to labor unity, however, the women of the League placed their hopes and ideals into the hands of the men of the Federation, who had scant respect for the purposes of the League. Perhaps Robins and her colleagues should not have been surprised that they sometimes had to put aside their best instincts and most fervent beliefs to remain part of the labor movement. In exchange for hollow resolutions at AFL conventions and empty promises from Gompers, the League all too often subordinated its desire for reform to the needs of the great craft unions of the Federation. In the end, the League neither won the approbation of the Federation nor accomplished what it wanted for working women. Instead, the loyalty of League women to "the true body of organized labor" led them into a morass of compromise and frustration.

In the name of labor solidarity, Robins watched helplessly as the Amalgamated, her model progressive union and in part her creation, left the League and the Federation. In 1910, she had to turn down an offer of $25,000 from Boston citizens to organize textile workers throughout New England because the head of the United Textile Workers (UTW) of the AFL objected to her interference. At the command of the same union leader in 1912, the  Boston League cut off relief supplies to unskilled striking textile laborers in Lawrence, Massachusetts, while the UTW won a good settlement for the skilled craftsmen. The calloused behavior of the Federation and the dismal performance of the League led to Mary Kenney O'Sullivan's resignation from the WTUL and to the virtual collapse of the Boston branch. In order to pacify the Federation in 1914, the New York League voted down a resolution calling for minimum wage boards to establish rates for women, even though the League had lobbied for such a measure for years.[80]

In 1915, Robins was subjected to a bawling out by Gompers for "expressing an opinion in opposition to that of the American trade union movement" on the Clayton Act, an indiscretion that the president of the AFL believed "furnish[ed] ammunition to the enemy." In the same year, the League had to endure the humiliation of having Gompers instruct the Brotherhood of Carpenters and

Joiners that the $500 appropriated by that union for League organiz-
ing must instead be sent directly to the AFL since union organizing
should "be done by and through the American Federation of La-
bor."[81] In 1917, Gompers successfully "used all his influence" to
defeat Robins for the position she had held for years on the execu-
tive council of the CFL; he argued that she was against the war be-
cause she was pro-German, but a few years later, he attacked her in
the same forum for being pro-Russian and marching "with the red
flag." When the League worked out good relations with union locals
and city federations, which was not uncommon, the Federation
often disrupted them, as when Gompers in 1923 ordered the Phila-
delphia city central to repudiate its vote giving a League woman a
place in its assembly.[82]

One may conclude that the League made a bad bargain when
it tied its fortunes to the American Federation of Labor. But it had
nowhere else to go. A federation of women trade unionists was be-
yond the capacity of the League—and would have been bitterly
fought by the Federation. Robins found the Socialist party unap-
pealing, and there was no labor party. She was devoted to the Pro-
gressive party at its height, but that was hardly a vehicle for aiding
unskilled working women. And if Robins had chosen to break with
the Federation—a move that the trade-union women of the WTUL
would have hotly opposed—the League would have lost the con-
siderable cooperation it enjoyed from the locals and city centrals
of the AFL. To be sure, sometimes Robins simply wished to defy
Gompers and the Federation, to give vent to her militant spirit, just
as when she led the march for the IWW through Chicago. But that
would not have served the cause of working women. Despite the
obstacles and frustrations, then, she stayed with the Federation,
and considering the problems she and her colleagues faced in
dealing with the leaders of the American labor movement, their ac-
complishments were certainly more noteworthy than their failures.

Robins's optimism was too strong for her to be dismayed for
long by the failures of the League. Pouring money and energy into
the WTUL, she was buoyed by its great potential. Having estab-
lished her organization as the champion of working women—an
accolade that even Gompers did not begrudge—she imagined that
the future of women's trade unionism was secure. She ended her

tenure as president of the League with her confidence and beliefs intact. It was not until she moved to Florida in 1924 that she came to a disenchanted perspective on the League and reform. But while in Chicago, she was "the League's evangelist," as Elisabeth Christman called her. And in Chicago, in the strike of 1910, Robins had witnessed the transformative powers of unionism, their capacity to fuse "alien spirits into the American spirit" and provide a citizenship of labor for the isolated and exploited. According to Mary Dreier, in the life of Robins "these fourteen weeks [of the strike] must be written large, as they became part of her being and were burned into her soul."[83] In the city of Hillman and Fitzpatrick, Addams and McDowell, Robins was rewarded with confirmation of her deepest convictions. If all the world had been Chicago, she need never have become disenchanted with reform. In that progressive city, she could even contemplate the unlikely possibility of winning over the leaders of the Federation to her way of thinking: "We [in the League] are establishing a standard," she wrote to a friend in 1916, "which before very long will have to be accepted even by those labor men not yet with us."[84]

## Notes

1. The following account of the parade is drawn from the May 16–21 reports in the *Chicago Record-Herald*, the *Chicago Daily Socialist*, the *Chicago Daily News*, and the *Daily Inter-Ocean*. On the trial and the IWW, see Paul F. Brissenden, *The I.W.W.: A Study of American Syndicalism* (New York: Russell and Russell, 1957), pp. 170–75; William Preston, Jr., *Aliens and Dissenters: Federal Suppression of Radicals, 1903–1933* (New York: Harper and Row, 1966), pp. 38–46.

2. MDR to MED, May 22, 1907, box 26, MDR Papers; MDR to Mrs. Louise deKoven Bowen, May 20, 1907, copy, box 2, RR Papers.

3. On the rumor and the blackballing, see MED, *Robins*, p. 44, and MDR to Ethel Smith, May 6, 1927, copy, box 31, MDR Papers. Arthur Brisbane, a journalist, endorsed MDR for secretary of labor: see H. A. Jung to Arthur Brisbane, Dec. 4, 1928, copy, box 32, MDR Papers.

4. On MDR not seeing red flags, see MED, *Robins*, p. 40. On Parsons, see Avrich, *The Haymarket Tragedy*, p. 452, and Carolyn Ashbaugh, *Lucy Parsons: American Revolutionary* (Chicago: Charles H. Kerr Co., 1976).

5. MED, *Robins*, pp. 43–44.

6. MDR to MED, Mar. 18, 1912, box 28, MDR Papers; MDR, "Self-

Government in the Workshop: The Demand of the Women's Trade Union League," *Life and Labor* 2 (Apr. 1912): 110.

7. MDR to Antoinette Stearly, Jan. 27, 1938, copy, box 50; cf. MDR to MED, Sept. 19, 1899, box 25, MDR Papers.

8. Edward Pessen, *Most Uncommon Jacksonians: The Radical Leaders of the Early Labor Movement* (Albany: State University of New York Press, 1967); Eric Foner, *Free Soil, Free Labor, Free Men: The Ideology of the Republican Party before the Civil War* (New York: Oxford University Press, 1970), pp. 11–39; David Montgomery, *Beyond Equality: Labor and the Radical Republicans, 1862–1872* (Urbana: University of Illinois Press, 1967), pp. 170–96.

9. *Life and Labor* 6 (Feb. 1916): 22; Frank Morrison, "February 12: A Retrospect," *Life and Labor* 8 (Feb. 1918): 23; William Z. Foster, "How Life Has Been Brought into the Stockyards," *Life and Labor* 8 (Apr. 1918): 69; Address by RR, Sept. 27, 1908, Convention of the New York WTUL, box 3, RR Papers; "Republican National Committee, Advisory Committee on Politics and Platform, Questionnaire on Industrial Relations and the Problem of Capital and Labor, Some Answers Submitted by Mrs. Raymond Robins," Mar. 20, 1920, box 21, MDR Papers.

10. MDR to Meyer Lissner, Apr. 23, 1920, box 31, MDR Papers. On the Clayton Act, see Jerold S. Auerbach, ed., *American Labor: The Twentieth Century* (Indianapolis: Bobbs-Merrill Co., 1969), pp. 123–24.

11. The Clayton Act is quoted in Newton Jenkins, "Workers Plan War on Injunctions," *Life and Labor* 6 (July 1916): 101.

12. John Fitzpatrick to MDR, May 27, 1935, box 47, MDR Papers. On *Life and Labor*, see Kenneally, *Women and American Trade Unions*, p. 49.

13. "Mrs. Raymond Robins, Opening Address to the Sixth Biennial Convention of the NWTUL," *Life and Labor* 7 (July 1917): 103, 106; see also "The Fourth Biennial Convention," *Life and Labor* 3 (July 1913): 210.

14. MED, *Robins*, p. 80. For further discussion, see chapter 4.

15. "The Menace of Great Armaments," *Life and Labor* 4 (Sept. 1914): 263.

16. MDR to William G. Redfield, Aug. 27, 1919, box 31, MDR Papers; "Minutes of the 4th Biennial Convention of the NWTUL," June 2–7, 1913, St. Louis, Mo., p. 301, reel 21, NWTUL Papers.

17. Quoted in Stewart, *Philanthropic Work*, p. 371.

18. MDR, "The Minimum Wage," *Life and Labor* 3 (June 1913): 169; "Trade Unionism for Women," in Shailer Mathews, ed., *The Woman Citizen's Library: A Systematic Course of Readings in Preparation for the Larger Citizenship*, vol. 11 (Chicago: Civic Society, 1914), pp. 2911–12.

19. MDR, presidential address, in "Minutes of the 8th Biennial Con-

vention of the NWTUL," June 5–10, 1922, Waukegan, Ill., pp. 6–7, ll-12, reel 22, NWTUL Papers; RR, Address at "National Protest," meeting of the Chicago Federation of Labor, Apr. 19, 1908, Chicago, Ill., box 3, RR Papers; see also, MDR, address, Conference of the International Federation of Working Women, Aug. 14, 1923, box 18, MDR Papers.

20. F. S. Potter, "The Educational Value of the Women's Trade Union League," *Life and Labor* 1 (Feb. 1911): 37.

21. Maud Swartz, "On the Value of the Union Shop," Oct. 1923, box 21, NWTUL Papers; Mary Beard, *The American Labor Movement: A Short History* (New York: Macmillan Co., 1928), pp. 1, 9. On Beard, see the introduction to *Mary Ritter Beard: A Sourcebook*, ed. Ann J. Lane (New York: Shocken Books, 1977), pp. 1–74.

22. MDR, "Self-Government in the Workshop," *Life and Labor* 2 (April 1912): 109–10; Agnes O'Brien, "Suffrage and the Woman in Industry," *Life and Labor* 5 (July 1915): 132.

23. Swartz is quoted in "Minutes of Executive Board Meeting, NWTUL," Oct. 8–10, 1924, box 15, MDR Papers.

24. Mary Anderson, "Joint Advisory Committee for the Summer School for Women Workers in Industry," Mar. 19, 1921, box 20, MDR Papers; Mary Anderson, editorial, *Life and Labor* 1 (June 1911): 195; Anna Rudnitsky, "Time is Passing," *Life and Labor* 2 (Apr. 1912): 99.

25. MDR, essay on "National Work," Jan. 1912, box 1, NWTUL Papers; cf. Elizabeth Maloney, "Towards the Eight-Hour Day," *Life and Labor* 1 (Nov. 1911): 323. O'Sullivan is quoted in "Minutes of the 2nd Biennial Convention of the NWTUL," Sept. 25–Oct. l, 1909, Chicago, Ill., closing session, reel 19, NWTUL Papers.

26. MDR, notes for address to Congress of International Federation of Working Women, 1923, box 3; "Suggested Plan of Study for Women's Trade Union League Educational Program," n.d., box 16, MDR Papers.

27. Leonora O'Reilly, "International Congress of Women at the Hague," *Life and Labor* 5 (July 1915): 126; see also Agnes Nestor to MDR, Jan. 6, 1925, box 35, MDR Papers.

28. On Philadelphia, see "Minutes of the Executive Meeting of the NWTUL," Jan. 14–15, 1923, reel 3, NWTUL Papers. On Chicago, see "Minutes of the 7th Biennial Convention of the NWTUL," June 2–7, 1919, Philadelphia, Pa., p. 12, reel 22, NWTUL Papers; Lillian Herstein in interview with Elizabeth Balanoff, Oct. 30, 1970, Roosevelt University Oral History Project in Labor and Immigrant History, bk. 1, p. 52, Roosevelt University Library, Chicago, Ill.; Keiser, "John Fitzpatrick," p. 76; Nestor, *Woman's Labor Leader*, p. 283; "Proceedings, Committee of Women and Children in Industry, Mid-West Conference," Sept. 13–14, 1918, box 18,

MDR Papers. On the Workers' Education Bureau, see Boone, *Women's Trade Union Leagues*, p. 119.

29. MDR to Mabel Gillespie, Jan. 20, 1915; MDR to MED, Jan. 15, 1915, box 29, MDR Papers; "Minutes of the 5th Biennial of the NWTUL," June 1–7, 1915, New York, N.Y., p. 325, reel 21, NWTUL Papers.

30. On the proposal, see Edwin G. Cooley, *Vocational Education in Europe: Report to the Commercial Club of Chicago* (Chicago: Commercial Club of Chicago, 1912), pp. 332–36.

31. MDR, "Industrial Education," *Life and Labor* 3 (Aug. 1913): 231–32; see also MDR, presidential address, draft, Biennial Convention of the NWTUL, Sept. 27, 1909, box 3, MDR Papers.

32. The statement from the meat-packing firm is quoted in Bari Jane Watkins, "The Professors and the Unions: American Academic Social Theory and Labor Reform, 1883–1915" (Ph.D. diss., Yale University, 1976), p. 250. The sweatshop manager is quoted in Chicago Joint Board, *The Clothing Workers of Chicago, 1910–1922* (Chicago: Chicago Joint Board, Amalgamated Clothing Workers of America, 1922), p. 19. The League woman is quoted in "Minutes of the 4th Biennial Convention of the NWTUL," June 2–7, 1913, St. Louis, p. 172, reel 20, NWTUL Papers.

33. Ruth I. Austin, "Teaching English to Our Foreign Friends, Part I: Among the Bohemians," *Life and Labor* 1 (Sept. 1911): 260; John Marie Daly, "Mary Anderson: Pioneer Labor Leader" (Ph.D. diss., Georgetown University, 1968), p. 9. Also see Timothy L. Smith, "Immigrant Social Aspirations and American Education, 1880–1930," *American Quarterly* 21 (Fall 1969): 524–26; Abraham Cahan, *The Rise of David Levinsky*, (1917; reprint ed., New York: Harper and Row, 1966), pp. 175–76.

34. Agnes Aitkin, "Teaching English to Our Foreign Friends, Part II: Among the Italians," *Life and Labor* 1 (Oct. 1911): 309; "New York," *Life and Labor* 2 (Dec. 1912): 381.

35. Violet Pike, "New World Lessons for Old World Peoples, Lesson VI: Joining the Union," *Life and Labor* 2 (Mar. 1912): 90.

36. The quotation is from Selig Perlman and Phillip Taft, *History of Labor in the United States, 1896–1932* (New York: Macmillan Co., 1935), pp. 306–7. On the new union contracts, see MDR to MED, June 16, 1920, box 32, MDR Papers. On MDR's view of Hillman and the Amalgamated, see MDR to MED, Sept. 21, 1924, RR Papers; MDR to MED, Nov. 10, 1927, box 31; MDR to Faith Pigors, Dec. 31, 1940, box 46, MDR Papers. On MDR's pride, see MDR to MED, Sept. 26, 1924, box 25, MDR Papers. On the 1910 strike, see N. Sue Weiler, "Walkout: The Chicago Men's Garment Workers' Strike, 1910–1911," *Chicago History* 8 (Winter 1979–80): 238–49; Chicago Joint Board, *Clothing Workers of Chicago*, pp. 17–48;

Matthew Josephson, *Sidney Hillman, Statesman of American Labor* (Garden City, N.J.: Doubleday and Co., 1952), pp. 47–58; Howard Barton Meyers, "The Policing of Labor Disputes in Chicago: A Case Study" (Ph.D. diss., University of Chicago, 1929), pp. 646–727.

37. Quoted in Chicago Joint Board, *Clothing Workers of Chicago*, p. 19.

38. Quoted in ibid., p. 22; cf. Josephson, *Hillman*, pp. 48–49; Weiler, "Walkout: The Chicago Men's Garment Workers' Strike," p. 239.

39. Weiler, "Walkout: The Chicago Men's Garment Workers' Strike," p. 241 (the 1976 videotape interview of Hannah Shapiro Glick by Rebecca Sive-Tomashefsky is on deposit in the Manuscript Collection, Preston Bradley Library, University of Illinois at Chicago).

40. O'Sullivan, unpublished autobiography, p. 96; Joel Seidman, *The Needle Trades* (New York: Farrar and Rinehart, 1942), pp. 16–20; Meyers, "Policing of Labor Disputes," pp. 647–49; for a description of the emerging factory system, see Cahan, *Rise of David Levinsky*, pp. 151, 201–11.

41. Meyers, "Policing of Labor Disputes," pp. 653–58. Hart, Schaffner was not a member of the Wholesale Clothiers' Association, but it also declared an open shop in 1904.

42. Mary Yates Donata, "Women in Chicago Industries, 1900–1915: A Study of Working Conditions in Factories, Laundries, and Restaurants" (M.A. thesis, University of Chicago, 1948), pp. 28–34; Emily Burrows, "Trade Union Organization among Women in Chicago" (M.A. thesis, University of Chicago, 1927), pp. 19–25, 55–60.

43. On the Italian woman, see the versions of the story in Alice Henry, *The Trade Union Woman* (New York: D. Appleton and Co., 1915), p. 106; MED, *Robins*, p. 75; and Anderson, *Woman at Work*, p. 41.

44. Women's Trade Union League of Chicago, *Official Report of the Strike Committee* (Chicago, 1911), pp. 20–24; MED, *Robins*, pp. 72–73.

45. On the "Uprising," see Dye, *As Equals*, pp. 88–94; on Philadelphia, see MDR, speech to the Agency for the Improvement of the Woman of the Community, Lake Geneva, Ill., Aug. 23, 1910, reel 2, MDR Papers.

46. Chicago Joint Board, *Clothing Workers of Chicago*, pp. 39–40; Katharine Coman, "Chicago at the Front," *Life and Labor* 1 (Jan. 1911): 11; Donata, "Women in Chicago Industries," pp. 35–36.

47. Donata, "Women in Chicago Industries," p. 36; Boone, *Women's Trade Union Leagues*, pp. 96–97. On the force of publicity, see Meyers, "Policing of Labor Disputes," p. 683. On Sandburg, see Anderson, *Woman at Work*, p. 40.

48. Women's Trade Union League of Chicago, *Official Report of the Strike Committee*, pp. 31–32; Meyers, "Policing of Labor Disputes," pp. 693, 696. The quotation from the *Survey* appears in Lela B. Costin, *Two Sisters for Social Justice: A Biography of Grace and Edith Abbott* (Urbana: University of Illinois Press, 1983), p. 80.

49. The quotations are from Meyers, "Policing of Labor Disputes," p. 672.

50. MDR, "Some of the Results of the Hart, Schaffner and Marx Agreement," [c. 1911], box 17; MDR to MED, Feb. 14, 1911, box 28; Olive Sullivan to MED, Mar. 16, 1911, box 28; MDR to MED, Sept. 7, 1911, box 28, MDR Papers.

51. MDR to RR, Mar. 2, 1912, box 60, MDR Papers.

52. MDR, "The Agreement Entered into between the Firm of Hart, Schaffner and Marx and their Employees, January 14, 1911," box 17; RR to MDR, May 3, 1912, box 60; MDR to MED, Mar. 10, 1920, box 32, MDR Papers. On Mullenbach, see Josephson, *Hillman*, pp. 51, 63–64.

53. MDR to RR, Mar. 10, 1913, box 60, MDR Papers.

54. MDR to Nan Stearly, Jan. 27, 1938, copy, box 50; MDR to RR, Dec. 11, 1921, box 63, MDR Papers; Bessie A. Hillman to RR, Feb. 28, 1945, box 35, RR Papers; also see Bessie A. Hillman to MED, Sept. 28, 1950, MED Papers, and Bessie A. Hillman in "Minutes of the 12th Biennial Convention of the NWTUL," May 19–22, 1947, Washington, D.C., p. 280, reel 26, NWTUL Papers.

55. Meyers, "Policing of Labor Disputes," pp. 691, 774; Josephson, *Hillman*, p. 48.

56. Josephson, *Hillman*, pp. 103, 107, 110. On the Amalgamated's secession, see Chicago Joint Board, *Clothing Workers of Chicago*, pp. 72–94; Josephson, *Hillman*, pp. 86–110 (on Hillman's statement, see p. 110). In early 1915, the Amalgamated in Chicago had about 8,500 members, mostly at Hart, Schaffner, while the UGW was left with fewer than 800 (Meyers, "Policing of Labor Disputes," p. 776). Nationally, the Amalgamated had about 38,000 members in 1915 and the UGW about 20,000 (Josephson, *Hillman*, p. 100).

57. MDR to RR, Feb. 20, 1915, box 8, RR Papers; MDR in "Minutes of the 5th Biennial Convention of the NWTUL," June 7–12, 1915, New York, N.Y., p. 300, reel 21, NWTUL Papers; "Minutes of the 9th Biennial Convention of the NWTUL," June 16–21, 1924, New York, N.Y., pp. 81, 110, reel 23, NWTUL Papers; cf. MDR to RR, Mar. 19, 1915, box 8, RR Papers.

58. MDR to RR, Nov. 12, 17, and Oct. 25, 1907, box 52, MDR Papers.

59. MED to MDR, Mar. 9, 1911, reel 22, MDR Papers. See David Mandel Halfant, "Attitudes of the American Federation of Labor toward Un-

skilled and Women Workers" (M.A. thesis, University of Chicago, 1921), p. 56.

60. Quoted in Davis, "The Women's Trade Union League," p. 5.

61. MDR, "Minutes of the 3rd Biennial Convention of the NWTUL," June 12–17, 1911, Boston, Mass., p. 403, reel 20, NWTUL Papers. Robins reported that Gompers "made a statement something like this."

62. For Scott's statement, see Boone, *Women's Trade Union Leagues*. For MDR's statement, see "Minutes of the 5th Biennial Convention of the NWTUL", June 7–12, 1915, New York, N.Y., p. 196, reel 21, NWTUL Papers.

63. MDR to MED, telegram, Apr. 16, 1924, box 29, MDR Papers.

64. MDR to Mrs. Willard [Dorothy] Straight, Feb. 22, 1918, reel 25, MDR Papers.

65. MDR to RR, Aug. 26, 1916, box 55, MDR Papers; MDR, in "Minutes of the 5th Biennial Convention of the NWTUL", June 7–12, 1915, New York, N.Y., p. 46, reel 21, NWTUL Papers; MDR to MED, Feb. 21, 1924, box 29, RR Papers.

66. Dye, *As Equals*, pp. 143–45.

67. On Chicago organizing, see MDR to RR, Mar. 11, 15, 19, 1915, box 8; MDR to RR, Aug. 29, 1916, box 11, RR Papers; MDR to MED, Sept. 3, 1918, reel 25; Olive Sullivan to MDR, Oct. 4, 1915, reel 23, MDR Papers; Nestor, *Woman's Labor Leader*, pp. 162, 240–49. On the national organizing, see Boone, *Women's Trade Union Leagues*, pp. 162–65; MDR to RR, Oct. 11, 1917, microfilm 567, no. 2, RR Papers.

68. MDR, presidential address to the Biennial Convention of the NWTUL, June 1917, reel 21, NWTUL Papers.

69. Letter from WTUL to Samuel Gompers, June 17, 1924, "Minutes of the 9th Biennial Convention of the NWTUL", June 16–21, New York, N.Y., pp. 113–14, reel 23, NWTUL Papers.

70. MDR to MED, June 9, 1910, reel 21; MDR to MED, Mar. 9, 1934, box 40, MDR Papers; see also Fannia Cohn in "Minutes of the 9th Biennial Convention of the NWTUL," June 16–21, 1924, New York, N.Y., p. 48, reel 23, NWTUL Papers.

71. Henry, *Trade Union Woman*, p. 36.

72. MDR to C. C. Catt, Nov. 14, 1917, box 24; RR to MED, Nov. 12, 1913, reel 23; MED to MDR, June 26, 1934, box 40, MDR Papers.

73. MDR to MED, Nov. 23, 1909, box 21, MDR Papers. In 1938, along with the Amalgamated and the ILGWU, the United Mine Workers were expelled from the AFL and formed the Congress of Industrial Organizations (CIO) (see Elisabeth Christman to MDR, Oct. 31, 1935, box 41, MDR Papers; and Josephson, *Hillman*, pp. 387–89, 426–27). For a general per-

spective, see James O. Morris, *Conflict within the AFL: A Study of Craft versus Industrial Unionism, 1901–1938* (Ithaca, N.Y.: Cornell University Press, 1958).

74. The AFL's statement of principles is quoted in Halfant, "Attitudes of the American Federation of Labor," p. 46. Gompers is quoted in Gerald N. Grob, *Workers and Utopia: A Study of Ideological Conflict in the American Labor Movement, 1865–1900* (Evanston, Ill.: Northwestern University Press, 1961), p. 141.

75. Rose Schneiderman, in "Minutes of the 9th Biennial Convention of the NWTUL," June 16–21, 1924, New York, N.Y., p. 79, reel 23, NWTUL Papers; on the AFL's proposal, see MDR to RR, Apr. 17, 1924, box 58, MDR Papers.

76. This perspective is shaped by Grob's *Workers and Utopia*; see also Norman J. Ware, *The Labor Movement in the United States, 1860–1895: A Study in Democracy* (New York: D. Appleton and Co., 1929). For a different emphasis on the Knights, see Leon Fink, *Workingmen's Democracy: The Knights of Labor and American Politics* (Urbana: University of Illinois Press, 1983).

77. Grob, *Workers and Utopia*, pp. 34–38, 98, 112, 133; Josephson, *Hillman*, p. 105.

78. See Susan Levine, "Labor's True Woman: Domesticity and Equal Rights in the Knights of Labor," *Journal of American History* 70 (Sept. 1983): 336.

79. On the characteristics of the Knights, see Grob, *Workers and Utopia*, especially chapters 3, 6, and 7. On women and "labor feminism" in the Knights, see Levine, "Labor's True Woman" and "Their Own Sphere: Women's Work, the Knights of Labor, and the Transformation of the Carpet Trade, 1870–1890" (Ph.D. diss., City University of New York, 1979). On feminist values and reforming society, see chapter 4 below.

80. On the Boston offer, see MDR, in "Minutes of the 9th Biennial Convention of the NWTUL", June 16–21, 1924, New York, N.Y., p. 81, reel 23, NWTUL Papers. On the Lawrence strike, Elizabeth G. Evans to MDR, Mar. 25, 1912, copy, reel 22; MED to MDR, Mar. 18, 1912, reel 12, MDR Papers; Sue Anislie Clark to MDR, appendix to "Minutes of Executive Board," Apr. 17–19, 1912, reel 8, NWTUL Papers; see William L. O'Neill, *Everyone Was Brave: A History of Feminism in America* (Chicago: University of Chicago Press, Quadrangle Books, 1969), pp. 159–60. On the New York League, see Irwin Yellowitz, *Labor and the Progressive Movement in New York State, 1897–1916* (Ithaca, N.Y.: Cornell University Press, 1965), pp. 65–66.

81. On the Clayton Act, see Samuel Gompers to MDR, Aug. 31, 1915,

reel 2, NWTUL Papers; MDR to Samuel Gompers, July 10, 1915, copy, reel 2, NWTUL Papers; Agnes Nestor to MDR, Apr. 29, 1924, reel 29, MDR Papers; Address of Samuel Gompers, "Minutes of the 5th Biennial Convention of the NWTUL," June 7–12, 1915, New York, N.Y., June 8, p. 122, NWTUL Papers. On the $500, see Kenneally, *Women and American Trade Unions*, p. 82; Frank Duffy to Samuel Gompers, Mar. 5, 1915, copy, reel 2, NWTUL Papers; MDR to MED, Mar. 19, 1915, reel 23, MDR Papers.

82. On attacking MDR, see MDR to MED, Sept. 22, 1917, reel 24; MDR to MED, May 18, 1922, reel 27, MDR Papers; "Statement by President Samuel Gompers, Executive Council Meeting," Cincinnati, Ohio, May 12, 1921, American Federation of Labor Papers, President's Office, Conference Archives Division, Wisconsin State Historical Society, Madison, Wisc. On Philadelphia, see "Executive Council Meeting", NWTUL, Jan. 14–15, 1923, reel 3, NWTUL Papers; on local support, see Gladys Boone, in "Minutes of the 9th Biennial Convention of the NWTUL," June 16–21, 1924, New York, N.Y., p. 101, reel 23, NWTUL Papers.

83. See Elisabeth Christman to MDR, May 18, 1938, box 44, MDR Papers. On alien spirits, see the statement on unions in *Life and Labor* 6 (Aug. 1911): 232. On MDR and the strike, see MED, *Robins*, pp. 71–72.

84. MDR to Mrs. William Cochran, Aug. 13, 1916, reel 24, MDR Papers.

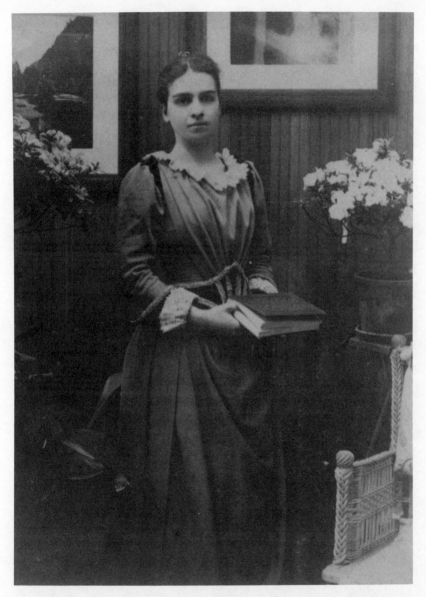

Robins characterized her early to mid twenties as "stormy and rebellious" years in which she searched for meaningful work. (Rare Books and Manuscript Library, University of Florida)

Mary Dreier and Margaret Dreier Robins saw themselves as lifelong partners in social reform, and Mary self-consciously modeled her career after that of her elder sister. (Rare Books and Manuscript Library, University of Florida)

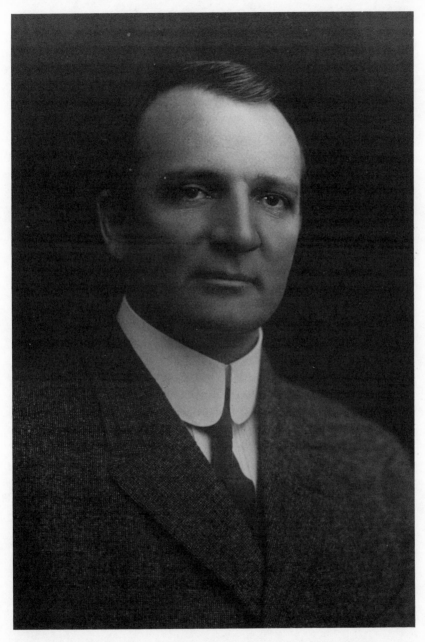

Margaret Dreier had decided not to marry, but at age 36, she met the social reformer Raymond Robins, a man five years her junior and both a lawyer and a minister. They married in 1905. (Rare Books and Manuscript Library, University of Florida)

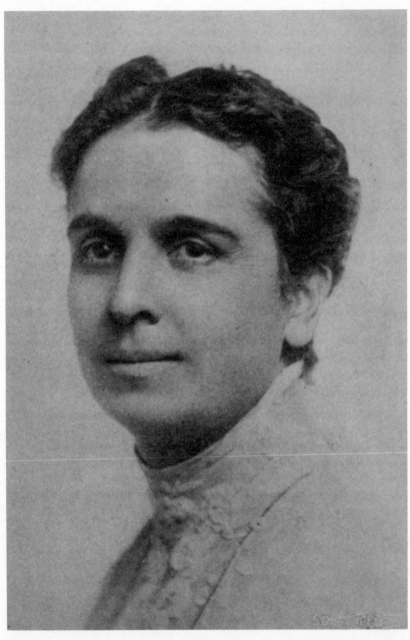

Margaret Dreier Robins, shown here in her late thirties after assuming the presidency of the Women's Trade Union League in 1907. (*Life and Labor*)

The first biennial convention of the WTUL met as an adjunct to the AFL in Norfolk, Virginia, in 1907. Shown from left to right are Hannah Hennessy, Ida Rauh, Mary Dreier, Mary Kenney O'Sullivan, Margaret D. Robins, Margie Jones, Agnes Nestor, and Helen Marot. (From Mary E. Dreier's *Margaret Dreier Robins,* 1950)

The League's emblem dramatized the message that American women would fight, if necessary, to prevent industry from sapping the "glory and strength" of motherhood. (Rare Books and Manuscript Library, University of Florida)

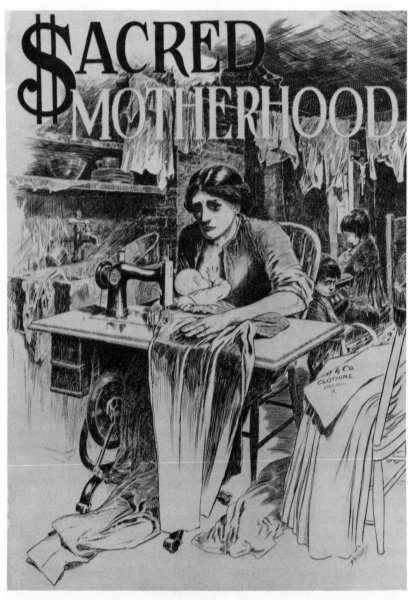

This 1907 lithograph hung in Robins's office during her tenure as president of the League and was also used as a postcard soliciting milk money for the infant children of strikers during the Chicago garment strike in 1910–1911. (Chicago Historical Society)

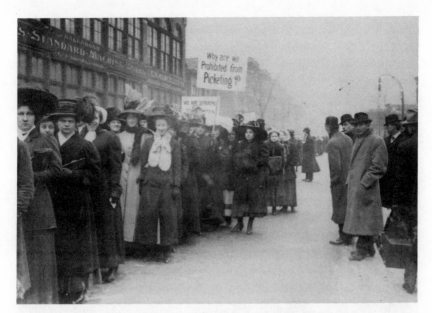

League women supported the right of women workers to picket, and often allies joined the picket lines with strikers. (Chicago Historical Society)

Josephine Casey and a fellow worker were jailed after a corset strike in Kalamazoo, Michigan, in 1912. (*Life and Labor*)

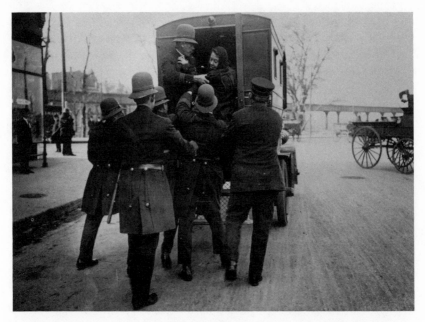

Women strikers were often arrested and transported in a "black Maria" to jail, where wealthy WTUL allies waited to offer money for bail. (Chicago Historical Society)

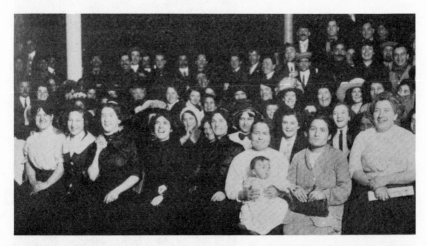

In order to combat demoralization and to promote a sense of solidarity, League members sponsored parties and other social activities during strikes. Here a group of laundry workers gathers during a strike in 1912. (*Life and Labor*)

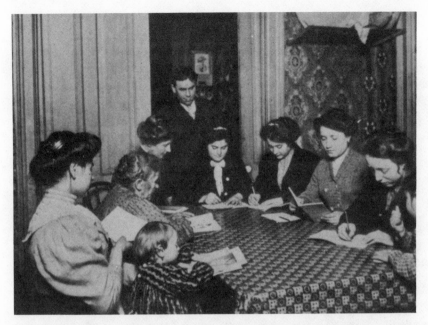

The League sponsored English classes in the homes of Italian workers, as mores often made it difficult for these women to attend meetings outside the home. (*Life and Labor*)

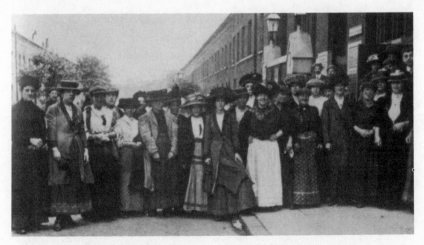

Jam workers organized by the League in 1912 wait outside their local union headquarters to be enrolled as union members. (*Life and Labor*)

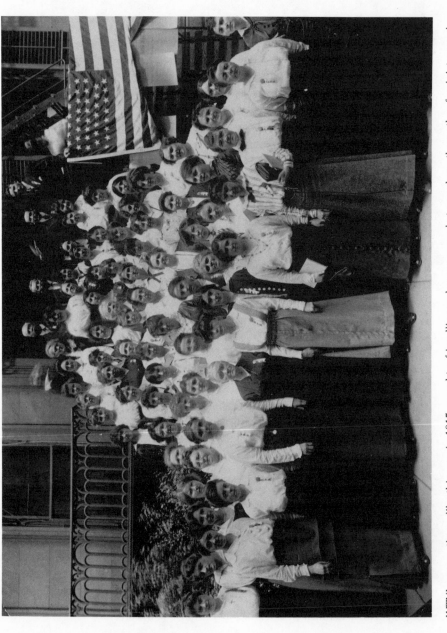

WTUL conventions, like this one in 1915, sought a friendlier and more casual atmosphere than other feminist organizations at the time. In the first row, starting second from left, are the following: Melinda Scott, Margaret Dreier Robins, Winifred O'Reilly, Leonora O'Reilly, Rose Schneiderman, and Agnes Nestor. (Chicago Historical Society)

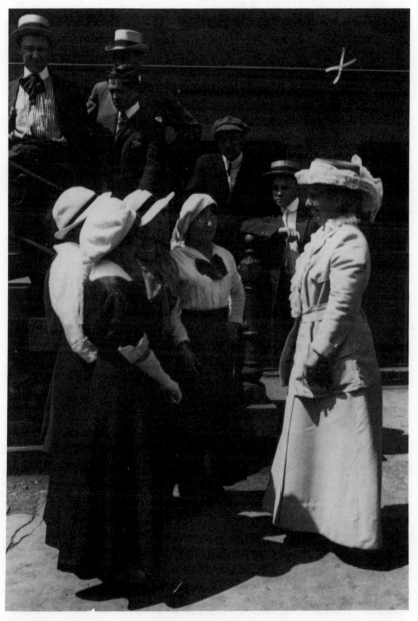

Robins enjoyed direct involvement with strike activity; here she discusses problems with garment strikers in 1915. (Chicago Historical Society)

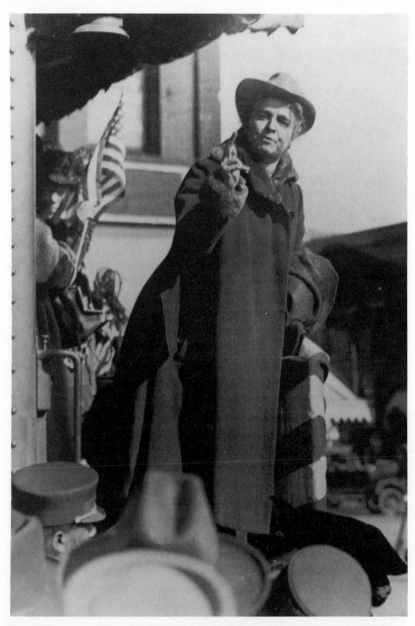

Robins was known for her effectiveness as a stump orator, such as when she argued for woman suffrage during the 1916 presidential campaign. (Rare Books and Manuscript Library, University of Florida)

The Robinses retired in 1924 to Brooksville, Florida, where they endeavored to turn this antebellum plantation, which they named Chinsegut, into a center for "better breed and seed" for poor farmers of the region. (Rare Books and Manuscript Library, University of Florida)

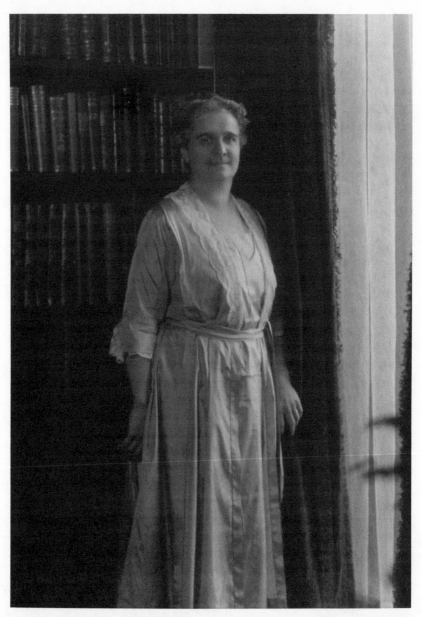

Robins, shown here in her seventies, spent her last years disillusioned with the new directions of American Reform. (Rare Books and Manuscript Library, University of Florida)

# 4

## "A Gift of Nature": Feminism and the Ideology of Motherhood

In June 1911, soon after the League's success in the "Uprising of the Twenty Thousand" in New York City and in the Hart, Schaffner and Marx struggle in Chicago, Robins presented the third national convention of the League with her most ambitious statement on the common purpose of unionism and feminism in American society:

> The nature of the attack of modern industrial despotism upon the integrity and promise of our individual and national life is such as makes a special call upon women of our country, and it seems to have been reserved for this generation to work out new standards of social justice and develop a new basis for our industrial civilization. Freedom, maternity, education and morality—all the blessed and abiding interests of childhood and home are at issue in this supreme struggle. All women who honor their sex and love their country should unite with us and our working sisters in the struggle for industrial freedom.

Robins went on to lament that "the glory and strength of motherhood" was being sapped by commercial values and industrial exploitation.[1] As the delegates to the convention listened to Robins, they could see above her a large reproduction of the League's emblem, which carried the same message: Minerva, the Roman goddess of wisdom and war, reached over the League's motto—"The Eight Hour Day, A Living Wage, To Guard the Home"—to clasp the hand of a young mother, babe in arms, standing before the smoke-

stacks of a factory. Along with the emblem of the League, Robins displayed in her office a framed copy of Luther Bradley's *$acred Motherhood,* a lithograph by the *Chicago Tribune* artist for the city's Industrial Exhibit in 1907. The sketch depicted a weary tenement mother at her sewing machine, bent to her work while cradling a nursing infant.[2] The emblem and lithograph expressed fundamental aims of the League. For Robins and her colleagues, matters of industrial and union organization were inseparable from considerations of motherhood, family welfare, and feminist solidarity; patriotism and civilization demanded the unity of women, who alone could speak and act for humanity. Robins shared the conviction of a friend that "one woman, it mattered not how born or how reared, would stand by another woman . . . to see fair play was achieved and a fair chance given to all."[3]

In part, Robins's stress upon feminist solidarity was a result of her recognition that the League was not without internal discord stemming from ethnicity, religion, class, regionalism, politics, and personality. Some lasting friendships, like those between Rose Schneiderman and Pauline Newman, both Russian Jews, and between Nestor and Maloney, who were Irish Catholics, grew out of shared ethnic experiences. So, too, the animosity between Schneiderman and Melinda Scott derived from ethnic resentment. The president of the League had her share of prejudices, for Robins despised the Catholic hierarchy, a view that made her consider some young Catholics unimaginative and victims of authoritarianism. On the other hand, she was enthusiastic about Jewish culture, which seemingly produced "eager Jewish girls" who made admirable reform workers. "Rose [Schneiderman]," she wrote to Raymond, "has more resources than either Mary A[nderson] or Elisabeth C[hristman] and that I presume is due to her Hebrew ancestry,— what gifts they have for the arts and beauty!" Members of the League generally viewed Jewish women as bright and aggressive, albeit contentious and unpredictable; Italians were seen as sociable but unintelligent. "American" women, that is, those of British and Protestant background, were considered initially indifferent but were solid and capable when committed to the cause. As Newman asserted, "It is hard to get American girls into the organi-

zation, but when you once get them, you have them, they are with you; they don't come in through one door and go out the other door as our Jewish girls do."[4]

In general, League women celebrated ethnic variety. They hired organizers and sought students from diverse ethnic backgrounds for their training school. They printed circulars in as many as eleven languages, and their assemblies were enlivened with folk songs from different countries. The extent to which the League accommodated the ethnic particularity of its members is evident in its attempts to organize Italian women, a notoriously difficult group to bring into unions. Since Italian women had not joined the shirtmakers' strike of 1909–10 in significant numbers, the New York WTUL put into action a plan that provided a dowry or "trousseau insurance" for Italian factory workers, many of whom had come to America to earn enough money to return home with a dowry. Leaders of the League hoped that providing the young woman with a dowry at the conclusion of her working years would cause her to identify more closely with her union experience. The League also adopted methods that were compatible with the domestic experience of married Italian workers. Thus Chicago League women set up meetings in neighborhood homes, to which the Italians agreed to come only after being guaranteed that men would not be in attendance. In addition, the meetings were arranged for early Saturday afternoon, thereby enabling the women to return home in time to prepare the family's meal.[5]

The very nature of women's work in industry led the League to embrace diversity, for ethnic women, unlike their male counterparts, never monopolized specific trades. Although Jewish women dominated the garment industry, others, especially Italians, worked alongside them. Irish women numbered heavily among bookbinders and glove workers but were not a majority in either trade. Italians only briefly dominated the flower-making craft. Faced with a transient female labor force, employers hired women with slight regard for their ethnic background. Thus when a wage-earning woman spoke of "the girls" in her factory, she usually meant a group of considerable ethnic variety. That variety posed difficulties for the League as it tried to accommodate different mores and tra-

ditions, as well as long-standing prejudices and resentments, to the cause of unionism. At the same time, ethnic variety in the workplace in part shaped the League itself inasmuch as reformers had to build an institution that would appeal to widely different groups, to bring together women "no matter how born or reared."

Within the national organization of the League, regional differences were more important than ethnicity in causing discord. From the beginning of the WTUL, the New York branch was suspicious of prospective members among allies and stressed commitment to the closed shop as a test of loyalty to trade unionism. The Chicago branch did not share this attitude, a clear reflection of the more hospitable environment that the Chicago League enjoyed. More than 80 percent of Chicago's working women made at least six dollars a week, which was the nation's average for women workers; yet only half of New York City's female work force received that much.[6] Furthermore, the Chicago League maintained exceptionally good relations with the Chicago Federation of Labor. According to Robins, "We in Chicago have the great advantage of receiving the very hearty co-operation of our leading labor men. . . . This co-operation is absolutely lacking to the eastern women workers."[7] Of course, as Robins was aware, that co-operation was in large part her own achievement. As Raymond's wife and as Fitzpatrick's close friend, Robins was ideally positioned to bring the WTUL and the CFL into harmony. Moreover, the Chicago Teachers' Federation, affiliated with both the WTUL and the CFL, helped strengthen the ties between the two organizations. Many teachers, including Margaret Haley and Fitzpatrick's wife, Catherine, were wives or daughters of union men. Unlike in New York City, in Chicago the teachers helped blur the line between labor concerns and progressive reform.[8]

The Chicago tradition of reform also set the Chicago League apart from other branches, especially in its policy of emphasizing union organization, education, and legislation simultaneously. Illinois women won the nation's first state factory inspection law in 1892 and the eight-hour day for women in 1893 (subsequently struck down by the Illinois Supreme Court), so they came to the League with enthusiasm for the reform possibilities of both legisla-

tion and union organization. The year that Robins moved to Chicago, women from that city were mainly responsible for convincing Theodore Roosevelt to include a call for an investigation into the conditions of women workers in his 1906 State of the Union address.[9] Unlike the New York League, which turned to legislation in 1913, the Chicago branch began its drive to reinstitute the eight-hour day in 1908, two years before its first major organizational drive. It continued important organizational battles into the 1920s, well after its significant legislative programs had been enacted. At all times, and due partly to the influence of Robins, the Chicago League attempted both to organize workers and to insure legislative protection for them. The resources of the League were limited, however, and allies and workers did not always agree upon Robins's policy of organizing workers and obtaining desired laws at the same time. As Robins said in 1909,

> Some members looked upon the purposes of the League as largely educational, feeling that the investigation of industrial conditions among women workers, looking to the securing of legislation, and the interpretation of trade unionists and allies to each other, constituted its most important functions. Other members felt that to organize women into trade unions, and to strengthen women's unions already in existence by developing leadership among the working women themselves, were more important; and that, although the two theories were not at all incompatible with each other, the resources of the League necessitated deciding upon one policy or the other at the present time.[10]

Robins believed that the two theories were in fact compatible with each other, indeed, that they necessitated each other, and that conviction, bolstered by Chicago reform traditions, sometimes put the Chicago League at odds with its sister branches.

Discord arising from ethnicity and regionalism was compounded by that based upon personality. Every woman with any responsibility in the League, as O'Reilly put it, wanted to "be something." When trying to explain the frequent disagreements between herself and Robins across the years, Newman rejected conventional notions of class, ethnicity, and ideology as the source of the

clashes; they were due instead to Robins being "a bossy, opinion-
ated woman accustomed to having her own way," Newman claimed,
adding: "So was I!"[11]

To have arrived at a position of leadership in the abrasive,
male-dominated world of trade unionism was an indication of an
exceptionally assertive female personality. It is not surprising,
therefore, that League reformers were notably combative and sen-
sitive. Robins spent considerable time easing hurt feelings, patch-
ing up disagreements, and having consoling conferences with
"Leonora, Melinda, Rose, Pauline Newman. . . . They don't know
the abc of working together."[12] The rancor at the biennial conven-
tion in 1922 astonished a new delegate, who rose to the floor to
complain of the "considerable gossip" and the "many slurring re-
marks" she had overheard among her sisters.[13] The very success
of League reformers occasionally stirred ill feelings. In 1914 the
federal government set a precedent when Woodrow Wilson, at
Robins's suggestion, appointed Agnes Nestor to the Commission
on National Aid to Vocation Education. State and federal govern-
ments thereafter sought to place "a working woman" on commis-
sions or agencies dealing with female wage earners, and they usu-
ally asked Robins for possible appointees. It was an important but
thankless task, for opinion within the League sharply differed as to
whether a particular individual was representative of the widely di-
verse women who belonged to the working class. "Of course, it
would be impossible," Mary Anderson wrote to Robins, "to have
Rose Schneiderman before a Congressional Committee. She does
not represent the American working woman." When Melinda Scott
was suggested as a nominee to the National War Labor Board in
1918, Schneiderman protested, "I am quite sure that it must seem
to all the labor people that there is no other women [sic] in the
labor movement capable to fill an important office but Miss Scott,
which, of course, is not true."[14]

To be sure, it was not true. The League's very diversity and in-
ternal discord, however, insured that there would be no consensus
on who best typified "the American working woman." Such a con-
sideration made the feminist ideology of the League all the more
important, for by emphasizing the common bond of womanhood
among League members, the divisive elements of ethnicity, reli-

gion, and personality could more easily be subsumed in the continuing work of reform. The feminism of the League, therefore, not only motivated the organization's drive for women's trade unions and for protective legislation; it also played a significant role within the League by uniting diverse women in a common cause and by providing an intellectual ground for the institutional rituals of the WTUL.

Like most feminists since the 1840s, Robins believed in both sexual equality and a gender-defined society. She demanded all the "rights of *personality*," such as suffrage, equal access to education, and entry to the "male" professions, and she applauded female achievement as vindication of the strength of womanhood. Nevertheless, she insisted on the necessity of essentially different realms for women and men.[15] Indeed, she not only accepted separate but equal spheres for the sexes, she actively celebrated and promoted them throughout her career. She did not see feminism as a rejection of domesticity, but rather as an extension of woman's role and power within the home into the larger society. In that regard, her own marriage, she thought, set an excellent example: "Can there be any better illustration," she wrote to Mary Dreier, "of the growing fellowship in marriage than the fact that even in . . . legislative work Raymond and I appear at the State Capitol on the same day—he to represent the . . . man's interest in . . . city government and I to fight for the right of the women workers to be protected by the law."[16]

Robins argued that women had identified so closely with the ideals and aspirations of the home that woman and home had become virtually synonymous. Since the American Revolution, she believed, women had sought to realize democracy through their training of the young: "They realized that here was *their* first great obligation—to fit themselves to fit their children for citizenship."[17] Robins's generation of female reformers identified the woman with that work that they saw as flowing from woman's nature as "life-giver" and "race-builder," terms used interchangeably with "woman." Of course, Robins recognized that not all women were meant to have babies, especially since she never bore the child that she so much desired. Yet for her and other feminists, moth-

erhood had never implied mere biological reproduction any more than the home had been understood only as a dwelling. Rather, behind the words "mother" and "home" stood a cultural nexus that defined women, their values, behavior, and emotions. Robins's conception of mother and home prescribed a range of feelings and behavior that women were to carry into the workplace, professions, and politics. Motherhood was thus both a metaphor for female nature and the context that defined female behavior and thought.

Motherhood involved the socialization of what Robins and League members saw as instinct and what they regarded as "a gift of nature." Particular women might not be biological reproducers, but as a sex women were nonetheless endowed with instincts that gave them not only the legitimizing authority but also the psychic capacity to organize and control crucial dimensions of social life. "Some of us who are not really truly mothers in the narrow sense," O'Reilly wrote to Robins, "express the mother instinct in the sense of social motherhood." Fannia Cohn agreed: "A woman is the mother; whether she has children or not her mission is to work for the good of the [human] race." Stella Franklin even defined feminists as those with an "inspired understanding" of that "mother-instinct" that rules in all women.[18] In other words, all feminists—indeed, all women—were mothers, for mothering women need not bear children.

Members of the League understood themselves as "mothering" the young trade unionists and college women involved in the labor movement, sometimes maternally referring to them as "my girls" or "little daughter."[19] Like their counterparts in social settlements and women's colleges, older women in the League received intense gratification from giving young women opportunities for self-development. "This is the spring time of your life," Cohn wrote to a young woman with whom she had established a close relationship. "I enjoy immensely watching you develop." Young women often responded in kind, as did O'Sullivan, who regarded Ellen Gates Starr of Hull House as "another mother."[20]

Women associated with the League used the language of motherhood to interpret their work. Emma Steghagen was described as "hatching a new branch" of the League in Galesburg

while working there with trade-union women, whereas a new branch in Philadelphia was referred to as the organization's "baby League." A delegate to the national convention in 1911 commented that when potential members come along, "the League tries to be a mother in every possible way to them." Schneiderman recalled "nursing little groups of milliners . . . who could not get any attention from the internationals. . . . Organization of a . . . group means fostering and nursing, getting them over the period when they cannot make any demands."[21] In fact, the League itself became a sort of surrogate parent when it "adopted" an orphaned Armenian baby and assumed financial responsibility for the child's care. When Myrtle Whitehead Miller, who had been trained in the League's school, died in her twenties, the League established a trust fund for her daughter, Catherine, and members maintained close contact with her throughout her adolescence.[22] Robins had an especially maternal relationship with Nestor and Christman, and when the Robinses retired to Florida, they virtually adopted Lisa von Borowsky, the young woman who worked as their secretary and became their principal heir.[23] Significantly, when League women adopted babies, they always chose girls, no doubt feeling like Katherine Dreier, who wrote to Robins that she aspired to "adopt a little girl, whom I hope to help to grow into a fine young woman."[24]

Robins and her associates encouraged women to "mother" the world by entering the arena of the larger society through suffrage, politics, and the professions. Louise deKoven Bowen insisted that society needed female police in order "to 'mother' the girls in all public places," and McDowell believed that a woman would "bring to industry and politics . . . mothering qualities" and thereby "humanize the life about her."[25] McDowell pointed to Sara Ann Lees, mayor of Oldham, England, as an example of what women could accomplish with political power. She saw in the English town a "personality mothering its life" and contrasted a grimy slum—"Oldham before it was Mothered"—with a garden suburb, "Oldham after it was Mothered."[26] Similarly, Frances Perkins, who worked with Mary Dreier on industrial problems and went on to become Franklin Roosevelt's secretary of labor, felt that the key to reformers' success with politicians was "to associate them with

motherhood." After winning a crucial piece of legislation, Perkins thought to herself, "That is the way to get things done. So behave, so dress and so comport yourself that you remind . . . [male politicians] subconsciously of their mothers."[27]

Raymond teased his wife that although she had been born a daughter of privilege, she had become "the mother of her people." Congratulating her on the League's success, he reminded her that the WTUL was like a child that she had raised from infancy into maturity and power. In all her work as a reformer, he thought, "the spirit of the 'Mother of Her people'" characterized her relationship with others.[28] In a similar vein, Anne Hard, a journalist who had known Robins in her early days, recalled the last time she had seen her old friend: "She seemed to me as beautiful as ever . . . white hair and those great dark eyes—what a woman! Too bad she never had any children and yet she had that Great Mother quality which Jane Addams had!"[29]

For Robins, woman's sphere encircled the social, incorporating those merits that unified a society fragmented by the dominance of male values. "I take it," she argued, "that our brothers represent the individual; that we [represent] constructive movement . . . it is for the men to lead forward in the individual development and for us women to make universal." To universalize and share constituted the core of women's endeavor because it promoted the democratic ideal. Man forged ahead but disrupted the social fabric by his heedless "individualistic" strivings; woman "followed along and patched together what men tore asunder." Woman in society, like the nurse on the battlefield, stood for an "ideal of intercourse between man and man. . . . She practically places herself at the mercy of those to whom she ministers, with the simple faith that the trust she gives must be reciprocated." By embodying sacrifice, woman could thereby evoke trust and create a sense of the public in an otherwise atomized society. Henrotin agreed with Robins that women exemplified social cohesion, inasmuch as by living "so near the elements of life—food, clothes, home, children," women sensed the "solidarity of all those elemental interests that touch us all so closely."[30]

In contrast to Charlotte Perkins Gilman, often seen as representative of Progressive feminist thought, Robins believed that

women rather than men embodied wholeness, for through sharing, sacrificing and living close to those "elementals," women stayed in contact with a fuller range of human experience.[31] Although Robins recognized that men dominated the political arena, her conception of motherhood implied that women more fully embodied the public because they alone understood the social consequences of private acts. Necessary as were the achievements of men, the male character was essentially divisive, atomistic, grasping, short-sighted, and narcissistic. Women complemented men inasmuch as the female character was social, generous, nurturing, healing, and elemental. According to Robins, nature had assigned to women, "the builders of the race," the task of protecting life, and only women could take "the record of misery, shame and degradation" compiled by men and transform it into something vital and creative.[32]

For Robins, the crucial challenge of her generation of women was to overcome what she called that "isolated social ethic" that had reduced women's concerns to their individual homes and off-spring. Mothering, she believed, must be extended outside the home; society must be infused with female values. The pernicious effects of male values were most starkly seen in the workplace, whether in factories or tenement shops. For some time, of course, male workers had been subject to the exploitation of the industrial world. The late nineteenth century, however, had seen women in-creasingly drawn into the same brutal round, with predictable damage to themselves, their homes, and their families. As Robins saw it, the task of the League was to secure protection for women workers, through unions and by law, so that female nature could have the benefit and nurturing influence for which it was intrin-sically intended. If female nature was not protected, if maternal values were destroyed by "industrial despotism," then the "prom-ise of our individual and national life" was in peril.

The League represented an institutionalized expression of "socialized" motherhood, an organized concern for women whose female nature seemed threatened and for youngsters whose child-hood appeared vulnerable. Although the major thrust of the League's organizational life grew out of concern for young, unmar-ried women, an important emphasis was always the working

mother—as, indeed, the emblem of the League indicated. Mothers often worked sixteen hours a day in their homes, sewing garments, shelling nuts, making artificial flowers or knitting baby clothes. The wages were appallingly low—flower makers earned about four cents an hour—and tenement work often involved substantial child labor. Robins sought the abolition of "sweated labor" from the home, and at least she convinced the secretary of war in 1918 to forbid the manufacture of army clothing in tenement homes.[33]

In Robins's eyes, industry had robbed women of work traditionally associated with the home only to have such labor reenter the household under conditions that were "home-destroying." League women saw homework as destructive because it deprived the child of play, disrupted the mother-child relationship and sapped the energy of both mother and child. Robins wrote to Norman Hapgood, the muckraking journalist, that "America will not stand for this break down of the home if she but knows the facts." As the Chicago League told the Illinois Industrial Commission, the facts were "long hours, insanitary conditions, neglected children, destroyed homes, and the spreading of contagious diseases, and a pittance for pay."[34] Such conditions, it was argued, constituted unnatural intrusions into the family life of the worker. It was therefore the responsibility of women through the League and similar institutions to force such work back into the factory, its "right and normal habitation," where laborers could be organized.[35] According to Robins, the home should not be invaded by oppressive working conditions; rather, the head of the household should be given a living wage, making demeaning and poorly paid labor unnecessary and illegal.

The original "equal pay for equal work" campaign stemmed from concern to protect the worker's home and family life from underbidding women. The League feared that men's wages would fall as a result of women entering the marketplace. O'Reilly put the issue bluntly: "We have got to have the wages equaled in order that the man you marry will have enough money to support you."[36] Of course, League members believed in the necessity of paying both sexes equally; it was to them a matter of individual right as well as a social good. Their strongest argument for equal pay, however, centered on the need to protect the financial integrity of the worker's

home and the man's income. Robins constantly reminded her female constituency, mainly young and unmarried, that if women underbid men in the workplace, they would jeopardize their future home and potential motherhood. She argued that a woman by underbidding became "her own worst competitor," a threat to her own home and future as wife and mother. She was convinced that the young woman must learn to play her role as a breadwinner within the larger context of her future responsibilities as a homemaker and mother; hence, she should demand equal pay and join her brother in the trade-union movement.[37] O'Sullivan maintained that "women have no right to enter industries in which men are employed and lower the standard of wages; they must enter on an economic and physical equality. The welfare of the home and future depends on wages." If the working woman did not demand equal pay, according to Robins, she would unwittingly aid "in making her husband an industrial slave, thus losing for herself his fellowship, for her children the companionship of a father, and for the community the services of a citizen."[38] O'Sullivan, a widow with three children to support, reserved her special wrath for those married women who undercut the family because they could afford to offer their labor cheaper than could those with responsibilities for children: "Many of these . . . women have married with the intention of not having children; they are not only an economic disgrace, but an immoral influence whose very presence and words poison the air of a work room."[39]

League women strongly supported the campaign for the minimum wage in order to protect the man's income, as well as to provide economically desperate young women an alternative to bad marriages or prostitution. While serving as the sole female member of the New York State Factory Investigating Commission, Mary Dreier ultimately convinced the other commissioners, including Alfred Smith, Robert Wagner, and Samuel Gompers, to recommend a state-wide minimum wage to the New York legislature. Yet she had encountered vigorous opposition from her fellow commissioners.[40] Since European laws in the late eighteenth and early nineteenth centuries actually suppressed the laborer's income, trade unionists in the United States remained suspicious of a wage level sponsored by the state. They feared that as in Europe, the

minimum wage would become the standard for most workers. As early as 1909, however, Robins called for the establishment of a minimum wage, a proposal that resulted in considerable rancor within the League. The Chicago branch immediately endorsed the plan while the New York League resisted it, arguing with Gompers that a minimum wage might well become the norm and hence decrease the worker's income. Robins countered that because skill no longer served as a criterion for wages, any industry unwilling or unable to pay workers a "living wage" was parasitic. She became increasingly interested in the relationship between wages and family life and cited a study of a Connecticut town that showed that infant mortality increased as fathers' wages decreased.[41]

Robins also believed that the minimum wage was necessary to prevent adolescent girls from entering an unsuitable marriage or from taking "the long chance," a contemporary euphemism for entering prostitution.[42] American feminists had always insisted that women held the key to the family's (and therefore America's) future because they could refuse irresponsible men the "joy" of fatherhood. Create satisfying working conditions and pay women a living wage, Robins contended, and they would not choose marriages of convenience out of weariness and self-defeat. Moreover, a properly remunerative wage for a young woman would not only provide her with the necessities of life but would open to her "all the possibilities of the joy of her motherhood" and allow for the "conditions making for the education and development of all the fine power hidden and held within her." As the wife of an immigrant worker more prosaically put it, "It isn't so much what you buy, as how you feel. . . . You got more self-respect and you hold your head higher. . . . It's like yeast; it just raises you right up through and through." In Alice Henry's words, a secure income encouraged women workers "to develop who knows what capacities, what unguessed-of powers."[43]

The campaign for the minimum wage was for the purpose of protecting motherhood and the family. So too was Robins's program to insure the health of working women, which elaborated on themes of the nineteenth-century health reform movement.[44] She believed that "conditions which undermine physical strength are likely to undermine spiritual vitality." Fitness meant the opposite of that "exhausted vitality" that accompanied long hours, low pay,

insanitary conditions, and fatigue. "With acute knowledge of human nature," Robins argued, "the manufacturer who wishes to exploit understands that if he can but exhaust the energy [of the worker] . . . there is no vitality left for protest to seek . . . a fuller life." As she understood it, the task of organized labor was to establish "conditions of life which fit the race mother for her task."[45] In the service of that ideal, the League helped introduce into the Illinois state legislature a bill providing for the eight-hour day for women—and Robins insisted that it be written as a health measure. She relied on the argument of attorneys Louis Brandeis and Josephine Goldmark before the U.S. Supreme Court that "as healthy mothers are essential to vigorous offspring, the physical well-being of woman becomes an object of public interest and care in order to preserve the strength and vigor of the race"; woman's physical structure and the "proper discharge of her maternal functions" justified legislation that protected her.[46] In the end, the League compromised on a bill for a ten-hour workday, legislation that was upheld by the Illinois Supreme Court in part because Robins hired Brandeis and Goldmark to present their arguments to the judges.

Robins endorsed the abolition of night work for women with small children, again using reasons of health and family. As head of the Department of Women and Children in Industry, Illinois Division, during World War I, she secured a ruling that prohibited women with preschool children from working at night. She argued that night work had the effect of driving women to exhaustion, especially when they tried to carry out their domestic responsibilities as well. Furthermore, night work kept spouses apart and was detrimental to proper child care. As Anderson said, "No mother who is perpetually weary can hope to bring the clear brain and patient wisdom to bear upon childish problems that every child needs if he is to grow into the kind of young citizen this country wants to have."[47] Nestor felt that she was living proof of her proposition that industry was "sapping the vitality of the woman worker and producing a race of anemic women" inasmuch as she was driven to place herself under the care of a "nervous specialist" as a result of her nine years of labor at piecework.[48]

Indeed, a "breakdown in health" was not uncommon even among the League's allies and trade-union reformers. Robins, Mary Dreier, Swartz, Cohn, and Nestor all experienced such a failing at

one time or another. While visiting Mary's home in 1908, Raymond was so struck by the nervous exhaustion among his sister-in-law's colleagues that he wrote to his wife, "It is deadly, this trying to do work with half-dead people and nervous wrecks for helpers. Mary should determine which she wants to do, run a hospital or a Women's Trade Union League—and then do that one thing."[49] Students who came to the League's training school were frequently "not in the pink of physical condition," and needed some surgery that had been repeatedly postponed. Robins's experience with working women and with her associates in the League convinced her that extensive contact with industrial labor generally led to women developing physical or emotional illness.[50]

Preoccupation with health was not new, but League women focused on neurasthenia in the industrial women. They observed a pattern that kept women "tensed to continual hurry."[51] Pacemaking in the garment and affiliated industries was a particular concern, as was Frederick Taylor's time-motion approach. The work of telephone operators aroused especially strong criticism, for operators typically handled 250 calls an hour, with each demanding six different motions, a pace that workers were convinced meant a risk to health. As evidence, the League's journal quoted a physician: "After these girls have gone on for four or five years and get married or for other purposes leave, they turn out badly in their future domestic relations. They break down nervously and have nervous children, and it is a loss to the community."[52] As always, the concern of the League was not merely for the poor health of women workers, however deeply Robins and her colleagues sympathized with their plight. Rather, League reformers were concerned with the effect of debilitating conditions upon motherhood and the family, those institutions that molded democratic culture.

The "dangerous trades" posed problems for women workers that could more easily be dealt with by protective legislation than could the problems of wages, work hours, and nervous disability. League member Alice Hamilton, the first woman on Harvard's medical faculty, supported Robins's contention that women should be prohibited from working in lead industries: "Lead is . . . a race poison. . . . In the case of the man a poison can act only on the germ cell, but in the case of the woman the toxic action can con-

tinue throughout nine months of pregnancy."[53] Robins favored ex-
cluding women from jobs involving heavy lifting, impressed by the
testimony of laundry workers such as Maggie Hinchey, who found
it devastating to see a woman "about to become a mother standing
at a machine holding 80 pounds of steam, 16 or 17 hours a day, day
in, day out, up to the hour of maternity, and four days later to see
her laid out in a casket with her baby by her side."[54]

While protective legislation expressed the regulatory aspects
of Robins's campaign, behind these public prohibitions lay a thor-
oughgoing plan for promoting the health of women workers. From
Mary Wollstonecraft and Angelina Grimké to Frances Willard and
Charlotte Perkins Gilman, physical exercise as a means of building
female morale and vitality had been a feminist emphasis, one that
Robins appropriated as a League goal. Physical culture classes
consequently became an important aspect of the League's pro-
grams and its training school. Robins encouraged working women
to swim in Lake Michigan every summer morning and she asked
University of Chicago instructors to coach women's athletics for
the League. Her most ambitious efforts on behalf of the health of
working women centered on the health committee organized in
1910 by the Chicago WTUL. Designed under Robins's direction, the
work of the committee resulted in the first comprehensive health
plan sponsored by a labor organization in the United States. In
1917, Robins went on to endorse a national health insurance pro-
gram that included incentives for preventing disease as well as ma-
ternity benefits for working mothers.[55] The health committee con-
centrated on preventive medicine, not simply on treatment during
emergencies and illnesses. Working women affiliated with the
League were entitled to two physical examinations a year in ex-
change for a nominal fee, as well as to lectures by physicians on
health-related topics. By 1912 the health committee had a staff of
six physicians, most of whom were League members, treating the
client so as to do "the thing that needs to be done to bring her back
to normal womanhood—not only that she may support herself and
her family, as she often must, but that she may have a fighting
chance for immortality in her children."[56]

Proper nutrition also had a place in Robins's concern for the
health of working women. She had begun her reform career by su-

pervising the diets of patients at Brooklyn Hospital, and as president of the League she called upon that experience when she promoted lectures on nutrition in the branches of her organization. During the Hart, Schaffner and Marx strike, while organizing the distribution of mammoth amounts of bread, eggs, and bacon to over 11,000 families, Robins also lectured workers on the nutritive value of foods like beans and oatmeal. In addition, the League provided milk to the 5,000 babies of strikers, the money for which had been raised through mailings of postcards with Bradley's *$acred Motherhood* on the back.[57]

Placing strong emphasis on health education, the Chicago League presented lectures on such topics as exercise, eugenics, neurasthenia, prenatal care, and sex hygiene. Commenting on a similar program in New York City, O'Reilly said that the lectures gave working women confidence that "they would have control over" their bodies and their well-being. The programs, League women agreed, empowered women, "not only for their own sakes but also for the sake of the race."[58] The issue of birth control was central to the question of female power and confidence. But because it was a forbidden topic, the League did not confront the issue in a public forum until 1915, the year that Margaret Sanger, a pioneer in the field, was forced to flee from New York to London.[59] In 1922, the League took the position that birth control information should be made available to all citizens as a democratic right. Working women in Chicago, however, were already being given "the secret" (as contraception was called) through the League's health committee. Dr. Rachelle Yarros, a physician Robins recruited for the committee and a proponent of sex research, worked closely with the birth control movement in Illinois. Yarros persuaded the Chicago Woman's Club in 1915 to organize a birth control committee, which soon became the Illinois Birth Control League; in 1923, she opened the nation's second birth control clinic—Sanger's had been the first—in a Chicago neighborhood.[60]

The outrageous spectacle of child labor naturally brought together the League's various concerns about the workplace, health, and motherhood. For Robins, child labor was spiritually deforming as well as physically debilitating. Introducing children to laborious routine deprived them of variety and play, thereby creating passive,

submissive adults whose imagination and anger could be stirred only with difficulty. In the bitter winter of 1911, Robins distributed leaflets to children on their way to work in Chicago's restaurants, thinking that they looked like "so many little rabbits [scurrying] to their burrows."[61] Reformers agreed that one rarely found vigorous bodies or animated faces among children who labored in America's streets, shops, and factories. "Her rebellion is gone," a League member lamented about a factory child: "She has been conquered in body and spirit by the great, grinding machine which stitch by stitch is crushing out of her all normal childhood and girlhood and motherhood." According to a League writer, play is "the child's chief aim, as it is one of her chief needs."[62] Robins believed that workers were submissive and dependent in part because they had been deprived of playtime as children. She felt that her generation of reforming women should secure the playtime of America's children by banning them from the workplace through obtaining new legislation and by working for enforcement of existing laws.

In their fascination with the phenomenon of play, Progressives designated the years before them as "the century of the child." In comparing her own parents, who gave her a play-filled childhood, with those of her contemporaries, Robins concluded that the stultified adults that she saw had "never play[ed] themselves." Raymond, who was active in establishing playgrounds, received a plea to solicit "your friend Theodore Roosevelt . . . to tell the story of his own play life" as a means of interesting Americans in recreation and health.[63] In the absence of such exalted testimony, however, women of the League often composed lengthy odes on the lost childhood and stolen playtime of the young, works in which fervor and mawkishness fought themselves to a standstill: "But soon the foreman found her—he was big and she small; / And when he took her doll away she could not cry at all."[64]

Still, such poems were eloquent testimony to the deeply held view that a successful adulthood was but the elongated shadow of a playful childhood, that a mother could not realize her full maternal instinct without a sense of freedom and possibility. Play confirmed Robins's perception of the world as an open realm characterized by variety and plentitude. In her perspective, an individual's life was ideally undefined, an "adventure" shaped as much by

chance and will as by habit and impersonal force. She wanted her followers in the League to achieve responsible maturity by recapturing something of their childhood, just as she herself had done in her mid-thirties.

Clearly, the idea of motherhood had significant implications for members of the League. The League's concern for working women as mothers and as potential mothers, as well as its ambition for permeating society with the ideals of motherhood, motivated Robins and other feminists to organize women into trade unions, to lobby for the minimum wage and maximum hours, to oppose the use of women in dangerous and debilitating work, and to promote preventive medicine, physical exercise, proper nutrition, and sex education. The same concern and ambition made it imperative to them that work be taken out of the home, that the child be removed from the workplace, and that a spirit of play be infused in young workers. Sacred motherhood was being profaned by the industrial system, and League women were aware that only far-reaching changes in society could accommodate the full implications of their idea of maternity. In a speech to the League in 1911, Robins called for a crusade in the name of womanhood, a "supreme struggle" for childhood and the home. She was reminding her listeners that the goddess who presided over the League was not only wise but warlike as well.

As a consequence of the collective bent of League members, the commitment to an ideology of motherhood, and the guidance of Robins, the WTUL had a pronounced domestic aspect, a warmth and conviviality that drew together women in its ranks. Parties, picnics, games, and sports were an integral part of life in the League, an expression of its ethos, not a trivial way of finding relief from the hard pursuits of picketing and recruiting. Moreover, the success of the League in overcoming the diversity within its ranks was in part due to Robins's self-conscious use of institutional rituals as bonding mechanisms. What Robins called "happy times" offered alternative perceptions to young women who, as a League writer put it, had "been forced all too early into an experience of the hard practical side of life." In a format letter of 1908, the League advised potential leaders of new branches that "meeting often takes the form

of a party with talks. We help the new girls that way to realize their own value and strength and elevation that comes through union."[65] Robins assiduously set a tone in the League in which work and sociability reinforced each other, in which entertainment and administration naturally merged, and in which the business of unionism was indistinguishable from the practice of fellowship. It was such a tone that enabled League women in 1912 to debate alternative strategies during the Lawrence, Massachusetts, garment strike and then move on during the same session of the executive board to discuss whether the WTUL's official flower should be a carnation or an aster—the sort of subject, the women were aware, that men's trade unions had yet to confront.[66]

Robins constantly emphasized "happy times" and sought to identify union activism with sociability and camaraderie. She knew that young women who participated in trade unions usually paid a heavy price. Inasmuch as union activity, especially strikes, disrupted relationships within the workplace, activists were often subject to ridicule and ostracism from sister workers. In addition, many young women were seen to be violating family honor by joining a walkout, and, as Nestor recalled, unionists in the Philadelphia garment strike of 1909–10 were "known in their own neighborhoods disdainfully as 'Strikers.'" Mary Dreier said that during the "Uprising" in New York City, "It was a hard and sad thing for the mothers of some of these young girls as they thought of arrests as a terrible disgrace and we had to plan all sorts of honors and appreciation for the girls to lessen the blows."[67]

The conviviality of the League, as well as "honors and appreciation," were not only for the young, however. They were important for all members active in the League, for they expressed a female culture that refused to be limited to the quotidian world. Recalling a placard at a strike proclaiming the need for both "Bread and Roses," Stella Franklin insisted that workers must "not only eat the bread of existence but also enjoy the roses of life." Social activities, then, not only "took every one away out of this workaday world, into the realm of mystery and romance and play and make-believe," they also expressed a quest for fellowship among the women of the League.[68] Both allies and trade unionists sought what they called a "larger life" that encompassed female camaraderie

and self-development. David Dubinsky, president of the ILGWU, readily acknowledged that a union "could not hold working women just by a dollar more in their pocket and a short work day. You had to give them something more."[69]

For the women of the League, that "something more" was the institutional ritual that united and sustained them. Among New England women in the previous century, female rites such as gift giving, parties, and social visiting were important bonding mechanisms, intensifying women's identification with one another and thereby creating a specifically female cultural world.[70] Unlike members of the League, those women came from a homogeneous background and were not engaged in public careers or reform activities. Nevertheless, the women of the WTUL also created their own cultural world. Underlying the public side of their lives and their organization, their network of personal relationships and the fabric of their communal life combined to give them support and confidence in the broader society. Female rites such as birthday and anniversary parties, open houses, housewarmings, choral gatherings, strike celebrations, pageants, and festivals provided League women with convivial contact across class, religious, and ethnic barriers. Female friendship was important in the lives of nineteenth-century middle-class women, and allies brought into the League the romantic sensibility characteristic of middle-class female culture since the 1830s. Female friendship, what Margaret Fuller defined as "the same love that we shall feel when we are angels," created a special realm, seemingly lit by a sacred glow, evocative, liberating, and highly charged. Working women reflected the same attitudes, as when female workers in Lowell, Massachusetts, organized their free time with one another in gender-defined activities, such as reading, sewing, and shopping.[71] The distinct sphere of female sensibility was noted in Abraham Cahan's 1917 novel, *The Rise of David Levinsky*, when his hero wandered the garment district of New York's Lower East Side: "When I see the crowds returning from work in the cloak-and-waist district I often pause to watch the groups of girls as they walk apart from the men. Their keeping together, as if they formed a separate world full of its own interests and secrets, makes a peculiar appeal to me."[72]

In addition to offering opportunities for friendship and sociability, the League's gatherings gave emotional sustenance to

women who often found their working environment enervating and brutalizing. Looking at it cynically, one may conclude that the League's pageants and parties merely made the monotony and fatigue of factory work endurable, providing a sugary coating to bitter lives, easing the exploitation to which young women were subject. As Robins saw them, however, social activities stimulated the emotions, prompting creativity and, hence, evoking novel self-perceptions; a "larger life" expanded one's sense of the self and brought forward "unguessed-of powers." At times the League's female rites led to "an awakening," the libidinally loaded phrase that Robins used to describe a young woman's budding interest in the labor movement. The Chicago WTUL sponsored Sunday afternoon poetry readings, for through such occasions, Robins believed, the young worker became aware that she had her own story to impart, her own poetry to share. "And so," Robins later recalled, "one of the first demands in the old days when we were simply reading poetry was for classes in public speaking."[73] She thought that communally reading poetry inspired women to develop skills, such as mastering grammar, elocution, and parliamentary law, that would make them more effective and forceful in the wider world.

Other contemporary feminist organizations, such as the National American Woman Suffrage Association and the General Federation of Women's Clubs, were marked by the strict formality of their meetings. In the assemblies of the League, however, Robins encouraged the abandonment of parliamentary procedure for the sake of informal and friendly discussion, even though she stressed that young women should master the rules of order. At the League's convention in 1915, one delegate observed that although the League had "grown in surety and strength to somewhat the proportions of a women's labor parliament," the assembly still seemed more like a "jolly family gathering." In tone and atmosphere the conventions of the League were akin to intimate occasions at Robins's home, to large banquets, and to victory celebrations after a strike. "I like to remember your parties at 1437 [West Ohio Street]," Nestor wrote to Robins. "They were great events in our lives and what a feast you would spread for us and then the talkfest that would follow."[74]

Events in the cycle of life, such as birthdays and anniversaries, were a focus of special attention. Important milestones in the history of the League were also celebrated, as when the Philadelphia

branch marked its own foundation with a "happy Birthday supper of the League family, when 60 members sang songs, told tales, and predicted great things for the future."[75] Often women composed songs, poems, and plays on the occasion of birthdays, dramatizing events from the life of the colleague who was being singled out. Birthdays evoked a sense of communality—after all, everyone had one—while also momentarily elevating an individual who was made to feel a special part of the group.[76]

Social gatherings and celebrations clearly were not merely preliminary to serious work, nor were they peripheral to the League's identity as a group. Male unionists, however, generally saw them as a waste of time, feminine frivolities that were incidental to the real business of unions. Most League members rejected male unionists' criticisms that they were ineffectual, and they opposed the move by Gompers in 1924 to bring the WTUL under the auspices of a women's department in the AFL. In writing to Robins, Nestor described a party held by the League and wished that Gompers could have attended, since it was exactly the kind of activity that male unionists had warned the League not to sponsor: "We had 111 at the dinner and fully one hundred were trade union women and most of the program was singing. . . . We had so much singing that it was really everybody's party. It was a great success. I tried to picture the men getting it up or arranging it."[77] Leaders of the AFL were apparently oblivious to the feeling of communality evoked by such female rites as parties and songfests, even though men had similar experiences in saloon fellowship and rites of apprenticeship.

League women also frequently vacationed together. Middle-class Americans had begun taking vacations in the 1850s, but low wages and long work weeks made vacations prohibitive for most factory workers. Few of the working women associated with the League took vacations before joining the organization. Anderson was thirty-nine years old before she had her first vacation, a trip to Colorado, financed by an ally, with Nestor.[78] Middle-class women often sponsored vacations for specific working women, but the League's drive to provide vacation time for workers grew as much from the aspirations of female wage earners as from any desire by the allies to impose their own values upon others. Anna Rudnitsky,

a Jewish immigrant working as a seamstress, bemoaned her long hours for low wages: "I see the pictures of the trees and the great rivers and the mountains, and away back in Russia I was told about Niagara Falls. Now why if I work all day and do good work, why is there never a chance for me to see these wonders?"[79]

As a response to such frustrations, the Chicago League set up a retreat center, one of the first of its kind, near the city to provide an inexpensive vacation spot for working women of the League. Fannia Cohn later founded Unity House, a cooperative vacation retreat in the Pocono Mountains for ILGWU workers.[80] That League women often chose to vacation together, indeed established centers for that purpose, attests to the significance they attributed to their convivial, extra-curricular activities. After Robins retired to Brooksville, Florida, her home became a favorite vacation destination for old League associates, as did Mary Dreier's Maine summer home.

Whether on vacation or at home in the city, drama held a special attraction for Robins and WTUL members. Robins's belief that the labor movement should "express itself through pageants," led her to encourage colleagues to read and act plays, as well as to write plays and pageants themselves. She frequently used the metaphors of "the festival of life" and "the pageant of life" to describe the richness and diversity that she felt lay beyond the horizon of most working women but could nevertheless be tapped by means of drama. Calling upon her childhood experiences as a drama director, Robins enjoyed "the something which happens to each of us when for the moment we are caught up in a spirit of exaltation."[81] Under her guidance, the League's plays and pageants often dealt with themes drawn from the history of women or labor. Their purpose, however, was less to inform than to elicit creativity. By writing, staging, and acting, Robins trusted that women would discover their own hidden potential for transcending the ordinary. Usually didactic and naive, League dramas celebrated the powers and capacities of womanhood, allowing women to play roles not otherwise encountered or encouraged. Furthermore, the plays and pageants were bonding mechanisms, events that Robins felt approximated a "community festival." When Nestor responded to Robins's description of a League event, she agreed that "it just

proves how much of a community spirit can be aroused with a pageant."[82]

Some working women criticized the social and leisure-time activities of the League as stemming from the charitable concerns of middle-class allies, while later critics have seen them as deflecting precious energy from the serious tasks of economic reform.[83] Such criticisms, however, would not have rung true to most League members. For the majority of women in the WTUL, whether allies or trade unionists, there would have been little energy or optimism in tackling economic reform without the intimate, ritualized social contact that they experienced with one another. Of course, there was no clear connection between communal poetry readings and organizing a new union or between choral singing and recruiting in tenement shops. The relationship between League sociability and reform efforts was more subtle and circuitous than that. League meetings that deliberately took the form of "a party with talks," pageants about heroic women, birthday celebrations for Jane Addams, and honors bestowed upon an arrested striker obviously did not accomplish specific economic ends. Yet they were crucially important in sustaining individual motivation and in creating group solidarity. With all the disadvantages suffered by unskilled working women, and with all the barriers to fellowship thrown up by diverse and even antagonistic backgrounds, the institutional rituals of the League were critical in encouraging commitment to the WTUL and to reform itself.

Not long after her retirement, Robins was gratified to learn that her old friend Anna Ickes wanted a young relative "to get 'lighted' from your flame . . . that you had more power to quicken young women than any person she had ever known."[84] The strength of Robins's leadership sprang from her capacity to impart courage and inspiration to younger women, to help them confront their sense of helplessness and to encourage them to explore new possibilities. After she addressed a League organizational meeting of 150 young women, a member of the audience was overheard saying, "She'd put courage into a donkey!" Olive Sullivan expressed her gratitude to Robins for being encouraged to speak publicly: "Much do I owe to you for insisting that I do the things you felt I could do. All that has made me very self-reliant and I certainly have

faced the time when I needed it." On hearing of Robins's death in 1945, Ada Rose remembered first meeting her thirty-five years earlier during the Philadelphia shirtwaist strike of 1910. Rose recalled that Robins was "appalled at the idea of a child of twelve being involved in a strike. But by her gracious manner she did not let me know, nor did I feel . . . any sign of her being sorry for me. Instead, she gave me an inspiration that I was fighting for my fellow workers and myself, an inspiration that I still follow, an inspiration that through the many years has helped over many a difficult job."[85]

Inspiration, it may be said, came naturally to Robins. She possessed considerable confidence and certainty, and her sense that the world must yield to principle and determination was enormously impressive to allies and trade unionists alike. Her presence was felt in all the activities of the League, which she consciously molded into a sort of home for reformers. And true to her conception of a home—so like that she had known as a child—the League provided abundant room for social activities that were constructive, for dramas that were educational, for authority leavened by affection, and for self-development modeled upon an exemplary individual. Robins came to dominate the League in the first place by virtue of her willingness to fund it. But she would have meant little to the ongoing spirit of the organization if she had lacked that "Great Mother quality" that so inspired her associates. Her moral force within the League came above all from the way she wielded the gentle authority of a parent in making her younger followers feel that "to me also has been given control over life."[86]

An ideology of motherhood was behind the League's programs for protective legislation. But the feminists of the WTUL soon discovered that there was more than one brand of feminism and that not all committed women shared their values and goals. Many feminists, especially those associated with the National Woman's party, would come in the 1920s to renounce the protective legislation that Robins helped enact. They perceived it as treating women as a special class and hence as inherently discriminatory. Alice Paul, the leader of the Woman's party, asserted that "personally, I do not believe in special protective labor legislation for women. It seems to me that protective labor legislation should

be enacted for women and men alike in a trade or in a geographical district and not along sex lines. I think that enacting labor laws along sex lines is erecting another handicap for women in the economic struggle."[87] The new feminists attacked as sexist the assumptions that motivated the League's reform agenda. They generally denied or ignored the contention that there was a uniquely beneficent female nature whose influence was needed to counteract the depredations of a male-dominated society. For her part, Robins deeply resented that what she called "individualistic" feminists, like Paul, Suzanne La Follette, and Doris Stevens, had captured the slogan of equality, even though she and like-minded reformers had been fighting for the rights of women and for equitable social conditions for decades. Putting aside theories about woman's nature, Robins was convinced that such feminists did not have compassion for scrubwomen, factory workers and tenement-house mothers; certainly they were not products of the working class and had rarely seen the brutal aspects of industry.[88] The League of Women Voters, in agreement with the WTUL on the matter, stated that "the non-wage-earning feminist or the professional woman in her individualized, creative job is more often an individualist, asserting the laissez-faire philosophy and her own personal liberty without realizing the hardships it imposes upon women in modern industry."[89] In Robins's eyes, the self-centeredness of the "individualists" was also evident in the new female styles and behavior of the 1920s: the craze for bobbed hair, short skirts, cigarette smoking and nightclub lounging seemed a visible if banal manifestation of the retreat of women from social causes.[90]

Robins disapproved of the new breed of feminists in the 1920s, just as she had kept her distance from suffragists, women she viewed as often using the working women's groups merely to further the suffrage amendment. Robins was chairman of the Chicago Woman Suffrage party in 1911 and later served on the Leslie Woman Suffrage Commission, a national lobbying group for the amendment. Suffrage was not a consuming issue for her, however. She saw it primarily as a vehicle for other concerns—above all, for protecting the "working mothers of our country." Mary Dreier agreed with her that "ardent" suffragists were single-issue tacticians: "I think they think of nothing else. . . . In fact, they did not seem to

converse with anybody but themselves."[91] Robins saw the woman's movement and the labor struggle as twin expressions of the same goals, but although she wanted suffragists to join with the labor movement, the alliance never took place. In the end, branches of the League formed their own separate organizations to further the cause of suffrage.[92]

Not only did the League oppose the Woman's party over the issue of protective legislation in the 1920s, it also refused to support the Equal Rights Amendment because it would have struck down protective legislation for women; Robins opposed the amendment until her death in 1945. She warned a League convention in 1922 that the slogan of "equal rights" was as effective for the Woman's party as "open shop" had been for manufacturers. And as misleading, for both presented in democratic guise what would in fact result in disadvantages for women and workers respectively.[93] The purpose of protective legislation, of course, was to safeguard the role of women as mothers, for motherhood guaranteed social bonds and human connections. Like so many of her Progressive contemporaries, Robins could not conceive of personal fulfillment or self-realization except in terms of social efficacy and civic responsibility. On the other hand, those in the Woman's party pursued a single-minded policy of exclusiveness, choosing to concentrate on obtaining legal rights for women while viewing issues of racial equality, good government, pacifism, and social service as diversions from that all-important cause. Women who were not exclusively committed to equal rights were "followers of men, worms of the dust, who cannot see that tyranny of half the race over the other half is the first wrong to be righted, and its overthrow, the greatest revolution conceivable."[94] Of course, this was a principled position, but from Robins's point of view, "individualistic" feminists could not see beyond their own desires and ambitions to the greater good of society. Even worse, the new feminists had apparently adopted all the deplorable aspects of male society, those divisive, narcissistic, and materialistic elements that Robins thought the healing and harmonizing female character was destined to set right.

The ideology of motherhood played the same role in Robins's understanding of feminism and female liberation as did the notion

of strict equality for the new generation of feminists. From Robins's perspective, female fulfillment meant realizing one's potential motherhood, whether literally or in service to humankind. The new feminists of the 1920s rejected the idea of sacred motherhood in favor of an emphasis on individual achievement and equality of opportunity with men; women were to be seen not as mothers, potential and otherwise, but as equal wage earners in the marketplace and as individual achievers in the professions. In other words, the new feminism undercut the idea of female uniqueness, the very belief that had inspired League members to build a cross-class and cross-cultural coalition of women.

Robins and her colleagues faced no great dilemma in ideologically and morally justifying the necessity for such a coalition: women, they believed, should unite not out of mere self-interest or in order to fight oppression, but because they are women, with a natural instinct as well as an intrinsic duty "to mother" a fragmented world. In contrast, the new feminists (and those who came after) had to deal with the necessity for organizing women in the absence of the rationale that had so ably served the women of the Progressive period. But when feminism was stripped of the ideology of a uniquely female nature, there seemed to be little that was distinctly feminist about it as a social and political movement. To the veterans of the League, the organization of women around the drive for equality, though it was admirable in itself, seemed scarcely different from that of any other self-interested group demanding enhanced opportunities. The new feminists wanted the same rights that men already had but they did not want to reform the system as such. Middle-class and professional in background, they saw no reason to reach out and ally with women of the working class, for they had no basis for assuming that ethnic, religious, and class barriers would collapse before the imperatives of a common female identity.[95] In short, there was no longer anything to unite the Schneidermans with the deKoven Bowens, the O'Reillys with the Dreiers. From the perspective of "individualistic" feminism, the League was an obsolete institution, sentimental in tone and naive in purpose, opposing the most egalitarian and progressive measures, pursuing inappropriate, unrealistic, and even harmful goals on the basis of ill-conceived and prejudicial assumptions.

For her part, Robins could only view the new feminism with dismay and alarm. In her eyes, there was much more involved than a mere change in intellectual fashion. Indeed, the fate of her country appeared to be at stake, for she had always seen the future of America as dependent upon the creation of new standards of social justice, and she had looked to women, to their nurturing and life-giving nature, for the development of "a new basis for our industrial civilization." Having scorned the notion of sacred and reforming motherhood, the new feminists had no concern for such lofty ambitions. Robins consequently felt that she no longer understood the new generation, she who had devoted her life to inspiring young women. She had to learn to live with a sense of grievous loss and disappointment. In these "difficult and hideous years," she confessed to her sister in 1927, "hideous in the public life of our people and in the noisy flaunting of cheap hopes and cheaper materialism," she found herself wondering for the first time, "Who will save America?"[96]

## Notes

1. MED, *Robins*, p. 80.

2. See frontispiece. MDR's framed copy of the sketch is in unprocessed material, RR Papers.

3. MDR to [?] Roberts, Apr. 3, 1925, copy, box 29, MDR Papers.

4. MDR to RR, July 30, 1938, box 74, MDR Papers; Newman quoted in "Minutes of the 3rd Biennial Convention of the NWTUL," June 11–17, 1911, Boston, Mass., p. 729, reel 20, NWTUL Papers.

5. "Woman's Department," *Union Labor Advocate* 8 (Aug. 1907): 20–22; 8 (Sept. 1907): 27; *The Woman's Journal* 41 (June 1910): 89; MDR to MED, June 9, 1910, MED Papers.

6. U.S. Congress, Senate, *Report on Condition of Woman and Child Wage-Earners in the United States*, vol. 5: *Wage-Earning Women in Stores and Factories*, 61st Cong., 2nd Sess., Senate doc. no. 645 (Washington, D.C.: Government Printing Office, 1910), p. 348. Forty-four percent of Chicago's female workers made eight dollars or more a week while 23 percent earned ten dollars or more a week.

7. MDR to Mrs. Willard [Dorothy] Straight, Feb. 22, 1918, box 31, MDR Papers.

8. On the Chicago WTUL, the CFL, and the Teachers' Federation, see chapter 2.

9. MDR to MED, Sept. 29, 1905, box 25, MDR Papers.

10. "Minutes of Executive Board of National Women's Trade Union League," Mar. 18, 1909, typescript, box 4, file 38, Leonora O'Reilly Papers, Schlesinger Library, Radcliffe College, Cambridge, Mass.

11. Pauline Newman to the author, July 23, 1977.

12. MDR to RR, Mar. 19, 1916, box 61, MDR Papers.

13. Letta Perkins, in "Minutes of the 8th Biennial Convention of the NWTUL," June 5–10, 1922, Waukegan, Ill., p. 92, reel 22, NWTUL Papers.

14. Mary Anderson to MDR, Feb. 27, 1920, box 31, MDR Papers; Rose Schneiderman to Emma Steghagen, Sept. 28, 1918, reel 2, NWTUL Papers.

15. MDR to Miss [?] Leonard, July 12, 1940, copy, box 46; MDR, speech, banquet of the WTUL at Forest Park Pavilion, St. Louis, Mo., May 20, 1910, box 3; Ruth Levinson to MDR, June 6, 1932, box 43, MDR Papers. For changing notions of male and female realms, see Paula Baker, "The Domestication of Politics: Women and American Political Society, 1780–1920," *American Historical Review* 89 (June 1984): 620–47.

16. MDR to MED, May 1, 1909, box 27, MDR Papers.

17. MDR, speech on the work of the Woman's Municipal League [c. 1904], box 3, MDR Papers.

18. Leonora O'Reilly to MDR, Sept. 23, 1912, box 28, MDR Papers; "Minutes of the 9th Biennial Convention of the NWTUL," June 16–21, 1924, New York, N.Y., p. 48, reel 23, NWTUL Papers; S. M. Franklin, "When We Have Time to Read," *Life and Labor* 3 (June 1913): 181–82.

19. RR to MDR, Nov. 8, 1909, box 59, MDR Papers; Cohen, "Fannia Cohn," p. 206; Daly, "Mary Anderson," p. 38; "Minutes of the 9th Biennial Convention of the NWTUL", June 16–21, 1924, New York, N.Y., p. 95, reel 23, NWTUL Papers.

20. Cohen, "Fannia Cohn," p. 206; O'Sullivan, unpublished autobiography, p. 65.

21. S. M. Franklin, "The Fifth Biennial Convention," *Life and Labor* 6 (Jan. 1916): 14; "Minutes of the 4th Biennial Convention of the NWTUL," June 2–7, 1913, St. Louis, Mo., p. 52, reel 20, NWTUL Papers; "Minutes of the 9th Biennial Convention of the NWTUL", June 16–21, 1924, New York, N.Y., pp. 77–78, reel 23, NWTUL Papers.

22. Emma Steghagen to the executive board, NWTUL, Jan. 20, 1920, box 2, NWTUL Papers; Catherine Miller to MDR, Nov. 9, Dec. 3, 1932, box 44, MDR Papers.

23. Lisa von Borowsky to the author, July 28, 1977.

24. O'Reilly, diary, vol. 18, Jan. 19, 1911, O'Reilly Papers; Katherine Dreier to MDR, Jan. 11, 1911, box 28, MDR Papers.

25. Louise deKoven Bowen, "The Need of Women Police," *Life and*

*Labor* 3 (May 1913): 154; Mary McDowell, "Some Observations on Working Women in Germany," *Life and Labor* 4 (May 1912): 134.

26. Mary McDowell, "Mothering a Municipality," *Life and Labor* 4 (Oct. 1914): 297–99.

27. Quoted in George Martin, *Madame Secretary, Frances Perkins* (Boston: Houghton Mifflin, 1976), p. 146.

28. RR to MDR, Feb. 3, 1922, box 63; Mar. 26, 1923, box 64; Feb. 20, 1931, box 69; Nov. 22, 1931, box 70; Apr. 30, 1929, box 67; June 9, 1934, box 72, MDR Papers.

29. Mrs. William [Anne] Hard to Mary Anderson, [c. 1950], Mary Anderson Papers, Schlesinger Library, Radcliffe College, Cambridge, Mass.

30. MDR, speech, banquet of the WTUL at Forest Park Highlands Pavilion, St. Louis, Mo., May 20, 1910, box 3, MDR Papers; MDR, "District Nursing," [c. 1908], box 3, MDR Papers; "Minutes of the 2nd Biennial Convention of the NWTUL", Sept. 25–Oct. 1, 1909, Chicago, Ill., opening session, reel 19, NWTUL Papers. MDR's statement regarding our "individualistic" strivings is quoted in "Woman Leader Speaks to Women," *Peoria Transcript*, Oct. 22, 1908.

31. See Charlotte Perkins Gilman, *Women and Economics* (1898; reprint ed., New York: Harper and Row, Harper Torchbooks, 1966), p. 43; also see Hill, *Charlotte Perkins Gilman*, pp. 265–69. Gilman, like MDR, believed that women were superior because of their nurturant qualities. Gilman, however, wanted to deemphasize the home and reproduction in order to free women for the professions.

32. MDR, speech on the work of the Woman's Municipal League, [c. 1904], box 3, MDR Papers.

33. MDR, speech fragment, [n.d.], box 3; "Report of Committee on Women and Children in Industry," 1918, box 18, MDR Papers.

34. MDR to Norman Hapgood, Nov. 30, 1908, box 26; WTUL of Chicago, "A Plea for Women Workers," presented to Industrial Commission of the State of Illinois, Jan. 1909, box 17, MDR Papers.

35. Edith Wyatt, "Garment Workers at Home," in *Handbook of the Chicago Industrial Exhibit* (Chicago, 1907).

36. "Minutes of the 2nd Biennial Convention of the NWTUL", Sept. 25–Oct. 1, 1909, Chicago, Ill., closing session, reel 19, NWTUL Papers.

37. MDR, "Industrial Education," *Life and Labor* 3 (Aug. 1913): 230; MDR, "The Need of a National Training School, the Minimum Wage, Industrial Education," presidential address, Fourth Biennial Convention, WTUL, St. Louis, Mo., June 2, 1913, box 3, MDR Papers.

38. Mary Kenney O'Sullivan, "The Need of Organization among Working Women," First National Conference on Women in Industry, Mar.

26, 1905, reel 8, MDR Papers; MDR, presidential address, "Minutes of the 2nd Biennial Convention of the NWTUL", Sept. 25–Oct. 1, 1909, Chicago, Ill., opening session, reel 19, NWTUL Papers.

39. O'Sullivan, "The Need of Organization among Working Women."

40. See MED to MDR, July 26, 1914, box 36, MDR Papers.

41. MED to MDR, July 26, 1914, box 36; RR to MDR, Dec. 3, 1914, box 60, MDR Papers; S. M. Franklin, "The Fifth Biennial Convention," *Life and Labor* 5 (July 1915): 117–18; "Republican National Commission, Advisory Committee on Politics and Platform: Questionnaire on Industrial Relations and the Problem of Capital and Labor, Some Answers Submitted by Mrs. Raymond Robins," Mar. 20, 1920, box 21, MDR Papers.

42. On the perceived connection between prostitution and wages, see Connelly, *Response to Prostitution*, pp. 30–35; Ruth Rosen, *The Lost Sisterhood: Prostitution in America, 1900–1918* (Baltimore: Johns Hopkins University Press, 1982), pp. 61, 66.

43. MDR, "The Minimum Wage," *Life and Labor* 3 (June 1913): 171; Mary Field, "The Drama of Wages," *Life and Labor* 3 (Mar. 1913): 90; Alice Henry, "The Living Wage," *Life and Labor* 3 (July 1913): 195. The members of Working Girls Clubs in the early twentieth century were also deeply interested in the "awakening to a consciousness of faculties hitherto unsuspected," as one young woman put it: see Joanne Reitano, "Working Girls Unite," *American Quarterly* 36 (1984): 132.

44. Reformers' concern for nutrition and feminists' enthusiasm for exercise for women are discussed in Gerda Lerner, *The Grimké Sisters from South Carolina* (New York: Schocken Books, 1967), pp. 252–53, 321–22. On the attitude toward exercise for women in the nineteenth century, see John S. Haller and Robin M. Haller, *The Physician and Sexuality in Victorian America* (Urbana: University of Illinois Press, 1974), pp. 174–87; on the role of exercise in women's education, see William Leach, *True Love and Perfect Union: The Feminist Reform of Sex and Society* (New York: Basic Books, 1980), pp. 64–80.

45. MDR, "Report of Committee on Women and Children in Industry," 1918, box 18, MDR Papers; MDR, "Industrial Education," *Life and Labor* 3 (Aug. 1913): 230; presidential address, "Minutes of the 2nd Biennial Convention of the NWTUL", Sept. 25–Oct. 1, 1909, Chicago, Ill., opening session, reel 19, NWTUL Papers.

46. MDR, notebook on court decision, Oregon ten-hour day, 1908, box 10, MDR Papers.

47. Mary Anderson, "Night Work for Women Described by Women's Bureau," box 19, MDR Papers; "Minutes of Department of Women and Children in Industry," Jan. 22, 1918, box 18, MDR Papers; *Life and Labor* 8 (Mar. 1918): 57.

48. Nestor, *Woman's Labor Leader*, p. 121; Mary McDowell, "The Girls' Bill," *Survey* 22 (July 1909): 512.

49. Rose Schneiderman to MDR, Jan. 8, 1930, box 39, MDR Papers; Nestor, *Woman's Labor Leader*, p. 95; Cohen, "Fannia Cohn," pp. 2, 148–49; RR to MDR, Sept. 26, 1908, box 59, MDR Papers.

50. Alice Henry to executive board, July 17, 1922, copy, reel 2, NWTUL Papers; Agnes Burns, "At the League's Training School," *Life and Labor* 6 (Mar. 1916): 39; Louisa Mittelstadt, "Women Must Organize!" *Life and Labor* 4 (July 1916): 106.

51. Nestor, *Woman's Labor Leader*, p. 29.

52. Mary Caroline Crawford, "The Hello Girls of Boston: An Averted Strike," *Life and Labor* 2 (Sept. 1912): 261.

53. Alice Hamilton, *Industrial Poisons in the United States* (New York: Macmillan Co., 1925), p. 110; see Angela Nugent Young, "Interpreting the Dangerous Trades: Workers' Health in America and the Career of Alice Hamilton, 1910–1933" (Ph.D. diss., Brown University, 1982). On protective legislation in the Progressive era, see Alice Kessler-Harris, *Out to Work: A History of Wage-Earning Women in the United States* (New York: Oxford University Press, 1982), pp. 180–214; 205.

54. Maggie Hinchey, "Senators vs. Working Women," *Life and Labor* 2 (July 1912): 215. Hinchey herself, however, was not enthusiastic about protective legislation in later years.

55. "Minutes of the 7th Biennial Convention of the NWTUL," June 2–7, 1919, Philadelphia, Pa., p. 325, reel 22, NWTUL Papers.

56. *Health Committee*, printed sheet, WTUL of Chicago, [c. 1912] Chicago Historical Society, Chicago, Ill.; "Minutes of the 3rd Biennial Convention of the NWTUL," June 12–17, 1911, Boston, Mass., p. 218, reel 20, NWTUL Papers.

57. Weiler, "Walkout: The Chicago Men's Garment Workers' Strike," p. 245; Women's Trade Union League of Chicago, *Official Report of the Strike Committee*, p. 20.

58. Leonora O'Reilly, report on education, "Minutes of the 4th Biennial Convention of the NWTUL," June 2–7, 1913, St. Louis, Mo., p. 82, reel 20, NWTUL Papers; *Life and Labor* 3 (Feb. 1913): 61.

59. On Sanger, see David Kennedy, *Birth Control in America: The Career of Margaret Sanger* (New Haven: Yale University Press, 1970).

60. *Notable American Women* 3: 693–94.

61. "Address of Mrs. Raymond Robins to NWTUL Biennial Convention," June 1922, box 3, MDR Papers. On the protest against child labor, see Josephine Goldmark, *Impatient Crusader: Florence Kelley's Life Story* (Urbana: University of Illinois Press, 1953), pp. 78–96, 114–20.

62. Dora Allen, "Lost—A Childhood" in *Handbook of the Chicago*

*Industrial Exhibit*, p. 76; *Life and Labor* 5 (June 1915): 111. On some aspects of play in the Progressive period, see Benjamin McArthur, "The Chicago Playground Movement: A Neglected Feature of Social Justice," *Social Service Review* 49 (Sept. 1975): 390–93. On theoretical issues raised by the subject of play, see Roger Caillois, *Man, Play and Games*, trans. Meyer Barash (New York: Schocken Books, 1979); Eric H. Erikson, *Toys and Reason: Stages in the Ritualization of Experience* (New York: W.W. Norton and Co., 1977).

  63. MDR to RR, Dec. 6, 1933, box 72, MDR Papers; Charles Frederick Weller to RR, Apr. 19, 1916, box 10, RR Papers.

  64. The quotation is from Harriet Monroe's "Nine Years Old," a twenty-line ode that appeared in *Handbook of the Chicago Industrial Exhibit*, p. 76.

  65. *Life and Labor* 1 (Mar. 1911): 93; format letter from NWTUL to Mrs. D. W. Knefler, May 8, 1908, box 1, NWTUL Papers.

  66. "Minutes of Meeting, National Executive Board, NWTUL," Apr. 17–19, 1912, box 1, NWTUL Papers.

  67. Nestor, *Woman's Labor Leader*, p. 108; MED to manager, Ladies' Whitegood Workers, Aug. 22, 1959, MED Papers.

  68. S. M. Franklin, "When We Have Time to Read," *Life and Labor* 2 (Nov. 1912): 344; *Life and Labor* 5 (Jan. 1915): 28.

  69. Dubinsky is quoted in MED to MDR and RR, June 4, 1936, box 49, MDR Papers.

  70. See Carroll Smith-Rosenberg, "The Female World of Love and Ritual: Relations between Women in Nineteenth-Century America," *Signs* 1 (Autumn 1972): 1–29; see also Keith E. Melder, *Beginnings of Sisterhood: The American Woman's Rights Movement, 1800–1850* (New York: Schocken Books, 1977), pp. 30–48; Nancy Cott, *The Bonds of Womanhood: "Woman's Sphere" in New England, 1780–1835* (New Haven: Yale University Press, 1977), pp. 160–96; Thomas Dublin, *Women at Work: The Transformation of Work and Community in Lowell, Massachusetts, 1820–1860* (New York: Columbia University Press, 1979), pp. 58–107.

  71. Fuller is quoted in Mason Wade, *Margaret Fuller: Whetstone of Genius* (New York: Viking Press, 1940), p. 91. On female workers in Lowell, see Thomas Dublin, "Women, Work and the Family: Female Operatives in the Lowell Mills, 1830–1860," *Feminist Studies* 3 (Fall 1975): 30–39.

  72. Cahan, *Rise of David Levinsky*, pp. 526–27.

  73. MDR was quoted in "Educational Side of Women's Trade Unionism," *New York Tribune*, Oct. 12, 1919; see also "Some of the Happy Features of the Women's Trade Union League of Chicago," WTUL of Chicago, leaflet no. 3, June 1909, Chicago Historical Society, Chicago, Ill.

74. On the formality of meetings of feminist organizations, see O'Neill, *Everyone Was Brave*, pp. 104, 106; for the description of League conventions see S. M. Franklin, "The Fifth Biennial Convention," *Life and Labor* 5 (July 1915): 116. For Nestor's comment to MDR, see Agnes Nestor to MDR, Feb. 15, 1936, box 48; also see MDR to RR, Mar. 1916, box 60, MDR Papers.

75. Florence L. Sanville, "Stirring up Quaker City," *Life and Labor* 6 (May 1916): 76.

76. See Elisabeth Colson, "The Least Common Denominator," in *Secular Ritual*, ed. Sally F. Moore and Barbara G. Myerhoff (Amsterdam: Van Gorcum, 1977), pp. 189–98.

77. Agnes Nestor to MDR, Apr. 29, 1924, box 35, MDR Papers.

78. Daly, "Mary Anderson," p. 55.

79. Anna Rudnitsky, "Time is Passing," *Life and Labor* 2 (Apr. 1912): 99.

80. Rose Schneiderman, in "Minutes of the 9th Biennial Convention of the NWTUL," June 16–21, 1924, New York, N.Y., p. 4, reel 23, NWTUL Papers.

81. MDR to Elisabeth Christman, Apr. 1, 1932, box 43; MDR, "The Human Side of the Industrial South," address to the 11th Convention of the NWTUL, Southern Session, May 9, 1929, box 3, MDR Papers.

82. MDR to RR, Feb. 19, 1912, box 60; MDR to MED, May 16 and 24, 1926, box 36, MDR Papers.

83. See Chafe, *The American Woman*, pp. 73–74.

84. RR to MDR, Feb. 28, 1927, box 66, MDR Papers.

85. MDR to RR, Mar. 1912, box 60; Olive Sullivan to MDR, June 17, 1939, box 51; Ada Rose to Rose Schneiderman, May 18, 1945, box 78, MDR Papers.

86. Agnes Burn to MDR, Oct. 6, 1916, box 30, MDR Papers.

87. Alice Paul quoted in Nancy F. Cott, "Feminist Politics in the 1920s: The National Woman's Party," *Journal of American History* 71 (June 1984): 57; see also Christine A. Lunardini, "From Equal Suffrage to Equal Rights: The National Woman's Party, 1913–1923" (Ph.D. diss., Princeton University, 1981); Linda G. Ford, "American Militants: An Analysis of the National Woman's Party, 1913–1919" (Ph.D. diss., Syracuse University, 1984).

88. "Conference on So-Called Equal Rights Amendment Proposed by the National Woman's Party," Dec. 4, 1921, box 2, NWTUL Papers; "Statement of NWTUL to National League of Women's Voters for presentation to International Suffrage Alliance in Paris," Apr. 16, 1929, box 21; MDR to RR, June 7, 1926, box 66; MDR to MED, Dec. 14, 1940, box 46, MDR Papers. On the new emphasis in feminism beginning in the 1920s, see J. Stanley

Lemons, *The Woman Citizen: Social Feminism in the 1920s* (Urbana: University of Illinois Press, 1973), pp. 181–208; Rosenberg, *Beyond Separate Spheres*, pp. 84–113; Susan Ware, *Beyond Suffrage: Women in the New Deal* (Cambridge, Mass.: Harvard University Press, 1981), pp. 19–21; Susan D. Becker, *The Origins of the Equal Rights Amendment: American Feminism between the Wars* (Westport, Conn.: Greenwood Press, 1981).

89. "Statement of National League of Women Voters for Presentation to International Suffrage Alliance in Paris," Apr. 16, 1929, box 21, MDR Papers.

90. Cf. Letta Perkins in "Minutes of the 8th Biennial Convention of the NWTUL", June 5–10, 1922, Waukegan, Ill., p. 62, reel 22, NWTUL Papers; MDR to MED, Jan. 15, 1932, MED Papers.

91. MDR, presidential address, "Minutes of the 2nd Biennial Convention of the NWTUL", Sept. 25–Oct. 1, 1909, Chicago, Ill., opening session, reel 19, NWTUL Papers; MED to MDR, Nov. 27, 1906, box 26, MDR Papers.

92. MDR to RR, Nov. 2, 1907, box 59, MDR Papers.

93. On opposition to protective legislation and debate over the ERA, see Chafe, *The American Woman*, pp. 181–208; Cott, "Feminist Politics in the 1920s," pp. 56–63; Judith A. Baer, *The Chains of Protection: The Judicial Response to Women's Labor Legislation* (Westport, Conn.: Greenwood Press, 1978). On 1922, see Boone, *Women's Trade Union Leagues*, p. 139.

94. Alice Paul quoted in Cott, "Feminist Politics in the 1920s," pp. 67–68; 54–55.

95. The argument over protective legislation and the meaning of feminism laid bare contradictions in feminist theory that had been implicit throughout the nineteenth century; see O'Neill, *Everyone Was Brave*, pp. 2–48. For a case study of the different implications of views about a uniquely feminine nature, see Regina Markell Morantz, "Feminism, Professionalism, and Germs: The Thought of Mary Putnam Jacobi and Elizabeth Blackwell," *American Quarterly* 34 (Winter 1982): 459–78.

96. MDR to MED, Oct. 29, 1927, box 31, MDR Papers. On MDR's disenchantment after her retirement, see chapter 5.

# 5

# "The Lost Possibilities Haunt Us": Progressive Ideology and the New Deal

In 1924, at the age of fifty-six, Robins closed her cold-water flat in Chicago's Seventeenth Ward and moved to Chinsegut Hill, the 2,000-acre estate in western Florida that her husband had purchased with his Alaskan fortune. The Robinses had long planned to retire there, and by 1932 they had invested about $200,000 in renovating the double-porticoed house and in planting cypress, pine and eucalyptus. Still, the antebellum mansion, tended by descendants of former slaves of the plantation, was an unlikely setting for a Brooklyn-born Chicago activist.

Only a rutted sandy track linked Chinsegut Hill, sixteen miles from the Gulf of Mexico, with the drowsy farming town of Brooksville. There was no telephone, no electricity, and the rural postal delivery was notoriously slow. The Ku Klux Klan flourished in the barren area, and, according to Robins, her Hernando County neighbors "were like slugs, born in the mud" and content to remain there. The woman who had devoted her life to trade unionism and social reform gave herself over to poultry breeding, red-polled cows and hybrid oranges. She had not, however, decided merely to cultivate her own garden, for, as Raymond pronounced, Chinsegut Hill was to be a "lighthouse for better breed and seed," a model for innovation and education in the South. Robins was both flattered and comforted by Mary McDowell's likening the isolated plantation to "a [social] settlement in the wilderness."[1]

Yet glowing prospects for agricultural reform could not dis-
guise the fact that Robins had dramatically withdrawn from her
lifelong crusade for working women, a withdrawal prompted by
disappointment and deepened by disillusionment. In fact, her re-
tirement was symptomatic of what happened to many reformers
after World War I. Retreat from reform was widespread as America
entered a period of extended reaction; interest in politics dimin-
ished, while prosperity encouraged complacency and hedonism.
From Robins's point of view, the new feminists, who placed per-
sonal advantage before social causes, were merely succumbing to
the triumphant smugness of postwar America. As Raymond la-
mented, "How indifferent . . . to all the deeper interests of the
mind and soul political America has become." There was no com-
placency about radicalism, however, and the Red Scare took its toll
of the reform-minded. Yet even though Robins was accorded a cen-
tral place on the infamous 1924 "Spider Chart" of those said to be
female radicals—her part in the 1907 parade had not been forgot-
ten—that dubious prominence did not discountenance her.[2] It is
striking evidence of her irrepressibly optimistic temperament that
it only slowly became apparent to her just how uncongenial Amer-
ica had become to reform as she had known it.

Robins cheered herself with the view that the League was in
good hands as a new generation of leaders, working women whom
the allies had long nurtured, prepared to take charge. Believing
that "I have at least won my bets on the girls," she could tell herself
that the future of the League was secure, her work accomplished.
Raymond explained their move to Florida in typically grandiloquent
terms: "The task we undertook a quarter of a century ago for the
Group of Toil is nearly complete. With Lenin master of the land of
the Czars, and Macdonald master of Britain . . . with Sidney Hill-
man chief of a great corporation and labor banks, with the twelve-
hour day abandoned in the Steel Industry and the Coal Mines, we
can say that our eyes have seen the Glory of the Lord in our first
social task."[3] Henceforth Chinsegut Hill would be Robins's sanc-
tuary and cynosure, an exemplary and isolated arboretum from
which she could view the consequences of her life in the deeds of
those whom she had led and inspired.

Within little more than a year after her retirement, however,

those deeds proved to be exceptionally distressing to Robins. From her point of view, the League soon abandoned the course she had set for it. Instead of continuing to concentrate on union organization and protective legislation, the League exhausted its energies fighting the Equal Rights Amendment. While Robins applauded opposition to the ERA, she believed that the preoccupation with it was a serious tactical blunder. Furthermore, during the 1920s unions in general experienced hard times as they were undercut by prosperity, adverse judicial decisions, a drive by industry for the open shop, an antilabor backlash from the Red Scare, and internal dissent over the issue of industrial unionism.[4] Hence the ERA fight was distracting the League precisely when it had diminished resources of members and money for the traditional enterprises that were its raison d'etre. Robins was especially eager for the League to establish itself in the South, now a center for organizing textile and garment trades, and she was chagrined that the WTUL could not muster the strength to set up active branches there. In fact, even if Robins had continued pouring money into the League, it probably would have been reduced in any event in membership, organizing activity, and public presence. But she would never have countenanced the reduction of the organization to a virtual adjunct body of the AFL. In 1929 when the headquarters of the League was moved to Washington, D.C., where it would be under the effective domination of the AFL, Robins remarked, "I look upon the move . . . as quite disastrous and certainly incongruous to the Spirit of the age [which called for female independence]."[5] In short, for Robins the move represented a defeat for both the reformist and feminist impulses of the League.

More generally, Robins perceived the League's tactical blunders as due to a fundamental lack of vision in the generation of leaders who had succeeded her and her contemporaries. These new leaders, all trade unionists who had replaced allies in a turnover that began before the war, were by her lights devoid of imagination and enthusiasm. Robins was alarmed at their lack of concern for larger issues, such as a labor critique of society or participatory democracy in the workplace. She increasingly felt betrayed by former colleagues like Rose Schneiderman and Agnes Nestor as they entered bureaucratic jobs with the government or

with craft unions. She found them "drab," without passion or com-
mitment. They were "lowering the flag," and hence, as she com-
plained to Raymond, the glory of the League was gone. For their
part, those in charge of the League still asked for Robins's advice
but many clearly thought that the former president was outdated.
This was borne home to Robins with depressing clarity when she
sent to the *Life and Labor Bulletin* what she regarded as a serious
essay on unemployment, only to have the editors publish it as a
mere inspirational message in their Christmas issue. For Robins,
this slight was confirmation that the League's leaders were inca-
pable of either understanding the substance of her topic or of
providing their own inspiration for the membership. She believed
that the latter was the more serious fault, and she longed for some-
one to "grip the girls" again. "Leonora O'Reilly may be daffy," she
wrote to Raymond, "but she never furls the flag!"[6]

For two decades Robins had been the League's principal source
of inspiration, its soul. She had mediated between the League and
the wider governmental and industrial world. She had elaborated
the League's ideology and conveyed it to working women in simple
but thrilling rhetoric. She had set the tone of the League, filled its
journals, guided its course, and drafted its agendas. In all this she
had not displayed the slightest condescension in dealing with the
working women she and the allies were grooming for leadership.
Perhaps the most remarkable achievement in the internal history of
the WTUL is that whatever else divided the women of the League,
the class distinction between allies and workers was muted. In
Robins's case, condescension appeared only at the last, after the
close of her formal association with the League, when she had be-
come an anxious and distant critic of her successors. Only then
did she see her working-class associates in ungenerous terms: in-
capable of grasping large concepts and complicated analyses, po-
litically and organizationally inept, lacking transcendent vision
and rhetorical resources, mired in self-interest and materialism.

Of course, there had always been a trace of condescension
implicit in the basic aim of the League. "Helping industrial women
to help themselves" at least implied that they could not provide
their own perspective or impetus but must be brought by others to
see their best interests.[7] It is no derogation of Robins's long service
in the cause of working women to suggest that in the end she re-

vealed a measure of condescending superiority when she criticized her working-class successors for not directing the League according to her established guidelines and high principles. She had spent a quarter of a century teaching working women "to fight their own battles," only to realize when her self-appointed pedagogical mission was complete that the battles those women would fight would of necessity be entirely their own, not chosen by their erstwhile tutor and not always expressive of her values.

When Raymond told his wife in 1929 that the League was her child, "raised from feeble infancy into maturity and power," he was wrong, and by that time they both knew it. Indeed, the League was her child, but despite what she chose to believe when she retired, it was still feeble and uncertain, still needing the guidance and nurture of the "Great Mother."[8] Dismayingly soon after her retirement, Robins could not blink at the failure implicit in the subsequent sad career of the League. It is considerable testimony to her inveterate hopefulness that her disillusionment after 1924 did not extend so far into bitterness that she was led to disown the child who had so grievously disappointed her.

Additional disappointments followed in the early 1930s. The Robinses lost most of their fortune at the beginning of the depression. To preserve Chinsegut Hill as an experiment station, they turned it over to the Federal Department of Agriculture in 1932, although they retained the use of the mansion for the rest of their lives.[9] Shortly after, Raymond's public career was shattered when he suffered an attack of amnesia, disappeared for three months, occasioned a nationwide manhunt, and turned up happily prospecting in North Carolina in a pathetic reenactment of his Alaskan adventures. Robins's reaction was swift and bitter: "I'd rather he were dead." Raymond had named the Florida estate in memory of his youthful exploits—Chinsegut, he claimed, meant "the spirit of things lost" in Alaskan Inuit language—and in surveying the ruin of their dreams in the early 1930s, the Robinses might have concluded that the name was well chosen indeed.[10]

In Robins's eyes, reform, labor, and feminism all suffered as America moved into the 1930s. What she had sensed soon after she left public life, and had first recognized in the decline of the League in the years before the depression, was confirmed with the

administration of Franklin Roosevelt: her time had passed, her values and ideas were being abandoned in a changing America. "What changes and how terribly backward the march has been since the great war, when all our ideals were pressed to the wall," Mary Dreier wrote to Robins in 1932. Shortly before the presidential election of that year, Mary Anderson wrote to Robins that as Progressive reformers they both were part of the "Old Guard." In fact, from Anderson's perspective, that "Old Guard" broke ranks after 1920 as many retreated from effective action. To be sure, Anderson overstated the case, and Robins's perspective was colored by rejection of her views. Many Progressives remained active in reform and influential in government, while mountains of state legislation embodied Progressive ideals. But by the end of the 1920s, the tide had clearly shifted, and the formula for social change had been recast. Faced with a postwar society characterized by reaction and conformity, some Progressives, now "tired radicals," lost faith in progress.[11] At home, alarm over radicalism and surrender to greed seemed to dominate; abroad, the new international order was manifestly foundering. Above all, the times called into question the Progressive's faith in human nature. Acquisitive and complacent, the people seemed lacking in virtue and intelligence.[12] They had failed the Progressive movement, just as the new leaders of the League had disappointed Robins. Finally, the depression and the New Deal were massive confirmations for many Progressives that they were indeed mere revenants, guardians of forgotten principles and exhausted institutions. Like many of her reform contemporaries, Robins, a lifelong advocate of advanced and unpopular causes, suffered the unhappy fate of finding herself a conservative, nostalgic and intransigent. Even though a crusader for trade unionism, her most noteworthy response to the glory days of union organizing in the 1930s was to blame workers for being crass and selfish. A dedicated reformer, she viewed the busiest epoch of American reform with disdain and horror. She could well have echoed the lament of another opponent of the New Deal: "I have lived too long."[13]

To some extent, Robins rejected the New Deal because she was applying the values of a suddenly bygone age to a new era. The first two decades of the twentieth century witnessed in Pro-

gressivism the last, full-blown articulation of that optimistic, re-
publican, tolerant, and liberal Protestant view of the individual and
society that had informed America for one hundred years and that
found its most eloquent statement in Ralph Waldo Emerson's call
for the reformation of man. The era of Roosevelt spoke a different
language and pointed in a different direction. Roosevelt's advisor
Rexford Tugwell declared in 1935 that "the New Deal is attempting
to do nothing to *people*, and does not seek at all to alter their way
of life, their wants and desires."[14] With such self-conscious rejec-
tion of traditional reform goals, and in extending the purview of
government in a new fashion, the New Deal represented a break in
American political thinking.

What Robins and others thought was being lost with the New
Deal or, rather, consciously rejected, was the possibility of reform
based upon a conception of man and society that had been at the
basis of the American reform tradition.[15] That tradition saw the in-
dividual as possessing enormous potential for good, which could
only be realized by a properly structured society. The self was re-
garded as benign, creative, sympathetic and essentially rational;
society was malleable and responsive, a field of play not only for
the forces of corruption and aggrandizement but also for the vivify-
ing influences of reason and reform. Matching a tractable environ-
ment with a beneficent nature, the reformer worked to free the self
from the trammels that otherwise hinder and deform it. Such was
the agenda of Progressivism: to pass the laws and create the in-
stitutions that would release the individual's potential both as a
person and as a citizen. The Progressive's task was to liberate the
individual from enslaving ignorance, debasing labor, soulless pas-
times, corrupt authority and concentrated power. Once those mul-
tiple and interlocking tyrannies were destroyed, the hitherto "hid-
den treasures" of the self would be freed for social expression;
"every resource of body, mind and heart" would find vent in elevat-
ing fellowship and individual excellence.[16]

As early as the 1920s, these notions sounded naive, sentimen-
tal, and impossibly optimistic. Yet they had been at the basis of
Progressive reform. Because the whole existence of the individual
(potential or otherwise) was at stake, Robins wanted institutions
such as unions to "take in all of life," and a colleague aspired to

have the labor movement transfigure civilization itself.[17] Hence the disparate nature of many Progressive institutions, with settlement houses and trade unions assuming educational and recreational functions. The wide-ranging activities of the League were intended to be commensurate with the potentialities that Robins and her colleagues were striving to develop in young women. The "festival of life" would not be available to all if the League restricted itself to the factory and the union. When the League went beyond organizing workers and lobbying legislators to provide members with poetry readings, picnic outings, lectures, lending libraries, pageants, choral singing, and amateur theatrics, it was being true to the impulse that had inspired its foundation. When John Dewey introduced a range of new activities into the classroom, such as nature study and games, he was expressing the Progressive commitment to "the needs and opportunities for growth."[18] Impelled by the same motive, the Playground Association went beyond recreational concerns to lobby for community centers, which in the tradition of the social settlements would serve everyone and thus be agencies for "the social redemption of the people." The National Child Labor Committee decided after the war that protest against labor exploitation was too narrow a focus and that (as the committee's journal declared) "for the sake of the child, there must be education in and for health, efficiency, good living, good homes, good community life." So, too, Homer Folks led the Public Health movement toward the idea that the whole community—citizens, physicians, officials, and social workers—must be mobilized against illness because only then would intractable problems be solved and possibilities for individual and social development be revealed.[19] For the Progressive, no aspect of human life that needed reformation was so limited in scope or significance as not to open into the broadest considerations and the most far-reaching ambitions. Inside the decorous, tolerant Progressive, who was perhaps working to provide bathhouses for a neighborhood or civics classes for immigrants, there bided a moral crusader determined to alter the foundations of society.

According to Progressives like Robins, the New Deal tended to cut off possibilities of individual development and social reform by the imposition of government control. In effect, the power of gov-

ernment subverted both the individual and society, eliminating the possibility of reformers achieving that desired equipoise of human potential and social receptivity that was the goal of the Progressive. Under the New Deal, they thought, the individual lost a crucial measure of free choice and therefore ceased to heed either inner promptings toward reform or the admonitions of the reformer.[20] Progressive institutional reforms for direct democracy had been calculated to amplify those promptings and warnings. The referendum, recall, direct primary, and initiative were aimed at projecting the voice of the people past barriers of privilege, partisanship, and special interest. They were to provide avenues by which the concerns of an enlightened citizenry—enlightened because responsible and self-governing—could circumvent party bosses, political machines, and corporate influence. Private power would be exorcised once the public could be heard freely.[21] Trust-busting and regulatory commissions were also liberating, for they too curtailed special interests and promoted self-government, that is, decision making by the citizenry for the public good. Muckraking implied the same high estimation of the individual and society: if the public became aware of abuses and injustice, then rationality and enlightenment would express themselves through democratic avenues. Robins believed that America would not tolerate the effects of industry on the home "if she but knows the facts," while Jane Addams argued that Europeans would not allow the war to continue if they were properly informed. The Progressive was above all an educator, and the educational aspects of the League and the settlement houses testify to the deep faith the Progressives had in the ability of the individual and society to change for the better.[22]

For the Progressive, politics was, at best, a means of educating the public; it was not a good in itself because it involved the use (and inevitably the abuse) of power. Progressive institutional reforms were not regarded as essentially political in nature; rather, they were devices for combating the political world, which was invariably dominated by the factious, selfish, and venal. Even the Progressive Party campaign of 1912 was seen by many participants as a pedagogical mission and a moral crusade. As one member exclaimed, "Just think of having all the world listen to our story of social and industrial injustice and having them told that it can be

righted."[23] The spirit of Progressivism was evident at the Chicago convention when social workers formed a "Jane Addams Chorus" and sang "Onward Christian Soldiers." According to one observer, delegates were so ardent that the convention seemed like "a Methodist camp meeting done over into political terms."[24]

The Robinses had been very active in the Progressive party's campaign and had shared in the transient enthusiasm for political action. "I have never before in politics felt that I was standing upon more than half-truths and advancing other than uncertain political fortunes," Raymond declared. "Now I am sure that the whole result of this struggle shall be for the social welfare and moral strength of the country."[25] Naturally, the campaign fell far short of that, hence disillusionment with the party was rapid after 1912 and total after 1916. Defining politics, as Robins did, as the "civic expression of a moral truth" put exhortation and righteousness before electoral success, thus helping insure political defeat and disenchantment. As Raymond wrote to his wife in 1924, just before they retired to Florida: "I am eager to get away from the illusion of politics. Neither of us ever had 'our treasure' there. Even as a means to an end it seems the most futile and baffling of all the social forces."[26]

In Margaret Robins's perspective, the very nature of reform was changing under the impact of the New Deal. She was witnessing the end of the American reform tradition as she had known it, the sunset of that "long and splendid" day of Jeffersonian individualism, as Roosevelt proclaimed in 1932.[27] She saw in Roosevelt's vigorous efforts to counter the depression and to reform American economic life a repudiation of that for which she had labored. To be sure, she shared some of Roosevelt's concerns, such as compassion for the underprivileged and alarm at private economic power. And more than most Progressives, she might have been expected to respond sympathetically to Roosevelt inasmuch as her involvement in the League had carried her well beyond the concerns of those who were middle-class and Anglo-Saxon. Rather, unlike most Progressives, she had been involved throughout her career with those ethnic and working-class groups that the New Deal brought into the political process. Yet what Robins shared with Roosevelt only made her dismay at the thrust of his policies and their impact upon American society all the more poignant and

troubling. Moreover, her response to the New Deal throws into sharp relief not only the ideas and assumptions that had guided the League but the contrast between Progressive reform thought and the new modes of reform that were coming to dominate America.[28]

Robins believed that Roosevelt's administration was introducing something new and dangerous to America—a bureaucratic, "Prussianized" state, driven by an urge to control and supervise, intent on regulation and regimentation, dedicated to planning and paternalism, yet itself essentially devoid of moral intent and traditional virtue. As president of the League, Robins had advocated many of the specific programs later adopted by the New Deal, such as unemployment insurance and old-age pensions, but she found the tendency toward centralization behind Roosevelt's programs outrageous. "To entrust all the power to the Federal Government," she wrote to Raymond, "always seems to be almost the very worst way of doing anything and surely bureaucracy is deadly."[29] She believed that "control and planning from Washington is absentee landlordism . . . with a vengeance. . . . Regimentation and the subjugation of men is as old as organized society, but the effort to create a society of free men is a new story." According to Robins, difficulties were overcome by the cooperative action of virtuous individuals—the League, of course, was a wonderful example—and not by coercion of the state. In fact, the state could only stifle virtue and forestall initiative, for it acted in terms of masses and not individuals; it required automatons and not responsible citizens. Furthermore, the scope of the state's action was national, and it could not by its very nature take account of the local and personal.[30] As much as Robins loathed the debilitating effects of alcohol on workers, she had originally opposed the Prohibition amendment because it set a single standard without reference to the nation's cultural and regional diversity. So too, she objected in 1933 to cutting the salaries of government employees across the board rather than distinguishing between levels of income.[31]

"I know the work of the world is done in a piecemeal fashion," Robins admitted, and that modest conviction compelled her to see the sweeping measures of the New Deal, such as the National Recovery Administration (NRA), as destructive of particularity and in-

dividuality. "We cannot escape individual responsibility and indi-
vidual judgment," she asserted, "however much some might want
to run away from it into collectivism."[32] Acting upon and in the in-
terests of masses, the state applied universal rules to all citizens,
thereby transforming them from citizens into something perilously
like subjects. One of Robins's (and many Progressives') principal
complaints about Roosevelt was that he had struck a mortal blow
at the conception of America as a commonwealth by making citi-
zens dependent on the state for material welfare and guidance.
When the state became the lord of largesse, it turned the citizenry
into a congeries of groups, each seeking its own limited interest
and advantage, each striving to secure the favor of an impersonal
federal establishment. Between the yawping needs of the crowd
and the distant dispensation of government, any sense of the pub-
lic atrophied. Moreover, being on the dole removed "all sense of
personal responsibility," and a free society could not survive with-
out that quality.[33]

In the eyes of many Progressives, the New Deal thrived on fac-
tion, class warfare, and special interests. On the one hand, the
groups that constituted American society, divided one against the
other, depended upon the state to broker their differences. On
the other, the state found its power immensely expanded by the
divisiveness of society. With a people sunk in materialism and a
state acting by coercion and manipulation, there was no longer a
place for civic virtue, that animating sense of the public good that
transfixed Progressive thought. Progressives such as Robins and
Addams had worked for a protector state, one devoted to restrain-
ing the force of nefarious influences so that space was provided in
which virtue could flourish. They wanted a shepherd, virtuous and
mindful of the common. In the New Deal, as they saw it, they got a
Leviathan.

According to Robins, the broker state that the New Deal erected
was intrinsically immoral because it had abandoned the concep-
tion of citizenship. In America after 1932, there seemed no place
for citizens among the throng of wheelers, dealers, experts, and
bureaucrats. For the Progressives, "citizen" and "reformer" were
virtually synonymous. Acting with like-minded equals and im-
pelled by moral fervor, the citizen voluntarily launched himself into

righting the wrongs of society. He could do no less, for "today the citizen is the builder of the new world and to the citizen is entrusted the making of the covenant of the world."[34] A citizen was no more a mere voter than a trade unionist was simply a dues payer. By participation in civic life, the citizen realized a significant measure of self-government. By introducing democracy to the workplace through such devices as collective bargaining, the trade unionist was winning self-government and thereby realizing herself as a citizen.

Like Jane Addams and John Dewey, Robins conceived of citizenship in the widest, most morally charged terms. She envisioned the possibility of all eighteen-year-olds participating in an elaborate ritual in which, amid banners and music, the youngsters would be enrolled as citizens by taking an oath involving "consecration, self-sacrifice and service." When Robins registered in 1916 for her first presidential vote she told Raymond, "Someday we will have fitting halls of citizenship symbolic of our dream and adventure of Democracy!"[35] Citizen temples, covenant, consecration, sacrifice— Robins enveloped citizenship with piety because, as a Progressive, she believed that it was a God-given privilege and duty. She came from that nineteenth-century evangelical Protestant tradition that assumed that citizenship was an inalienable right, one that morally obliged the individual to safeguard the public good. Politics should be, she wrote early in her career, the "civic expression of a moral truth," and "the love of liberty is after all nothing but an instinctive turning to the light."[36]

Such elevated notions seemed suddenly out of place in New Deal America. It was, indeed, a new era. As far as Robins was concerned, whatever the minions of Roosevelt were up to, they were not evidently turning to the light. In their eyes, the citizen was a consumer and a taxpayer; politics was the construction of coalitions; reform was the efficient administration of relief; liberty was freedom from fear itself; while covenants and sacrifice were things best left to Eleanor, still a member of the WTUL.[37]

Robins felt that the New Deal represented the triumph of mechanistic understandings of both society and the individual over that vitalistic perspective that had informed her career.[38] Although they enacted certain desired programs, she believed that

few administrators of the New Deal regarded those programs as a means of elevating the moral or cultural tone of the country. By resorting to bureaucratic regimentation to address a deep-seated social crisis and by playing upon faction and class warfare when the nation was endangered, the Roosevelt administration had revealed itself as morally bankrupt. In the name of tough-mindedness and showy experimentation, it had devalued community, citizenship, democracy, and voluntarism.

By devaluing voluntarism in favor of government programs, the New Deal also had unwittingly reduced the role of women in shaping public policy. Women had been leaders in Progressive reform associations, and like Addams, Robins, and McDowell, they had pursued careers as volunteers. Of course, women were appointed as governmental employees during the 1930s, and many continued as activists, yet their influence as volunteers plummeted. When government experts and bureaucrats displaced volunteers, and when government subsidies took over the tasks of social settlements, women retreated from the prominent role they had enjoyed since the nineteenth century in molding public debate. To be sure, Roosevelt appointed a woman to his cabinet, but, although of great symbolic value, that gesture hardly compensated for the diminished public influence of countless female volunteers.

Saddest of all for Robins, she could plainly see the effects of the New Deal on that part of the population with which she was most familiar—union workers. She had pinned her hopes on trade unionism because she saw repression as the chief evil in society and laborers as the most repressed group. When workers, through unions, achieved self-government in the workplace, then their experience would educate them to citizenship, and society itself would thereby be invigorated and renewed. Robins's hopes suffered when the New Deal extended itself to workers, especially by imposing compulsory mediation by government between industry and unions and by government imposition (under the NRA) of wage guidelines upon workers. Hugh Johnson, the head of the NRA, even suggested in 1933 that unions and strikes had become superfluous with the creation of the mediation machinery of his agency. At least, he contended, unions should pursue their traditional goals only under "government supervision."[39] After the NRA

was struck down by the Supreme Court in 1935, Robins opposed the Wagner Act, which established the National Labor Relations Board and was widely regarded as very prolabor legislation. As she told Raymond, "Voluntary agreements [between unions and employers] seemed to me the better way." Robins protested in 1936 that "all these laws giving government control are going absolutely in the opposite direction from the way the fighting front of labor has gone for the past one hundred years." They were running counter to freedom and self-government for workers and were therefore "a very serious and tragic mistake."[40]

Even worse from Robins's point of view, the leaders and workers of the unions were doing to their own organizations what the New Deal was doing to the country: they were embracing bureaucratic solutions to their dilemmas and, more than ever, abandoning traditional values in their pursuit of material welfare. There was greater distance between leaders and workers as the former emerged as a professional administrative class within the unions. And, as with the New Deal, the administration increasingly relied on experts, such as professional negotiators, to run the unions.[41] Robins had never been sanguine about the AFL as an institution of reform, but a decade after she saw the new leaders of the League "lower the flag," she also perceived the unions of America surrendering their cherished independence. In the years before World War I, the AFL repeatedly rejected unemployment insurance as paternalistic, bureaucratic, and undemocratic—a dole, as Gompers called it. In 1933, however, the executive council unanimously voted for it; the CFL continued opposition until enactment of the first workmen's compensation laws in 1935.[42]

However much Robins favored unemployment insurance in principle, she could not help but see labor's change of heart as symptomatic of altered values. She particularly resented the adoption by labor circles of the "Security First" slogan during the 1930s. "We had a parade the other day in Tampa with the slogan, 'To Hell with Prosperity, We Want Security,'" she wrote to her sister, adding: "but I cannot feel that 'Security' is a better slogan than 'Making the World Safe for Democracy' was." As Robins saw it, labor leaders had finally abandoned the last vestiges of the heroic values that had motivated the movement for a century, and she continued to

believe that "we must try and win a deeper reason than higher wages and shorter hours for labor's emancipation." Economic security was a pathetic rallying cry, fit only for those incapable of seeing beyond their stomachs and pocketbooks. From her perspective, the laborers of society, in whom she had seen the greatest prospects for moral regeneration and social good, had proven false, "measly rabbits," who wanted safe burrows and certain rations rather than civic virtue and self-government.[43] In the end, it was Robins's misfortune that the values that had informed her career finally had no place in the aspirations of those in whom she had invested her best hopes for America.

Partly because of Robins's disenchantment with the working class, she became persuaded that cities and industrial life could not call forth the best in humanity. To be sure, this was not a new notion. Dislike of cities and admiration for village culture and values were common to many Progressives. In general, the New Deal intensified their rejection of the city, since Roosevelt was allied with urban political machines and with the ethnic blocs that supported them.[44] But the idea of the evil city and the beneficent country was new to Robins. Praise of farms and small towns became a leitmotif of her retirement years, acting for her as an additional argument for disliking the New Deal, as a justification for her rural pursuits at Chinsegut Hill, and as a substitute for that commitment to unionism and industrial workers that she found increasingly difficult to sustain. She concluded that reformers must turn their attention to the countryside, and she recommended that the League send its finest leaders to do for rural America (and especially for the South) what Addams, McDowell, Schneiderman, and Dreier had done for the nation's cities.[45]

Robins's late enthusiasm for country living partially explains her approval of an important Roosevelt project, the Tennessee Valley Authority (TVA). At first glance it seems strange that Robins would support what was widely regarded as the most radical and far-reaching exercise of power by the New Deal. To many observers, the TVA smacked of the national economic planning and mammoth enterprises of the Soviet Union. Nothing like the TVA had ever been seen in the United States; compared to it, the NRA and Civilian Conservation Corps were mere patchwork experi-

ments.[46] Yet Robins was greatly in favor of the TVA, not only because of her new rural perspective but because the vast undertaking could be encompassed by significant aspects of the ideology of the League.[47] In her view, the TVA exemplified the best sort of relationship between the federal government and local communities; citizens in the latter were to participate extensively in supervising the utility companies along the Tennessee River. It was important to Robins that the entire community and not a select few benefited from the advent of electrical power, as well as from the introduction of malaria control, library bookmobiles and recreational lakes.[48] The TVA could thus be seen by Robins as a project that restricted corporate wealth, encouraged participatory democracy, controlled bureaucracy, and promoted self-reliance. It thus represented for her a uniquely beneficent achievement of the otherwise deplorable New Deal, an almost ideal coordination between the means of governmental power and the ends of community vitality and freedom.

The New Deal and Progressivism may be seen as reverse images of each other, a consequence that derives from the deepest impulses of the respective movements. The New Deal exemplified a mastery of means combined with an impoverishment of ends. It had no fear of politics and power, no scruples about exercising governmental authority to alter the economy and society. Roosevelt, however, did not intrinsically link the use of democratic power with a value that was loftier than economic security. Democracy was regarded as a method and did not of necessity entail a vision of social good or human excellence.[49] Thus the best assertion of federal power under the New Deal was not accompanied by a coherent and reasoned articulation of the ends served by that assertion. New Dealers particularly scorned the old Progressive notions of self-reformation and the good society as the ends of civic involvement. Roosevelt at times employed Progressive language in public to describe his goals, but at other times and in private he dismissed it as so much "God stuff."[50] His disregard for principled ends even became a public issue when he attempted to pack the Supreme Court in 1937. In dealing with the courts, Progressives had raised the philosophical question of judicial review in a democracy. In reaction to the Supreme Court striking down New Deal

legislation, Roosevelt used an opportunistic argument involving a crowded docket and septuagenarian judges.[51]

One New Dealer was not surprised that many Progressives opposed Roosevelt's court-packing: that was only to be expected from decayed public men, puritanical moralists from another era. In a revealing excursion into the philosophical issues posed by expediency, New Deal aide Edgar Kemler celebrated "the deflation of American ideals" that characterized the New Deal.[52] He mocked the old reformer Oswald Garrison Villard's proud claim that Progressives always had "the rightful consciousness that the angels have fought with us." Since those "embarrassing" Progressive angels had been expelled from the New Deal, Kemler argued, government had abjured moral complacency and could therefore concentrate upon material objectives. John Dewey attacked the New Deal as "hit-and-miss opportunism"; but Kemler would have considered such a description, coming from a Progressive, as high praise, indeed. For Kemler the New Deal was expediently concerned with man's animal nature, not with his supposed angelic aspect; the times called for engineers and technicians, not for preachers and crusaders. Visions of the good society were merely "excess baggage" in the battle against the depression and fascism.[53] Progressives who survived into the New Deal and "a gangster world" were "antiques," "relics," and "zombies," whose antediluvian zeal for exhortation and morality was a salutary reminder to the new era of the price everyone paid for preoccupation with uplifting ends at the expense of realistic means.[54]

In contrast to the New Deal, Progressivism exemplified an eloquence about ends that often combined with a deficiency of means. Progressives did not lack for ideological justification and articulation. For them, democracy was an end in itself, a communal formulation of the values that animate society. As Robins wrote, democracy was "an appeal to the conscience of the people," awakening in them and building upon the "moral force" of the citizenry. Technically inefficient and morally precious, democracy was both the foundation of a good society and a goal toward which to strive.[55] Power and politics were inherently corrupt tools, fit only for rejection and destruction. The means for achieving the good society, such as trust-busting and the referendum, were essentially negative, since they were to clear the ground so that the individual

would be freed and society reformed. Given those accomplishments, education and moral discipline would suffice.

There was, at least, no doubt about what Progressives like Robins wanted and valued: creativity, vitality, self-realization, responsibility, fellowship, community, citizenship, democracy. Yet there is a weightless abstraction to this litany that makes it easy to comprehend the impatience of New Dealers with Progressive ideology. Starting from optimistic premises about man and society, Progressives resolved social questions into educational ones and educational questions into considerations of moral development.[56] They articulated their vision of the fulfilled individual and the receptive society, but their intense, unquestioning faith in the dormant existence of both prevented them from seriously considering how they were to be realized.

Of course, if pushed to the question of how the individual and society were to achieve their proper fulfillment, especially when present reality was so distant from the ideal, reformers might well have pointed to the numerous voluntary organizations that flourished in the Progressive period, such as the social settlements, the WTUL, the Consumers' League, the Child Labor Committee, the Juvenile Protective Association, the Playground Association, the Immigrants' Protective League, the American Association for Labor Legislation, and the National American Woman Suffrage Association (later the League of Women Voters). One of the most striking features of the Progressive era, these associations represented perhaps the greatest voluntary outpouring of emotion and effort for social service and reform in American history.[57] Progressive associations attacked a range of social ills and, one might conclude, in their modest, molecular fashion laid the foundation for the future.

Yet this argument does not in fact advance beyond an expression of faith that society will be redeemed by what Robert A. Woods, a settlement founder, called "the propaganda of deed." Faith sustained Progressive associations—faith, as Graham Taylor, another settlement pioneer, put it, "that right is might and must prevail, that truth will outlive error, that love abides and cannot fail."[58] In effect, faith in eventual triumph made detailed consideration of means beside the point. Coherent formulation of the relationship between reform activity and the good society was unnecessary, perhaps even self-defeating, since ends and means were

perceived as merging in the process of individual and social development. Robins and like-minded Progressives established a context within which the mundane, limited drudgery of reform—the provision of bathhouses and strike rations, the promotion of job security and the eight-hour workday—took on a transcendental glow. They saw incremental acts as both possessions unto themselves and as going to the farthest reach of the future. The "propaganda of deed" accrued meaning within an indefinite context of consequences; involvement in reform was assumed to have a ramifying influence that could be neither seen nor measured. Psychological gratification for the reformer was therefore often found more in a sensation of significance than in the accomplishment of particular goals. Hence, rhetoric substituted for argument in conceiving of the transition from well-intentioned associations in a hostile world to a society that fully realized progressive intentions. The rhetoric of Progressives was testimony to certainty about values and their eventual fulfillment.

Although Robins's rhetoric often sounds naive and sentimental to the modern ear, her audiences were thrilled when she placed ordinary tasks in the context of a winning struggle for self-fulfillment and social justice. Inspirational and eloquent in her public role, she was neither original nor profound; her mind was busy and innocent rather than reflective. She was, however, a representative thinker, one who could absorb and interpret the thoughts of her day. Her strength in the realm of ideas lay in her ability to provide her colleagues and followers in the League with an ideology that evoked excitement and dedication. When she exhorted working women to release the "hidden treasures" of the self and to bring into being a "festival of life," she was simultaneously presenting them with a reality they could share and an ideal they could approximate. By the terms in which she urged them to realize individual and social possibilities, she was implicitly absolved from dealing with the intractable question of how the larger society would reach the same desired goals.

Such questions were all the more easily avoided in that Robins was generally addressing audiences of the converted; her purpose was to invigorate her listeners, not to engage them in philosophical discourse. Her conceptual vocabulary, which she drew largely

from Dewey, James, and Emerson, worked toward the same end, for her emphasis upon possibility, potentiality, energy, development, adventure, creativity, and vitality naturally lent itself to the notion that in some sense ends were dynamically embedded in means. The idea of process permeated her thinking, as it did that of both Dewey and James. At times, her enthusiastic sense that she was part of a process in which intention and realization were fused assumed a comic cast. A proponent of evolution, she chided William Jennings Bryan, a guest at Chinsegut Hill in 1925 while en route to the Scopes trial, for not accepting that "love" and "service" could be grafted onto the evolutionary tree. At other times, she was touching and courageous, as when she comforted her husband in a moment of despair with the German proverb "Man's wishes are his Paradise."[59] Above all, Robins's affirmation of process as a human reality was congruent with her activism, indeed, essential to it, for it at once justified the imprecision of her concepts, the exultatory tone for which she strived, and the hopes she cherished for the future. That affirmation was the intellectual reflection of her optimistic temperament, an elevated expression of the certainty of triumph that she brought to all her labors of reform.

"It is the lost possibilities that haunt us," Robins said early in her career, "and that are calling out a greater social service than ever before."[60] More than three decades later, from Robins's perspective, the very ideals that had motivated Progressive social service and reform had joined the list of "lost possibilities." At the height of the Progressive era, Dewey had feared such an outcome. Writing upon the occasion of James's death in 1910, Dewey praised his fellow philosopher as having epitomized the American tradition, guided by thought and action yet open to freedom, adventure, and possibility. Dewey suggested that "a civil war, an internal split" loomed in American life between those who relied upon philosophical principles in action and those who were in thrall to materialism.[61]

For many Progressives, Dewey's premonition had been realized by the 1930s. As Raymond Robins put it, the events of those years had "broken the sequence of American life."[62] Insofar as the New Deal and Progressivism may be regarded as reverse images of

each other, the former preoccupied with results at the expense of traditional reform values and the latter content with values at the cost of substance and efficacy, American political thought was peculiarly bankrupt. As the depression wore on, New Dealers scorned the "Old Guard" Progressives as unworldly dreamers, given to abstraction, exhortation, and self-righteousness, while many Progressives castigated New Dealers as expedient bureaucrats, contemptuous of principle and tradition. It was as if the two camps had fought to exhaustion in the "civil war" feared by Dewey, with victory (or political power) going to the materialists. Still, there was considerable truth in both sets of accusations. Through the terms of abuse used by both sides, the essential nature of the respective movements may be discerned, as well as how distant the tone and spirit of each was from the other.

In the collision between Progressive ideology and New Deal practices, the historian is faced with a confrontation of political ethics, for "the emergency that gave rise to the New Deal also gave rise to a transvaluation of values."[63] To be sure, many Progressive proposals received legislative form in the Roosevelt administration, ranging from social security and unemployment insurance to old-age pensions and housing programs. But according to Progressives such as Robins, the spirit behind New Deal reforms and the means of their enforcement made all the difference. No doubt many Progressives would have agreed that in regard to numerous proposals, "Progressives blazed the trail . . . [and] the New Dealers turned it into a thoroughfare."[64] It is, however, equally true that most Progressives lamented that the New Deal highway necessarily led to an intellectual and moral dead end. From their perspective, there had been in the 1930s a disastrous divorce between theory and practice, between ends and means, and between value and action, which constituted a repudiation of the fundamental principles of the American reform tradition. With that tradition outcast and dying, and with a new society under construction, it was difficult to see when, if ever, the possibility of true reform would be resurrected.

Lost possibilities haunted Robins during her final years, the possibilities she had aspired to realize for ordinary men and women, for workers and unions, for the League and the reform

movement, for America and democracy itself. Despite her dis-
appointments, however, she rarely succumbed to bitterness and
despair. As with many of her former colleagues, her dominant atti-
tude toward the outcome of Progressive reform was one of be-
wilderment.[65] In 1936 she plaintively asked Agnes Nestor, "Why did
we miss out? What, in your judgment, was the mistake made by the
workers and by all of us who wanted some measure of justice for
our people in America?" In answering her mentor, Nestor pointed
to the essential mistake of all those who a generation before had
seen life so amenable to improvement, so malleable to the re-
former's touch: "If somehow we could get all the workers to under-
stand this great movement and our problems, if human beings
were all perfect—if somehow we were all so wise that things could
be done without reversals—well then, I suppose great progress
could be made and our world would be a different kind of place.
But folks are not like that." After this appraisal, Nestor went on to
comfort Robins with a line of poetry that Alice Henry had sent
them years ago: "'We shall not travel by the roads we make.' We
may not, but someone else will and someone made roads for us."[66]
The notion that Robins was part of an ongoing process, which had
always been an assurance to her of victory, was now to console her
in defeat.

Robins was reluctant to accept Nestor's contention that their
failure to sustain reform was due to too high an estimation of hu-
man nature. She had always found it difficult to accommodate
harsh facts. It could never be said of her what James remarked of
Jane Addams: "She inhabited reality."[67] Precise and shrewd when
dealing with such matters as strike organization and fund-raising,
Robins's realistic touch deserted her when she turned to larger
considerations, such as social movements and human capacities.
Her ideology, with its calm certainty of success and its robust lack
of qualms, failed her when she tried to encompass forces that were
not progressive. In addressing a League convention in 1922, she
floundered when trying to explain what had happened to America
in recent times: "We have been living in these difficult years and
life has been hard and ugly, and there are times when it seems that
nothing but ugliness stood out and men and women seemed to be
moved in numbers by mob action and the mob spirit; we were con-

scious of the ugliness of life, this ugly thing, and we have all been held by it, it seems so overwhelming in its power."[68] Similarly, she considered that the rise of fascism in Europe indicated that "the world is overtaken by a strange insanity," while the outbreak of World War II was explained as "a bestial throwback to the tribal age of the race."[69]

Ugliness, insanity, throwback—these are more terms of evasion than of rational comprehension. Robins refused to acknowledge that cruelty, oppression, and barbarism were intrinsic to human affairs. For her, courage and faith precluded a "sense of desperate tragedy."[70] In fact, in her optimism about human nature and in her obliviousness to sin and the tragedy of history, Robins bears considerable resemblance to her bête noir, Franklin D. Roosevelt.[71] Not without good reason did Raymond feel a sense of relief that his wife died a few months before she would have learned of the full horrors that had taken place in the land of her forebears, the nation of civic Bremen. Robins needed to see human flaws, social ills, and political defeat as epiphenomena, transient difficulties to be solved by intelligent effort in the service of mankind and history. For all her courage, imagination, and seemingly inexhaustible energy, she needed that expectation of triumph that is possible only when times are easy. She had too many certainties, too effortlessly earned and too inflexibly held, for a time of troubles. Her life had been hopeful and active because her early and mature adulthood had coincided with those years in American history in which society seemed to be conforming to her vision.[72] Later, when events proved otherwise, she could only stand in bewilderment, anxiously wondering what had gone wrong.

Robins was a classic example of the psychological type that William James in *The Varieties of Religious Experience* calls "the healthy-minded," individuals whose temperaments are "weighted on the side of cheer and fatally forbidden to linger . . . over the darker aspects of the universe."[73] Their souls have a "sky-blue tint," and their "tendency to see things optimistically is like a water of crystallization in which the individual's character is set." They are earnest, moralistic, saintly, and shallow. Walt Whitman is their poet and Emerson their oracle. They view the world as an abode of goodness, while evil is seen as alien and irrational. Unhappiness is

"mean and ugly," less a response to reality than a character flaw, a failure of nerve before the exhilarating potentiality proffered by existence. These relentless optimists are meliorists regarding social problems and latitudinarians concerning religion. Their Christianity bypasses hell-fire and suffering for a "new sort of religion of Nature," which uses the idea of evolution to bolster an invigorating belief in process and progress.

Robins's embrace of the "gusty, dawn-world confidence" typical of Progressives was clearly an expression of the deepest impulses of her personality. At the same time, James's description of "the healthy-minded" may be regarded as virtually an evocation of the ethos that informed Progressivism.[74] However that may be, the ranks of Progressives certainly included individuals of vastly different temperaments. Raymond Robins approximates James's contrasting psychological type, "the sick soul."[75] An atheist until his Alaskan conversion, Raymond carried into his Christianity and reformism elements of the morbidity, melancholy, and subjectivity that James identified as intrinsic to "the sick soul." Poor and neglected as a youth, he retained a sense that failure, danger, and disaster were an inevitable part of life. Whereas his wife was moderate and calm, he was extreme and excitable. Although both were confident in their reform work that they were battling for the Lord, Raymond was rather more certain that he stood at Armageddon. While Margaret's optimism was innate, the taproot of her personality, Raymond "had willed himself to be optimistic all his life."[76]

Unprepared by her experience or temperament for failure, Margaret was bewildered by what had happened to the reform movement and America. Raymond, with a perverse delight, as if glad that his worst expectations had been fulfilled, insisted on his despair and bitterness. Toward the end—and he survived his wife by nine years—he became increasingly hysterical and rigid. In his eyes, America had turned into "the land of the Frightened and the Home of the Slave."[77] When World War II began, he wrote to his wife that he hoped "blood and death and fire and red glare of burning cities will clarify and purify the life of man." A year earlier, Raymond had written that the depression hung on because the racial "stock" in the United States was degenerating. Furthermore, he told Margaret, "I feel under little compulsion to help in this coun-

try—seeing what we have done in the past and what fruits have come from great expense and the love and faith you have given so bountifully." But Margaret could never feel that way, any more than she could see promise in blood and fire. In responding to Raymond, she once more, quietly but firmly, expressed the hope that her husband no longer shared or comprehended: we must, she wrote, encourage reform, despite the obstacles, for a new generation of Americans was emerging, and true democracy could be achieved only through them.[78] She continued to hope that the new generation would return to the tradition of reform that had been abandoned. She died at the age of seventy-seven on February 21, 1945, and Raymond buried her the next day at sunrise beneath a giant oak at Chinsegut Hill.

If Robins had been so inclined, she could have perceived multiple ironies in her retirement years: the leader of working women ensconced in an antebellum mansion, the trade-union organizer disapproving of union activity, the reformer opposing reform, the urban activist lauding the countryside. But if Robins had been sensitive to irony, it is doubtful that she would have been as successful at inspiration and leadership as she was. The ideology of the League had its complexity, its own particular meed of richness for its devoted followers, but it was not such as to lead to recognition of the twists and turns of history. Members of the League needed to believe that they were on the winning (and morally righteous) side of a struggle for social justice. Such a view called for a fundamental simplification of issues, a strenuous healthy-mindedness toward society and history. Robins provided precisely that in her elaboration of the principles of League reform. Her personal strengths and shortcomings, then, were reflected in those of the League, and both are revealing of the strengths and shortcomings of Progressive reform itself. Only on the basis of a certain simplification could reform go forward and success be anticipated, but that simplification in the end limited the force of reform and presaged eventual failure. In her temperament, activism, ideology, and final disappointment, Robins was indeed a representative figure of the Progressive era. Moreover, her attitude toward the New Deal highlights the greatest and last irony in the historical career of Progressivism, that many Progressive reforms were realized under the

aegis of an administration and in the service of principles that Progressives opposed. In other words, Progressive reform became practice, but without the "excess baggage" of the values that meant everything to the Progressives. It was as if history had played an immense joke on Robins and her fellow reformers.

As William James was aware, there is something comic about "the healthy-minded." They are so at odds with reality, so oblivious to the dark side of life, that they virtually invite defeat and disenchantment; they set themselves up as fools and dupes. Robins cannot be fully understood, however, unless it is recognized that she was aware of that consideration, even though she was not a student of irony. Not only could she find it in James, she could also discover it in the thinker who had influenced her the most. She had turned to Emerson for resolution of her religious doubts in the late 1890s, finding in him a way to translate "the power of God into the everyday affairs of men." Josephine Shaw Lowell, Robins's mentor in New York in the early 1900s, no doubt used Emerson's essay on reform to convince Robins to take up the problems of workers.[79] Emerson similarly meant a great deal to Robins in her years of disappointment and bewilderment, and what had been her incentive to enter reform became her solace long after she had left it. "Sweetheart," she wrote to Raymond in 1938, "in between many things and a sense that the world is too much with us, I am reading Emerson with deepest joy." Emerson, she said, "speaks to my heart." She still hoped that America someday "may have grown up to him"—perhaps an echo of James's wish that there would come a time when "Emerson's philosophy will be in our bones, not our dramatic imagination."[80]

Emerson's essay on reform could stand as the credo of Progressivism: "The power which is at once the spring and regulator in all efforts of reform is the conviction that there is an infinite worthiness in man, which will appear at the call of worth, and that all particular reforms are the removing of some impediment." Yet in believing that love is "the one remedy for all ills," that "every calamity will be dissolved in the universal sunshine," reformers are ill adapted to the world, tending toward an excess of zeal commensurate with the evils requiring remedy. Defeat reminds reformers that they perforce dwell in a harsh, unwelcoming world and that

they are "liable to that slight taint of burlesque which in our strange world attaches to the zealot. A saint should be as dear as the apple of the eye. Yet we are tempted to smile, and we flee from the working to the speculative reformer to escape that same slight ridicule." As holy fools and secular saints, reformers seek to transfigure humanity "by the power of principles." In so doing, they bring to laborious existence something of their "abode in the deep blue sky," and though "the clouds shut down again . . . yet we retain the belief that this petty web we weave will at last be overshot and reticulated with veins of the blue."[81] In rereading Emerson, then, Robins encountered not only an argument for reform but a transcendent rationale for the inevitable twining of reform and folly, faith and defeat.

Robins found the same message in William James's *The Varieties of Religious Experience*, though whether she recognized herself as one of "the healthy-minded" is unknown. James considered himself something of an Emersonian, even though his father's old friend had "that ripe unconsciousness of evil" that appealed so much to those with "sky-blue" souls, a type for which James generally had scant respect.[82] James at least reveals himself as an Emersonian when he deals with the question of saintliness, in particular, with the problem of excessive tenderness and charity by saintly persons. These key passages, which are concerned with idealistic reform in an unsympathetic world, were copied into typescript and sent to Mary Dreier.[83] Given the extremely close relationship between Dreier and Robins, as well as the relevance of the subject to both of them, there is no doubt that the sisters found common comfort in James's discourse.

Like Emerson, James noted that saints (or reformers, as they appear in modern, secular guise) are "ill adapted" to the world and that their virtues are necessarily "manifested in excess." They often seem in the midst of the world's affairs to be preposterous inasmuch as "appeals to sympathy or justice are folly when we are dealing with human crocodiles and boa-constrictors." Hence, "hard-headed, hard-hearted, and hard-fisted methods" are seemingly necessary. But, James went on (and Dreier underscored), if there were no one willing to act generously, passionately, and

foolishly, "the world would be an infinitely worse place than it is now to live in. The tender grace, not of a day that is dead, but of a day yet to be born somehow, with the golden rule grown natural, would be cut off from the perspective of our imaginations." By keeping that day within humanity's imagination, however, saints, with their foolish optimism and blind trust, become a "genuinely creative social force." The likelihood that those with unrealistically high ideals will be defeated is not an argument against commitment to those ideals: "Momentarily considered, then the saint may waste his tenderness and be the dupe and victim of his charitable fever, but the general function of his charity in social evolution is vital and essential. If things are ever to move upward, some one must be ready to take the first step, and assume the risk of it."[84]

With a perspective on defeat informed by Emerson and James, Robins would not have flinched at being called a fool and a dupe in the service of reform. She was willing to take that risk. Nor would she have been impressed by the contention that her ideals had no place in "a gangster world," for she already knew that virtue was the prey of human crocodiles. The function of ideals, she understood, was to hold open possibilities, and that was perhaps even more important in defeat than in triumph. Of course, most New Dealers would have scorned the reforming saints and holy fools of Emerson and James, just as they ridiculed the "angels" who fought for the Progressives. Robins was certainly aware that in going to Emerson and James, she was seeking consolation in an exhausted tradition. In the Progressive movement, she had been a central part of "the zenith of reform, of the impulse, in secular form, for the achievement of virtue."[85] By the time of her death, she had well outlived the shift from evangelical reform to bureaucratic liberalism. Religious commitment, the lifeblood of the crusade for social justice, finally was drained from the American reform tradition.

It already seemed like much more than a generation ago that Robins had married Raymond and left New York for a new life of reform. As she wrote to Addams in 1930, "It came over me again and again, 'to think I am walking the streets where Jane Addams lives.' I thought of One who walked in Galilee and then I thought of you in Chicago." Those were the bright days when Addams was

casually and sincerely referred to as "Saint Jane" and when Mary McDowell was "the Angel of the Stockyards."[86] In the closing months of World War II, it hardly seemed possible to Robins that she was once part of a time when reform was so confidently, indeed religiously, anticipated. In 1922 she told a convention of the League that "the spirit of God is within each one of us, seeking to be released. . . . To set free the spirit of God within us—that is the task to which we here stand dedicated."[87]

That was a formidable enterprise for a trade-union organization, if not for the entire Progressive movement marching as to war. Spoken in the dying days of Progressive confidence, and on the occasion of Robins's retirement as president of the Women's Trade Union League, her declaration was as much a prayer for the future of reform as it was a confession of abiding faith. She could not know then that her prayer would go unanswered and that the catechism of reform would be rewritten for a more severe and secular age. When she finally came to that realization, at least her philosophy of reform provided a context in which her bewilderment and failure could be accepted as natural and even noble. When in 1937 she wrote to Raymond that "though we may not have any prophets, we certainly have saints—however few apart these may be," Robins was far too modest to have been thinking of herself.[88] Yet if one considers reforming saints as she had come to understand them, with their all-too-human experience of sacrifice and defeat, trust and betrayal, wisdom and folly, then Margaret Dreier Robins may be placed honorably in their ranks. In her ambition to create something of an earthly reflection of the heavenly city, she was no doubt destined to fail; but in keeping that possibility within the perspective of imagination, she also found her own salvation.[89] Her wishes were her paradise.

## Notes

1. MED, *Robins*, p. 25; MDR to Mrs. Ellis A. Yost, May 20, 1924, copy, box 29, MDR Papers; RR to MED, Jan. 4, 1935, MED Papers; MED to MDR, May 18, 1937, box 44, MDR Papers. MDR was always very active in civic life in Florida. She was president of the Hernando County YWCA, chairman of the Red Cross for the county, and treasurer of the Tamiani Trail Bookshop, which she founded and financed; she also was involved in

public-health education, investigated the problems of tenant farmers, and acted as a consultant to the League for its southern campaigns (see MDR to MED, Nov. 15, 1934, box 40, MDR Papers; MED, *Robins*, pp. 205–6).

2. RR to MDR, Feb. 20, 1924, box 58; MDR to Ethel Smith, May 6, 1927, box 31, MDR Papers. On the chart, see Lemons, *Woman Citizen,* pp. 210, 214–16.

3. For MDR's statement, see MDR to RR, Sept. 15, 1918, box 62, MDR Papers. For RR's statement, see RR to MDR, Jan. 18, 1924, box 58, MDR Papers.

4. See Joseph Rayback, *A History of American Labor* (New York: Macmillan Co., 1966), pp. 290–313.

5. MDR to MED, May 9, 1930, box 34; RR to MDR, Apr. 30, 1929, box 67, MDR Papers.

6. MDR to RR, June 15, 1924, box 66; Irma Hochstein to MDR, Oct. 28, 1931, box 36; cf. MDR to MED, Oct. 22, 1931, box 36; MDR to RR, June 15, 1924, box 58; MDR to RR, Sept. 1, 1930, box 60, MDR Papers.

7. The quotation is from MED, *Robins*, p. 22.

8. For the description of MDR as the "great Mother," see Mrs. William [Anne] Hard to Mary Anderson, [c. 1950], Mary Anderson Papers. Also see RR to MDR, Apr. 30, 1929, box 67, MDR Papers.

9. MED, *Robins*, pp. 220–21, 224, 232–33. In the stock market crash the Robinses lost all but $200,000 of two million dollars (RR to MDR, Apr. 24, 1931, box 60; RR to MDR, May 23, 1929, box 29, MDR Papers).

10. On RR's amnesia, see *New York Times* for Sept. 9, 11, 12, Oct. 7, Nov. 19, 23, 1932; both RR's disappearance and his discovery merited front-page headlines in the newspaper. MDR's statement comes from the author's interview of Lisa von Borowsky, the Robinses' secretary and companion, Mar. 22, 1979, Brooksville, Fla. On the meaning of Chinsegut, see Salzman, "Reform and Revolution," p. 122.

11. MED to MDR, Oct. 27, 1932, box 38; Mary Anderson to MDR, Mar. 18, 1932, box 37, MDR Papers. The phrase "tired radicals" comes from a contemporary analysis of Progressivism, Walter Weyl's *Tired Radicals and Other Essays* (1919): see William E. Leuchtenburg, *The Perils of Prosperity, 1914–32* (Chicago: University of Chicago Press, 1958), p. 124.

12. Leuchtenburg, *Perils of Prosperity,* pp. 120–39; Arthur A. Ekirch, *Ideologues and Utopias: The Impact of the New Deal on American Thought* (Chicago: Quadrangle Books, 1969), pp. 15–16; Arthur S. Link, "What Happened to the Progressive Movement in the 1920s?" *American Historical Review* 64 (July 1959): 833–51; Eric C. Goldman, *Rendezvous with Destiny* (New York: Knopf, 1958), pp. 291–94. On continued reform efforts in the 1920s, see Clarke A. Chambers, *Paul U. Kellogg and "The*

*Survey": Voices for Social Welfare and Social Justice* (Minneapolis: University of Minnesota Press, 1971); Chambers, *Seedtime of Reform: American Social Service and Social Action, 1918–1933* (Minneapolis: University of Minnesota Press, 1963).

13. Quoted by James T. Patterson, *Congressional Conservatism and the New Deal: The Growth of the Conservative Coalition in Congress, 1933–1939* (Lexington: University of Kentucky Press, 1967), p. 22; cf. MDR to MED, Mar. 21, 1933, box 39; MDR to Dorothea Dreier, March 31, 1933, copy, box 39, MDR Papers; Robert M. Crunden, *From Self to Society, 1919–1941* (Englewood Cliffs, N.J.: Prentice-Hall, 1972), pp. 177–91.

14. Quoted in William E. Leuchtenburg, *Franklin D. Roosevelt and the New Deal, 1932–1940* (New York: Harper and Row, 1963), p. 339; cf. Henry F. May, *The End of American Innocence: The First Years of Our Own Time, 1912–1917* (New York: Knopf, 1959); Robert H. Elias, *"Entangling Alliances with None": An Essay on the Individual in the American Twenties* (New York: W. W. Norton and Co., 1973); T. J. Jackson Lears, *No Place of Grace: Antimodernism and the Transformation of American Culture, 1880–1920* (New York: Pantheon Books, 1981).

15. On the New Deal as a "drastic new departure" in the history of American reform, see Hofstadter, *Age of Reform*, pp. 300–326; for a contrary interpretation, see Goldman, *Rendezvous with Destiny*, and Andrew M. Scott, "The Progressive Era in Perspective," *Journal of Politics* 21 (Nov. 1959): 685–701.

16. "WTUL of Illinois Year Book, Public Meeting of Industrial Committee, Illinois Federation of Women's Clubs," Mar. 6, 1908, box 17, MDR Papers.

17. F. S. Potter, "The Educational Value of the Women's Trade Union League," *Life and Labor* 1 (Feb. 1911): 37.

18. John and Evelyn Dewey, *Schools of Tomorrow* (New York: Dutton, 1915), p. 7; cf. Sidney Hook, "John Dewey—Philosopher of Growth," *Journal of Philosophy* 56 (1959): 1013.

19. On the playground movement, see McArthur, "Chicago Playground Movement," pp. 390–93; on the Child Labor Committee, see Chambers, *Seedtime of Reform*, pp. 13–14; on the public health movement, see Walter I. Trattner, *Homer Folks, Pioneer in Social Welfare* (New York: Columbia University Press, 1968). On the expansive and even "arrogant" schemes of Progressive social reformers, see Don S. Kirschner, "The Ambiguous Legacy: Social Justice and Social Control in the Progressive Era," *Historical Reflections* 2 (Summer 1975): 85.

20. Cf. MED to MDR, Mar. 22, 1932, box 37, MDR Papers.

21. Cf. Hofstadter, *Age of Reform*, pp. 200–201, 254–61; Grant Mc-Connell, *Private Power and American Democracy* (New York: Knopf, 1966), pp. 38–40; Robert S. Maxwell, *La Follette and the Rise of Progressivism in Wisconsin* (Madison: State Historical Society of Wisconsin, 1956); George E. Mowry, *The California Progressives* (Berkeley: University of California Press, 1951).

22. On MDR, see MDR to Norman Hapgood, Nov. 30, 1908, box 26, MDR Papers; on Addams, see Jane Addams, "The Revolt against War," in her *Women at the Hague* (New York: Macmillan Co., 1915), pp. 84–92; cf. Graham, *An Encore for Reform*, p. 12. On Progressive belief in education, see Lawrence A. Cremin, *The Transformation of the Schools: Progressivism in American Education, 1876–1957* (New York: Knopf, 1961).

23. Quoted in Davis, *American Heroine*, p. 186.

24. On the convention singing, see MED, *Robins*, p. 88 and Davis, *Spearheads*, p. 197; on the ardent delegates, see John Allen Gable, *The Bull Moose Years: Theodore Roosevelt and the Progressive Party* (Port Washington, N.Y.: Kennikat Press, 1978), pp. 75; cf. 96–97.

25. Quoted in Davis, *Spearheads*, p. 203.

26. RR to MDR, Apr. 25, 1924, box 58, MDR Papers. On the Progressive Party and the likelihood of defeat, see Gable, *Bull Moose Years*, pp. 6, 98, 187–88.

27. Roosevelt is quoted in William Leuchtenburg, *In the Shadow of FDR: From Harry Truman to Ronald Reagan* (Ithaca, N.Y.: Cornell University Press, 1983), p. 245.

28. On Progressive and New Deal connections with the ethnic working class, see John D. Buenker, *Urban Liberalism and Progressive Reform* (New York: W. W. Norton and Co., 1978), pp. 231–36. On Progressive reactions to the New Deal, see Graham, *An Encore for Reform*.

29. MDR to RR, Feb. 5, 1934, box 62; MDR to MED, Nov. 9, 1932, box 38; MDR to MED, Mar. 21, 1933, box 45, MDR Papers. On support for old-age pensions, see Emma Steghagen to MDR, July 18, 1942, box 48, MDR Papers.

30. MDR to John Dreier, Oct. 12, 1936, copy, box 49; MDR to RR, Nov. 6, and 10, 1936, reel 62; MED to MDR, Mar. 22, 1932, box 37, MDR Papers; cf. John Dewey, *The Public and Its Problems: An Essay in Political Inquiry* (New York: Holt and Co., 1927), p. 219.

31. Cf. MDR to Mrs. Ellis A. Yost, May 20, 1934, copy, box 29; MDR to MED, Apr. 24, 1933, box 39, MDR Papers. Also see MDR to RR, Apr. 18, 1933, reel 62, MDR Papers.

32. The quotation is from MDR to RR, Mar. 14, 1924, box 65; cf. MDR

188 Reform, Labor, and Feminism

to RR, Nov. 16, 1933, box 62, MDR Papers; Walter Lippman, *The Good Society* (Boston: Atlantic-Little, Brown, 1937), pp. 103–30.

33. MDR to Elisabeth Christman, May 27, 1936, copy, box 49; MED to MDR, Mar. 9, 1936, box 42, MDR Papers; MED, *Robins*, p. 219; cf. Leuchtenburg, *Franklin D. Roosevelt*, pp. 177–78; James Holt, "The New Deal and the American Anti-Statist Tradition," in *The New Deal*, vol. 1, *The National Level*, ed. John Braemen, Robert H. Bremner, and David Brody (Columbus: Ohio State University Press, 1975), pp. 27–49.

34. "Address of Mrs. Raymond Robins to the Congress of the International Federation of Working Women," Aug. 14, 1923, reel 12, MDR Papers.

35. MDR to MED, Oct. 2, 1914, box 23, MDR Papers; MDR to RR, Oct. 8, 1916, reel 567, no. 1, RR Papers; MED, *Robins*, pp. 110–11. MDR's idea of citizenship as social service is related to William James's "The Moral Equivalent of War," in his *Memories and Studies* (New York: Longman, Green, 1911), pp. 267–96.

36. MDR, "Democracy," pp. 1–2, in "Writings: Early Essays and Drafts," [1903?], box 1, MDR Papers.

37. RR to MDR, July 8, 1932, box 61, MDR Papers. In 1941, the WTUL gave a testimonial dinner for Eleanor Roosevelt in New York City; the first lady made a brief speech "on the purposes and idea of Democracy" (MED to MDR and RR, Jan. 29, 1941, MED Papers).

38. For the revolution in values represented by the mechanical model of society, see Wiebe, *Search for Order*, pp. 133–63.

39. Bernard Belush, *The Failure of the NRA* (New York: W. W. Norton and Co., 1975), p. 94. According to Hofstadter (*Age of Reform*, p. 311), the NRA codes amounted to ratifying "the trustification of society."

40. MDR to RR, July 5, 1937, reel 63; MDR to MED, May 30, 1936, box 43, MDR Papers. On the Wagner Act, see Leuchtenburg, *Franklin D. Roosevelt*, pp. 151–52.

41. Cf. Sidney Fine, "The History of the American Labor Movement with Special Reference to Developments in the 1930's," in *Labor in a Changing America*, ed. William Haber (New York: Basic Books, 1966), pp. 105–20.

42. Edwin E. Witte, "Organized Labor and Social Security," in *Labor and the New Deal*, ed. Milton Derber and Edwin Young (Madison: University of Wisconsin Press, 1957), pp. 361–72.

43. MDR to Elisabeth Christman, May 27, 1936, copy, box 49, MDR Papers. On Americans as "measly rabbits," see MDR to MED, June 19, 1937, box 50, MDR Papers.

44. On the "agrarian myth," see Hofstadter, *Age of Reform*, pp.

23–59; cf. Graham, *An Encore for Reform*, pp. 71–72; Morton J. Frisch, "The Welfare State as a Departure from the Older Liberalism," in *The Thirties: A Reconsideration of the American Political Tradition*, ed. Morton J. Frisch and Martin Diamond (De Kalb: Northern Illinois University Press, 1968), p. 69.

45. MED, *Robins*, p. 230; MDR to Lisa von Borowsky, Aug. 13, 1926, box 30; MDR to John Dreier, Oct. 12, 1936, copy, box 49; MDR to Elisabeth Christman, Mar. 19, 1936, box 42; MDR, "The Human Side of the Industrial South," address to the 11th Biennial Convention of the NWTUL, Southern Session, May 9, 1929, Washington, D.C., box 3, MDR Papers.

46. Leuchtenburg, *Franklin D. Roosevelt*, pp. 54–55, 164–65; Ekirch, *Ideologues and Utopias*, pp. 120–21.

47. Moreover, TVA had substantial Progressive roots in the efforts of Senator George Norris of Nebraska to maintain government control of the key power site at Muscle Shoals in the Tennessee Valley, a development begun during World War I. Progressives in the National Popular Government League and others who advocated public power made their support of Roosevelt over Hoover conditional on the former's views on Muscle Shoals: see Elliot A. Rosen, *Hoover, Roosevelt, and the Brain Trust: From Depression to New Deal* (New York: Columbia University Press, 1977), pp. 352–56; Preston J. Hubbard, *Origins of the TVA: The Muscle Shoals Controversy, 1920–1932* (Nashville: Vanderbilt University Press, 1961), pp. 1–27.

48. The last three items especially interested MDR. She always saw recreation as an important part of a worker's life; in Florida she became involved in public health work; and she founded a bookshop in Brooksville, which for many years functioned as the town's public library (MED, *Robins*, pp. 204–5, 235).

49. George Wolfskill, "New Deal Critics: Did They Miss the Point?" in *Essays on the New Deal*, ed. Harold M. Hollingsworth and William F. Holmes (Austin: University of Texas Press, 1969), p. 59; Frisch, "The Welfare State," p. 82.

50. George Wolfskill, *Happy Days Are Here Again!: A Short Interpretative History of the New Deal* (Hinsdale, Ill.: Dryden Press, 1974), p. 193.

51. Hofstadter, *Age of Reform*, p. 309; on the court-packing, see Leuchtenburg, *Franklin D. Roosevelt*, pp. 232–38.

52. In his introduction to Edgar Kemler's *The Deflation of American Ideals: An Ethical Guide for New Dealers* (1941; reprint ed., Seattle: University of Washington Press, 1967), Otis L. Graham states that Kemler, a minor government official, "possessed the combination of New Deal enthusiasms and historical perspective necessary to produce one of the first

descriptions of the temper that distinguished New Deal liberalism" (p. xiii). For Kemler on the court-packing, see *Deflation*, p. 73.

53. Kemler, *Deflation*, pp. 34, 25, 74; for Dewey's statement, see Cushing Strout, "Pragmatism in Retrospect: The Legacy of James and Dewey," *Virginia Quarterly Review* 43 (Winter 1967): 126.

54. Kemler, *Deflation*, pp. 73–74, 111. Kemler conceded that a few Progressives, such as Senator George Norris, the younger Robert La Follette, and Louis Brandeis, were able to transcend "the bugaboos of the Progressive Era" and thus represent "the shift from moral to engineering reform since the time of Woodrow Wilson" (pp. 81–82).

55. MED, *Robins*, pp. 13–14; MDR to RR, Apr. 10, 1913, box 55, MDR Papers; cf. Dewey, "Democracy as a Way of Life," in *Frontiers of Democratic Theory*, ed. Henry S. Kariel (New York: Random House, 1970), p. 13.

56. cf. Strout, "Pragmatism in Retrospect," p. 133.

57. It is striking that most of these associations were founded and dominated by women. For a discussion of this phenomenon, see Anne Scott, "On Seeing and Not Seeing: A Case of Historical Invisibility," *Journal of American History* 71 (June 1984): 14–18.

58. Woods and Taylor are quoted in Chambers, *Seedtime of Reform*, pp. 15, 147.

59. On Bryan, see MDR to MED, July 16, 1925, box 30, MDR Papers; cf. MED, *Robins*, p. 196. On the proverb, see MDR to RR, Aug. 8, 1938, reel 63, MDR Papers.

60. MDR, speech on household work, [1904 or 1905], box 8, MDR Papers.

61. John Dewey, "William James," in *Characters and Events* (New York: Holt, 1929), vol. 1, pp. 118–19, 122.

62. RR to MDR, Nov. 23, 1934, box 62, MDR Papers.

63. Hofstadter, *Age of Reform*, p. 322, n. 7.

64. Scott, "The Progressive Era in Perspective," p. 701.

65. Cf. Louise deKoven Bowen to MDR, May 12, 1937, box 44, MDR Papers.

66. MDR to Agnes Nestor, Jan. 8, 1936, box 3-F, Agnes Nestor Papers, Chicago Historical Society, Chicago, Ill.; Agnes Nestor to MDR, Feb. 15, 1936, box 48, MDR Papers.

67. Quoted in Margaret Tims, *Jane Addams of Hull House, 1860–1935* (London: Allen and Unwin, 1969), p. 86; cf. Chambers, *Seedtime of Reform*, p. 230.

68. Quoted in O'Neill, *Everyone Was Brave*, p. 245; cf. MED, *Robins*, p. 173.

69. MED, *Robins*, p. 255; MDR to MED, Oct. 29, 1927, box 37, MDR Papers. Hitler's Germany was an acutely painful spectacle for Robins. As she wrote to RR, "Most of those who had known Germany in the old days suffered something of a heartbreak to see the present tragedy. . . . If you had but known my father and mother you would understand the sorrow in my heart." (MDR to RR, Aug. 24, 1938; cf. MDR to RR, Sept. 7, 1938, reel 63, MDR Papers; MED *Robins*, p. 245).

70. MED, *Robins*, p. 264.

71. On Roosevelt having the temperament of a bold Progressive, see Clinton Rossiter, *Conservatism in America* (New York: Knopf, 1956), p. 92.

72. Cf. Graham, *An Encore for Reform*, p. 47.

73. For the following, see William James, *The Varieties of Religious Experience* (1902; reprint ed. New York: Modern Library, 1929), pp. 82, 79, 125, 80, 88–89, 130–31, 77–121.

74. The description of Progressive confidence is from Goldman, *Rendezvous with Destiny*, p. 83. Ernest Gellner ("Pragmatism and the Importance of Being Earnest," in *Pragmatism: Its Sources and Prospects*, ed. Robert J. Mulvaney and Philip M. Zeltner [Columbia: University of South Carolina Press, 1981], p. 43) suggests that a lack of angst and an excess of "cheerfulness" were the crucial drawbacks of the philosophy of the Progressive era; cf. Paul K. Conkin, *Puritans and Pragmatists: Eight Eminent American Thinkers* (New York: Dodd, Mead, 1968), p. 414.

75. For a description of "the sick soul," see James, *Varieties*, pp. 125–62.

76. The judgment on RR is in William L. O'Neill, *The Great Schism: Stalinism and the American Intellectuals* (New York: Simon and Schuster, 1982), p. 195.

77. Quoted in O'Neill, *The Great Schism*, p. 195.

78. RR to MDR, Sept. 1, 1939; RR to MDR, Aug. 6, 1938; MDR to RR, Aug. 10, 1938; reel 63, MDR Papers.

79. MDR to Jane Ickes, [n.d.], copy, box 51, MDR Papers; MDR to MED, Nov. 5, 1923, box 19, RR Papers; Stewart, *Philanthropic Work*, pp. 95–96.

80. MDR to RR, Aug. 14, 1938; cf. Aug. 22, 1937, and Sept. 15, 1938; MDR to RR, Aug. 28 and 29, 1939, reel 63, MDR Papers; William James, *Talks to Teachers on Psychology and to Students on Some of Life's Ideals* (New York: Holt, 1899), p. 234; cf. John Dewey, *Characters and Events* (New York: Holt, 1929), vol. 1, pp. 75–76.

81. On love as remedy, see Ralph Waldo Emerson, "Man the Reformer," in his *Nature: Addresses and Lectures* (Boston: Houghton Mifflin,

1886), pp. 237–38, 241; on the zealot, see Emerson, "The Transcendentalist," in *Nature: Addresses*, p. 335; on the blue sky, see Emerson, "Man the Reformer," pp. 223–24, 238; cf. "The Transcendentalist," p. 333.

82. On James as an Emersonian, see William James, "Address at the Emerson Centenary in Concord," in *Memories and Studies*, pp. 19–34; and Ralph Barton Perry, *Thought and Character of William James* (Boston: Atlantic-Little, Brown, 1935), vol. 2, p. 444 (MDR read this intellectual biography soon after its appearance: see Elizabeth Robins to MDR, Feb. 25, 1936, box 42, MDR Papers). The characterization of Emerson is by Henry James, Jr. as quoted in Edel, *Henry James: The Conquest of London*, p. 31.

83. The undated, carbon-copy typescript, now in the MED Papers, is an almost exact copy of pages 348–50 of James's *Varieties*. A comparison of the carbon-copy with MDR's typed correspondence makes it clear that the typescript was produced on MDR's typewriter; in all likelihood it was done some time in the 1930s.

84. James, *Varieties*, pp. 348–50.

85. The description of the Progressive movement is in McConnell, *Private Power and American Democracy*, p. 48.

86. MED, *Robins*, p. 216. John M. Mecklin's *The Passing of the Saint: A Study of a Cultural Type* (Chicago: University of Chicago, 1941) does not go beyond mid-nineteenth-century America; but in fact the "saint" as a cultural type does not disappear until the end of the Progressive era.

87. MED, *Robins*, p. 173.

88. MDR to RR, Sept. 12, 1937, reel 63, MDR Papers.

89. On MDR's ambition "to bring the Kingdom of God and His love a little nearer" to the exploited and the suffering, see MED, *Robins*, p. 248.

# Selected Bibliography

## Source materials

I. MANUSCRIPT COLLECTIONS

Cambridge, Mass. Radcliffe College. Arthur and Elizabeth Schlesinger Library on the History of Women in America. Mary Anderson Papers.

Cambridge, Mass. Radcliffe College. Arthur and Elizabeth Schlesinger Library on the History of Women in America. Mary Elisabeth Dreier Papers.

Cambridge, Mass. Radcliffe College. Arthur and Elizabeth Schlesinger Library on the History of Women in America. Papers of the International Federation of Working Women.

Cambridge, Mass. Radcliffe College. Arthur and Elizabeth Schlesinger Library on the History of Women in America. Leonora O'Reilly Papers.

Chicago, Ill. Chicago Historical Society. John Fitzpatrick Papers.

Chicago, Ill. Chicago Historical Society. Agnes Nestor Papers.

Chicago, Ill. Preston Bradley Library. University of Illinois at Chicago. Jane Addams Memorial Collection.

Chicago, Ill. Preston Bradley Library. University of Illinois at Chicago. Midwest Women's Historical Collection. Papers of Immigrants' Protective League.

Chicago, Ill. Preston Bradley Library. University of Illinois at Chicago. Midwest Women's Historical Collection. Women's Trade Union League of Chicago: Scrapbook.

Gainesville, Fla. University of Florida Library. Margaret Dreier Robins Papers.

Madison, Wisc. Wisconsin State Historical Society. Archives Division. American Federation of Labor Papers.
Madison, Wisc. Wisconsin State Historical Society. Archives Division. Anita McCormick Blaine Papers.
Madison, Wisc. Wisconsin State Historical Society. Archives Division. Henry Demarest Lloyd Papers.
Madison, Wisc. Wisconsin State Historical Society. Archives Division. Raymond Robins Papers.
Madison, Wisc. University of Wisconsin Library. Manuscripts Collection. William English Walling Papers.
Swarthmore, Penn. Swarthmore College Peace Collection. Jane Addams Papers.
Washington, D.C. Library of Congress. Papers of National Women's Trade Union League.

II. PERSONAL INTERVIEWS
Dreier, Barbara Loines. Vineyard Haven, Mass., July 16, 1976; July 18, 1977.
Dreier, John. Southwest Harbor, Maine, July 27, 1977.
Dreier, Theodore, Sr. Vineyard Haven, Mass., July 16, 1976; July 18, 1977.
Levitas, Mollie. Chicago, Ill., Nov. 10, 1978.
McKethan, Alfred. Brooksville, Fla., Mar. 26, 1980.
Newman, Pauline. New York, N.Y., July 23, 1977.
von Borowsky, Lisa. Seal Harbor, Maine, July 26–27, 1977; Brooksville, Fla., Mar. 26, 1980.

III. OTHER UNPUBLISHED SOURCES
Balanoff, Elizabeth, ed. Roosevelt University Oral History Project in Labor History, Bks. 1–10. Roosevelt University Library. Chicago, Ill.
O'Sullivan, Mary Kenney. Unpublished Autobiography. Arthur and Elizabeth Schlesinger Library. Radcliffe College. Cambridge, Mass.

IV. PUBLIC DOCUMENTS
Illinois. General Assembly. *Special Senate Committee to Investigate the Garment Workers' Strike.* Vols. 1–2. 47th General Assembly, 1911.
New York. *Census of the State of New York for 1865.* Albany: C. Van Benthuysen and Sons, 1867.
New York. Factory Investigating Commission. *Preliminary Report of the Factory Investigating Commission, 1912.* 3 vols. Albany, 1912.
New York. Factory Investigating Commission. *Second Report of the Factory Investigating Commission, 1913.* 4 vols. Albany, 1913.

New York. Factory Investigating Commission. *Third Report of the Factory Investigating Commission, 1914.* Albany, 1914.

New York. Factory Investigating Commission. *Fourth Report of the Factory Investigating Commission, 1915.* 4 vols. Albany, 1915.

United States Congress. Senate. *Report on Condition of Woman and Child Wage-Earners in the United States.* Vol. 5: *Wage-Earning Women in Stores and Factories.* 61st Cong., 2nd sess., Senate doc. no. 645. Washington, D.C.: Government Printing Office, 1910.

United States Congress. Senate. *Report on Condition of Woman and Child Wage-Earners in the United States.* Vol. 9: *History of Women in Industry in the United States,* by Helen L. Sumner. 61st Cong., 2nd sess., Senate doc. no. 645. Washington, D.C.: Government Printing Office, 1910.

United States Congress. Senate. *Report on Condition of Woman and Child Wage-Earners in the United States.* Vol. 10: *History of Women in Trade Unions.* 61st Cong., 2nd sess., Senate doc. no. 645. Washington, D.C.: Government Printing Office, 1911.

United States Congress. Senate. *Report on Condition of Woman and Child Wage-Earners in the United States.* Vol. 13: *Infant Mortality and Its Relation to the Employment of Mothers.* 61st Cong., 2nd sess., Senate doc. no. 645. Washington, D.C.: Government Printing Office, 1912.

United States Department of Commerce. Bureau of the Census. *Historical Statistics of the United States: Colonial Times to 1970.* Bicentennial ed. 2 vols. Washington, D.C.: Government Printing Office, 1975.

United States Department of Commerce and Labor. Bureau of the Census. *Manufacturers of the United States in 1860: Compiled from the Original Returns of the Eighth Census.* Washington, D.C.: Government Printing Office, 1865.

United States Department of Commerce and Labor. Bureau of the Census. *Statistics of Women at Work: Based on Unpublished Information Derived from the Schedules of the Twelfth Census: 1900.* Washington, D.C.: Government Printing Office, 1907.

United States Department of Labor. Bureau of Labor Statistics. *Summary Report on Condition of Woman and Child Wage-Earners in the United States.* Washington, DC.: Government Printing Office, 1916.

United States Department of Labor. Women's Bureau. *The Development of Minimum-Wage Laws in the United States, 1912 to 1925.* Bulletin no. 61. Washington, D.C.: Government Printing Office, 1928.

V. Periodicals
*Charities and the Commons*, 1906–14.
*Life and Labor*, 1911–21.
*Life and Labor Bulletin*, 1922–38.
*Survey*, 1908–14.
*Woman's Journal*, 1903–15.

VI. Books and pamphlets
Abbott, Edith. *Women in Industry: A Study in American Economic History*. New York: D. Appleton and Co., 1910.
Addams, Jane. *A New Conscience and an Ancient Evil*. New York: Macmillan Co., 1914.
———. *Twenty Years at Hull-House*. 1910. Reprint. New York: Macmillan Co., 1961.
———. *Women at the Hague*. New York: Macmillan Co., 1915.
Anderson, Mary, as told to Mary N. Winslow. *Woman at Work: The Autobiography of Mary Anderson*. Minneapolis: University of Minnesota Press, 1951.
Beard, Mary Ritter. *The American Labor Movement: A Short History*. New York: Macmillan Co., 1928.
———. *Mary Ritter Beard: A Sourcebook*. Edited by Ann J. Lane. New York: Schocken Books, 1977.
Bisno, Abraham. *Union Pioneer*. Madison: University of Wisconsin Press, 1967.
Boone, Gladys. *The Women's Trade Union Leagues in Great Britain and the United States of America*. New York: Columbia University Press, 1942.
Brandeis, Louis D., and Josephine Goldmark. *Women in Industry: 1908 Muller v. Oregon*. Brief for the State of Oregon, reprinted for the National Consumers' League. New York: Arno Press, 1969.
Butler, Elizabeth Beardsley. *Women and the Trades: Pittsburgh, 1907–1908*. The Pittsburgh Survey. Edited by Paul Underwood Kellogg. 6 vols. New York: Russell Sage Foundation Charities Publication Committee, Press of Wm. F. Fell Co., 1909.
Cahan, Abraham. *The Rise of David Levinsky*. 1917. Reprint. Introduction by John Higham. New York: Harper and Row, Harper Colophon Books, 1966.
Calhoun, Arthur W. *A Social History of the American Family from Colonial Times to the Present*. 3 vols. Cleveland: Arthur H. Clark Co., 1918.
Callender, James H. *Yesterdays on Brooklyn Heights*. New York: Dorland Press, 1927.

Chicago Joint Board. *The Clothing Workers of Chicago, 1910–1922*. Chicago: Chicago Joint Board, Amalgamated Clothing Workers of America, 1922.

Cooley, Edwin G. *Vocational Education in Europe: Report to the Commercial Club of Chicago*. Chicago: Commercial Club of Chicago, 1912.

Dell, Floyd. *Women as World Builders: Studies in Modern Feminism*. Chicago: Forbes and Co., 1913.

Dewey, John. *Democracy and Education: An Introduction to the Philosophy of Education*. New York: Macmillan Co., 1923.

———. *The Public and Its Problems: An Essay in Political Inquiry*. New York: Holt and Co., 1927.

Dreier, Mary E. *Margaret Dreier Robins: Her Life, Letters and Work*. New York: Island Press, 1950.

Ely, Richard T. *The Labor Movement in America*. Rev. ed. New York: Macmillan Co., 1905.

Emerson, Ralph Waldo. *Culture*. New York: Dorse and Hopkins, 1910.

———. *Nature: Addresses and Lectures*. Boston: Houghton Mifflin, 1886.

———. *The Selected Writings of Ralph Waldo Emerson*. Edited by Brooks Atkinson. New York: Random House, Modern Library College Edition, 1950.

Franklin, Stella Miles. *My Brilliant Career, 1901*. New York: Simon and Schuster, 1980.

Gilman, Charlotte Perkins. *Human Work*. New York: McClure, Phillips and Co., 1904.

———. *Women and Economics: A Study of the Economic Relations between Men and Women As a Factor in Social Evolution*. 1898. Edited by Carl N. Degler. New York: Harper and Row, Harper Torchbooks, 1966.

Gompers, Samuel. *Seventy Years of Life and Labor: An Autobiography*. 2 vols. 1925. Reprints of Economic Classics. New York: Augustus M. Kelley, 1967.

Graham, Abbie. *Grace H. Dodge: Merchant of Dreams*. New York: Woman's Press, 1926.

Hamilton, Alice. *Exploring the Dangerous Trades: The Autobiography of Alice Hamilton*. Atlantic Monthly Press Book. Boston: Little, Brown and Co., 1943.

———. *Industrial Poisons in the United States*. New York: Macmillan Co., 1925.

*Handbook of the Chicago Industrial Exhibit*. Chicago, 1907.

Hazelton, Henry Isham, ed. *The Boroughs of Brooklyn and Queens,*

*Counties of Nassau and Suffolk, Long Island*, New York, *1609–1924*.
6 vols. New York: Lewis Historical Publishing Co., 1925.

Henry, Alice. *The Trade Union Woman*. New York: D. Appleton and
Co., 1915.

———. *Women and the Labor Movement*. New York: George H. Doran
Co., 1923.

Herron, Belva Mary. "The Progress of Labor Organization among Women,
Together with Some Considerations Concerning Their Place in Indus-
try." *University Studies*, Vol. 1. Urbana: University Press, May 1905.

Hughes, Gwendolyn Salisbury. *Mothers in Industry: Wage-Earning by
Mothers in Philadelphia*. New York: New Republic, J.J. Little and Ives
Co., 1925.

Hunter, Robert. *Tenement Conditions in Chicago*. Chicago: City Homes
Association, 1901.

James, William. *Memories and Studies*. New York: Longmans, Green,
1911.

———. *Talks to Teachers on Psychology and to Students on Some of
Life's Ideals*. New York: Holt, 1899.

———. *The Varieties of Religious Experience*. 1902. Reprint. New York:
Modern Library, 1929.

———. *The Writings of William James*. Edited by John J. McDermott.
Modern Library Edition. New York: Random House, 1968.

Janney, O. Edward. *The White Slave Traffic in America*. New York: Na-
tional Vigilance Committee, 1911.

Kellor, Frances A. *Out of Work: A Study of Employment Agencies, Their
Treatment of the Unemployed, and Their Influence upon Homes and
Business*. New York: G. P. Putnam's Sons, Knickerbocker Press, 1905.

Kemler, Edgar. *The Deflation of American Ideals: An Ethical Guide for New
Dealers*. 1941. Reprint. Seattle: University of Washington Press, 1967.

King, Wilson. *Chronicles of Three Free Cities: Hamburg, Bremen, Lubeck*.
New York: E. P. Dutton and Co., 1914.

Kneeland, George J. *Commercialized Prostitution in New York City*. Intro-
duction by John D. Rockefeller, Jr. New York: Century Co., 1913.

Levine, Louis. *The Women's Garment Workers: A History of the Inter-
national Ladies' Garment Workers' Union*. New York: B. W. Huebsch,
1924.

Linn, James Weber. *Jane Addams: A Biography*. New York: D. Appleton-
Century Co., 1935.

Lippman, Walter. *The Good Society*. Boston: Atlantic-Little, Brown, 1937.

Marot, Helen. *American Labor Unions: By a Member*. New York: Henry
Holt, 1915.

————. *Creative Impulse in Industry: A Proposition for Educators.* New York: E. P. Dutton and Co., 1918.

Mathews, Shailer, ed. *The Woman Citizen's Library: A Systematic Course of Readings in Preparation for the Larger Citizenship.* Vol. 11. Chicago: Civic Society, 1914.

Nestor, Agnes. *Woman's Labor Leader: An Autobiography of Agnes Nestor.* Rockford, Ill.: Bellevue Books Publishing Co., 1954.

Odencrantz, Louise C. *Italian Women in Industry: A Study of Conditions in New York City.* New York: Russell Sage Foundation, Wm. F. Fell Co., 1919.

Perlman, Selig, and Phillip Taft. *History of Labor in the United States, 1896–1932.* New York: Macmillan Co., 1935.

Robins, Elizabeth. *Raymond and I.* Foreword by Leonard Woolf. New York: Macmillan Co., 1956.

Robins, Margaret Dreier, ed. *In Memory of the One Hundredth Anniversary of the Birth of Dorothea Adelheid Dreier.* New York: n.p., 1940.

Rosen, Ruth, ed. *The Maimie Papers.* Old Westbury, N.Y.: Feminist Press, 1977.

Schneiderman, Rose, with Lucy Goldthwaite. *All for One.* New York: Paul S. Eriksson, 1967.

Seligman, Edwin R. A., ed. *The Social Evil: With Special Reference to Conditions Existing in the City of New York.* A Report Prepared [in 1902] under the direction of the Committee of Fifteen. 2d ed., rev. New York: G. P. Putnam's Sons, Knickerbocker Press, 1912.

Smith, Hilda W. *Women Workers at the Bryn Mawr Summer School.* New York: Affiliated Summer Schools for Women Workers in Industry and American Association for Adult Education, 1929.

Stewart, William Rhinelander, ed. *The Philanthropic Work of Josephine Shaw Lowell: Containing a Biographical Sketch of Her Life Together with a Selection of Her Public Papers and Private Letters.* New York: Macmillan Co., 1911.

Van Kleeck, Mary. *A Seasonal Industry: A Study of the Millinery Trade in New York.* New York: Russell Sage Foundation, 1917.

Webb, Beatrice. *Beatrice Webb's American Diary, 1898.* Edited by David A. Shannon. Madison: University of Wisconsin Press, 1963.

Wilson, Howard E. *Mary E. McDowell, Neighbor.* Chicago: University of Chicago Press, 1928.

Women's Trade Union League of Chicago. *Official Report of the Strike Committee.* Chicago, 1911.

## Secondary materials

I. BOOKS AND PAMPHLETS

Ahlstrom, Sydney E. *A Religious History of the American People.* New Haven: Yale University Press, 1972.

Ashbaugh, Carolyn. *Lucy Parsons: American Revolutionary.* Chicago: Charles H. Kerr Co., 1976.

Auerbach, Jerold S., ed. *American Labor: The Twentieth Century.* Indianapolis: Bobbs-Merrill Co., 1969.

Avrich, Paul. *The Haymarket Tragedy.* Princeton: Princeton University Press, 1984.

Baer, Judith A. *The Chains of Protection: The Judicial Response to Women's Labor Legislation.* Westport, Conn.: Greenwood Press, 1978.

Baxandall, Rosalyn, Linda Gordon and Susan Reverby, eds. *America's Working Women.* New York: Random House, Vintage Books, 1976.

Belush, Bernard. *The Failure of the NRA.* New York: W. W. Norton and Co., 1975.

Bledstein, Burton J. *The Culture of Professionalism: The Middle Class and the Development of Higher Education in America.* New York: W. W. Norton and Co., 1976.

Bocock, Robert. *Ritual in Industrial Society: A Sociological Analysis of Ritualism in Modern England.* London: George Allen and Unwin, 1974.

Brissenden, Paul F. *The I.W.W.: A Study of American Syndicalism.* New York: Russell and Russell, 1957.

Buenker, John D. *Urban Liberalism and Progressive Reform.* New York: W. W. Norton and Co., 1978.

Buhle, Mari Jo. *Women and American Socialism, 1870–1920.* Urbana: University of Illinois Press, 1983.

Bullough, Vern L. *The History of Prostitution.* New Hyde Park, N.Y.: University Books, 1964.

Caillois, Roger. *Man, Play and Games.* Translated by Meyer Barash. New York: Schocken Books, 1979.

Cantor, Milton, and Bruce Laurie. *Class, Sex, and the Woman Worker.* Contributions in Labor History, no. 1. Westport, Conn.: Greenwood Press, 1977.

Carsel, Wilfred. *A History of the Chicago Ladies' Garment Workers' Union.* Chicago: Normandie House, 1940.

Chafe, William Henry. *The American Woman: Her Changing Social, Economic, and Political Roles, 1920–1970.* New York: Oxford University Press, 1972.

Chambers, Clarke A. *Paul U. Kellogg and "The Survey": Voices for Social*

*Welfare and Social Justice.* Minneapolis: University of Minnesota Press, 1971.

————. *Seedtime of Reform: American Social Service and Social Action, 1918–1933.* Minneapolis: University of Minnesota Press, 1963.

Chambers, John Whiteclay, III. *The Tyranny of Change: America in the Progressive Era, 1900–1917.* New York: St. Martin's Press, 1980.

Connelly, Mark Thomas. *The Response to Prostitution in the Progressive Era.* Chapel Hill: University of North Carolina Press, 1980.

Costin, Lela B. *Two Sisters for Social Justice: A Biography of Grace and Edith Abbott.* Urbana: University of Illinois Press, 1983.

Cott, Nancy F. *The Bonds of Womanhood: "Woman's Sphere" in New England, 1780–1835.* New Haven: Yale University Press, 1977.

Cremin, Lawrence A. *The Transformation of the Schools: Progressivism in American Education, 1876–1957.* New York: Alfred A. Knopf, 1961.

Crunden, Robert M. *From Self to Society, 1919–1941.* Englewood Cliffs, N.J.: Prentice-Hall, 1972.

Davis, Allen F. *American Heroine: The Life and Legend of Jane Addams.* New York: Oxford University Press, 1973.

————. *Spearheads for Reform: The Social Settlements and the Progressive Movement, 1890–1914.* Urban Life in America Series. New York: Oxford University Press, 1967.

Diner, Steven J. *A City and Its Universities: Public Policy in Chicago, 1892–1919.* Chapel Hill: University of North Carolina Press, 1980.

Dublin, Thomas. *Women at Work: The Transformation of Work and Community in Lowell, Massachusetts, 1820–1860.* New York: Columbia University Press, 1979.

Duffus, R. L. *Lillian Wald: Neighbor and Crusader.* New York: Macmillan Co., 1938.

Dye, Nancy Schrom. *As Equals and as Sisters: Feminism, the Labor Movement, and the Women's Trade Union League of New York.* Columbia: University of Missouri Press, 1980.

Dykhuizen, George. *The Life and Mind of John Dewey.* Carbondale: Southern Illinois University Press, 1973.

Edel, Leon. *Henry James: The Conquest of London, 1870–1881.* New York: Avon Books, 1978.

Elias, Robert H. *"Entangling Alliances with None": An Essay on the Individual in the American Twenties.* New York: W. W. Norton and Co., 1973.

Erikson, Erik H. *Identity and the Life Cycle: Selected Papers by Erik H. Erickson.* Psychological Issues, monograph 1. New York: International Universities Press, 1959.

————. *Life History and the Historical Moment*. New York: W. W. Norton and Co., 1975.

————. *Toys and Reason: Stages in the Ritualization of Experience*. New York: W. W. Norton and Co., 1977.

Farrell, John C. *Beloved Lady: A History of Jane Addams' Ideas on Reform and Peace*. Baltimore: Johns Hopkins University Press, 1967.

Fink, Leon. *Workingmen's Democracy: The Knights of Labor and American Politics*. Urbana: University of Illinois Press, 1983.

Foner, Eric. *Free Soil, Free Labor, Free Men: The Ideology of the Republican Party before the Civil War*. New York: Oxford University Press, 1970.

Foner, Phillip S. *History of the Labor Movement in the United States*. Vol. 3. *The Policies and Practice of the American Federation of Labor, 1900–1909*. New York: International Publishers Co., 1964.

————. *The Factory Girls*. Urbana: University of Illinois Press, 1977.

Gable, John Allen. *The Bull Moose Years: Theodore Roosevelt and the Progressive Party*. Port Washington, N.Y.: Kennikat Press, 1978.

Gilbert, James B. *Work without Salvation: America's Intellectuals and Industrial Alienation, 1880–1910*. Baltimore: Johns Hopkins University Press, 1977.

Goldman, Eric C. *Rendezvous with Destiny*. New York: Knopf, 1958.

Goldmark, Josephine. *Impatient Crusader: Florence Kelley's Life Story*. Urbana: University of Illinois Press, 1953.

Gordon, Linda. *Woman's Body, Woman's Right: A Social History of Birth Control in America*. New York: Penguin Books, 1977.

Graham, Otis L., Jr. *An Encore for Reform: The Old Progressives and the New Deal*. New York: Oxford University Press, 1967.

Grob, Gerald N. *Workers and Utopia: A Study of Ideological Conflict in the American Labor Movement, 1865–1900*. Evanston, Ill.: Northwestern University Press, 1961.

Hale, Nathan G., Jr. *Freud and the Americans: The Beginnings of Psychoanalysis in the United States, 1876–1917*. New York: Oxford University Press, 1971.

Haller, John S., and Robin M. Haller. *The Physician and Sexuality in Victorian America*. Urbana: University of Illinois Press, 1974.

Handlin, Oscar. *Al Smith and His America*. Boston: Little, Brown and Co., 1958.

Hersh, Blanche Glassman. *The Slavery of Sex: Female Abolitionists in America*. Urbana: University of Illinois Press, 1978.

Hill, Mary A. *Charlotte Perkins Gilman: The Making of a Radical Feminist, 1860–1896*. Philadelphia: Temple University Press, 1980.

Hofstadter, Richard. *The Age of Reform: From Bryan to F.D.R.* New York: Alfred A. Knopf, 1955.

Horowitz, Helen Lefkowitz. *Culture and the City: Cultural Philanthropy in Chicago from the 1880s to 1917.* Lexington: University Press of Kentucky, 1976.

Hubbard, Preston J. *Origins of the TVA: The Muscle Shoals Controversy, 1920–1932.* Nashville: Vanderbilt University Press, 1961.

Josephson, Matthew. *Sidney Hillman: Statesman of American Labor.* Garden City, N.Y.: Doubleday and Co., 1952.

Kenneally, James J. *Women and American Trade Unions.* Monographs in Women's Studies. St. Albans, Vt.: Eden Press Women's Publications, 1978.

Kennedy, David. *Birth Control in America: The Career of Margaret Sanger.* New Haven: Yale University Press, 1970.

Kessler-Harris, Alice. *Out to Work: A History of Wage-Earning Women in the United States.* New York: Oxford University Press, 1982.

Kett, Joseph F. *Rites of Passage: Adolescence in America, 1790 to the Present.* New York: Basic Books, 1977.

Kraditor, Aileen S. *The Ideas of the Woman Suffrage Movement, 1890–1920.* New York: Columbia University Press, 1965.

Lagemann, Ellen Condliffe. *A Generation of Women: Education in the Lives of Progressive Reformers.* Cambridge, Mass.: Harvard University Press, 1979.

Lancaster, Clay. *Old Brooklyn Heights.* Rutland, Vt.: Charles E. Tuttle Co., 1961.

Leach, William. *True Love and Perfect Union: The Feminist Reform of Sex and Society.* New York: Basic Books, 1980.

Lears, T. J. Jackson. *No Place of Grace: Antimodernism and the Transformation of American Culture, 1880–1920.* New York: Pantheon Books, 1981.

Leiby, James. *Carroll Wright and Labor Reform: The Origin of Labor Statistics.* Cambridge, Mass.: Harvard University Press, 1960.

Lemons, J. Stanley. *The Woman Citizen: Social Feminism in the 1920s.* Urbana: University of Illinois Press, Illini Books, 1973.

Lerner, Gerda. *The Grimké Sisters from South Carolina: Pioneers for Woman's Rights and Abolition.* Studies in the Life of Women. New York: Schocken Books, 1967.

Leuchtenburg, William E. *Franklin D. Roosevelt and the New Deal, 1932–1940.* New York: Harper and Row, 1963.

———. *In the Shadow of FDR: From Harry Truman to Ronald Reagan.* Ithaca, N.Y.: Cornell University Press, 1983.

————. *The Perils of Prosperity, 1914–32*. Chicago: University of Chicago Press, 1958.

Levine, Daniel. *Jane Addams and the Liberal Tradition*. Madison: State Historical Society of Wisconsin, 1971.

Lubin, Albert J. *Stranger on the Earth: A Psychological Biography of Vincent Van Gogh*. New York: Holt, Rinehart and Winston, 1972.

Lubove, Roy. *The Professional Altruist: The Emergence of Social Work as a Career, 1880–1930*. Cambridge, Mass.: Harvard University Press, 1965.

McConnell, Grant. *Private Power and American Democracy*. New York: Alfred A. Knopf, 1966.

Martin, George. *Madame Secretary, Frances Perkins*. Boston: Houghton Mifflin, 1976.

Mauss, Marcel. *The Gift: Forms and Functions of Exchange in Archaic Societies*. Translated by Ian Cunnison; introduced by E. E. Evans-Pritchard. Glencoe, Ill.: Free Press, 1954.

Maxwell, Robert S. *La Follette and the Rise of Progressivism in Wisconsin*. Madison: State Historical Society of Wisconsin, 1956.

May, Henry F. *The End of American Innocence: The First Years of Our Own Time, 1912–1917*. New York: Alfred A. Knopf, 1959.

Mecklin, John M. *The Passing of the Saint: A Study of a Cultural Type*. Chicago: University of Chicago Press, 1941.

Melder, Keith E. *Beginnings of Sisterhood: The American Woman's Rights Movement, 1800–1850*. Studies in the Life of Women. New York: Schocken Books, 1977.

Montgomery, David. *Beyond Equality: Labor and the Radical Republicans, 1862–1872*. Urbana: University of Illinois Press, 1967.

Moore, Sally F., and Barbara G. Myerhoff, eds. *Secular Ritual*. Amsterdam: Van Gorcum, 1977.

Morris, James O. *Conflict within the AFL: A Study of Craft versus Industrial Unionism, 1901–1938*. Ithaca, N.Y.: Cornell University Press, 1958.

Mowry, George E. *The California Progressives*. Berkeley: University of California Press, 1951.

————. *The Era of Theodore Roosevelt and the Birth of Modern America, 1900–1912*. New York: Harper and Row, Harper Torchbooks, 1958.

*Notable American Women, 1607–1950: A Biographical Dictionary*. Edited by Edward T. James. 3 vols. Cambridge, Mass.: Harvard University Press, Belknap Press, 1971.

*Notable American Women: The Modern Period*. Edited by Barbara Sicherman and Carol Hurd Green. Cambridge, Mass.: Harvard University Press, Belknap Press, 1980.

O'Neill, William L. *Everyone Was Brave: A History of Feminism in America*. Chicago: University of Chicago Press, Quadrangle Books, 1969.
———. *The Great Schism: Stalinism and the American Intellectuals*. New York: Simon and Schuster, 1982.
Patterson, James T. *Congressional Conservatism and the New Deal: The Growth of the Conservative Coalition in Congress, 1933–1939*. Lexington: University of Kentucky Press, 1967.
Pelling, Henry. *American Labor*. Chicago History of American Civilization. Chicago: University of Chicago Press, 1960.
Perry, Ralph Barton. *Thought and Character of William James*. Boston: Atlantic-Little, Brown, 1935.
Pessen, Edward. *Most Uncommon Jacksonians: The Radical Leaders of the Early Labor Movement*. Albany: State University of New York Press, 1967.
Pierce, Bessie Louise. *A History of Chicago: The Rise of a Modern City, 1871–1893*. Chicago: University of Chicago Press, 1957.
Platt, Anthony W. *The Child Savers: The Invention of Delinquency*. 2d ed. Chicago: University of Chicago Press, 1977.
Preston, William, Jr. *Aliens and Dissenters: Federal Suppression of Radicals, 1903–1933*. New York: Harper and Row, 1966.
Quandt, Jean B. *From the Small Town to the Great Community: The Social Thought of Progressive Intellectuals*. New Brunswick, N.J.: Rutgers University Press, 1970.
Rayback, Joseph. *A History of American Labor*. New York: Macmillan Co., 1966.
Rischin, Moses. *The Promised City: New York's Jews, 1870–1914*. New York: Harper and Row, 1962.
Rodgers, Daniel T. *The Work Ethic in Industrial America, 1850–1920*. Chicago: University of Chicago Press, 1974.
Rosen, Elliot A. *Hoover, Roosevelt, and the Brain Trust: From Depression to New Deal*. New York: Columbia University Press, 1977.
Rosen, Ruth. *The Lost Sisterhood: Prostitution in America, 1900–1918*. Baltimore: Johns Hopkins University Press, 1982.
Rosenberg, Carroll Smith. *Religion and the Rise of the American City: The New York City Mission Movement, 1812–1870*. Ithaca, N.Y.: Cornell University Press, 1971.
Rosenberg, Rosalind. *Beyond Separate Spheres: Intellectual Roots of Modern Feminism*. New Haven: Yale University Press, 1982.
Rossiter, Clinton. *Conservatism in America*. New York: Alfred A. Knopf, 1956.
Saarinen, Aline B. *The Proud Possessors*. New York: Random House, 1959.

Schlossman, Steven L. *Love and the American Delinquent: The Theory and Practice of "Progressive" Juvenile Justice, 1825–1920*. Chicago: University of Chicago Press, 1977.

Seidman, Joel. *The Needle Trades*. New York: Farrar and Rinehart, 1942.

Smuts, Robert W. *Women and Work in America*. New York: Columbia University Press, 1959.

Stein, Leon. *The Triangle Fire*. Philadelphia: J. B. Lippincott Co., 1962.

Stenbäk, A. *Headaches and Life Stress: A Psychosomatic Study of Headache*. Copenhagen: Munskgaard, 1954.

Strouse, Jean. *Alice James: A Biography*. New York: Bantam Books, 1982.

Syrett, Harold Coffin. *The City of Brooklyn, 1865–1898: A Political History*. New York: Columbia University Press, 1944.

Taft, Philip. *The A.F. of L. in the Time of Gompers*. New York: Harper and Brothers, 1957.

Tentler, Leslie Woodcock. *Wage-Earning Women: Industrial Work and Family Life in the United States, 1900–1930*. New York: Oxford University Press, 1979.

Thelen, David P. *The New Citizenship: Origins of Progressivism in Wisconsin, 1885–1900*. Columbia: University of Missouri Press, 1972.

Thernstrom, Stephan. *Poverty and Progress: Social Mobility in a Nineteenth Century City*. New York: Atheneum, 1970.

Tims, Margaret. *Jane Addams of Hull House, 1860–1935*. London: Allen and Unwin, 1961.

Trattner, Walter I. *Homer Folks: Pioneer in Social Welfare*. New York: Columbia University Press, 1968.

Wade, Mason. *Margaret Fuller: Whetstone of Genius*. New York: Viking Press, 1940.

Ware, Susan. *Beyond Suffrage: Women in the New Deal*. Cambridge, Mass.: Harvard University Press, 1981.

Weiss, Nancy J. *The National Urban League, 1910–1940*. New York: Oxford University Press, 1974.

Weld, Ralph Foster. *Brooklyn Is America*. New York: Columbia University Press, 1950.

Wertheimer, Barbara. *We Were There: The Story of Working Women in America*. New York: Pantheon Books, 1977.

Wiebe, Robert H. *The Search for Order, 1877–1920*. The Making of America, American Century Series. New York: Hill and Wang, 1967.

Wolfskill, George. *Happy Days Are Here Again!: A Short Interpretative History of the New Deal*. Hinsdale, Ill.: The Dryden Press, 1974.

Yellowitz, Irwin. *Labor and the Progressive Movement in New York State, 1897–1916*. Ithaca, N.Y.: Cornell University Press, 1965.

II. ARTICLES

Baker, Paula. "The Domestication of Politics: Women and American Political Society, 1780–1920." *American Historical Review* 89 (June 1984): 620–47.

Burnham, John C. "The Progressive Era Revolution in American Attitudes toward Sex." *Journal of American History* 59 (Spring 1973): 885–908.

Buroker, Robert L. "From Voluntary Association to Welfare State: The Illinois Immigrants' Protective League, 1908–1926." *Journal of American History* 58 (Dec. 1971): 643–69.

Conway, Jill: "Women Reformers and American Culture, 1870–1930." *Journal of Social History* 5 (Winter 1971–72): 164–77.

Cott, Nancy F. "Feminist Politics in the 1920s: The National Woman's Party." *Journal of American History* 71 (June 1984): 43–68.

Davis, Allen F. "Raymond Robins: The Settlement Worker as Municipal Reformer." *Social Service Review* 33 (June 1959): 131–41.

———. "The Women's Trade Union League: Origins and Organization." *Labor History* 5 (Winter 1964): 3–17.

Dublin, Thomas. "Women, Work, and Protest in the Early Lowell Mills: 'The Oppressing Hand of Avarice Would Enslave Us.'" *Labor History* 16 (Winter 1975): 99–116.

Dubofsky, Melvyn. "Organized Labor and the Immigrant in New York City, 1900–1918." *Labor History* 2 (Spring 1961): 182–201.

Dye, Nancy Schrom. "Feminism or Unionism? The New York Women's Trade Union League and the Labor Movement." *Feminist Studies* 3 (Fall 1975): 111–23.

Feldman, Egal. "Prostitution, the Alien Woman and the Progressive Imagination, 1910–1915." *American Quarterly* 19 (Summer 1967): 192–206.

Fine, Sidney. "The History of the American Labor Movement with Special Reference to Developments in the 1930's." In *Labor in a Changing America*, edited by William Haber. New York: Basic Books, 1966.

Holt, James. "The New Deal and the American Anti-Statist Tradition." In *The New Deal*, vol. 1. *The National Level*, edited by John Braemen, Robert H. Bremner, and David Brody. Columbus: Ohio State University Press, 1975.

Hook, Sidney. "John Dewey—Philosopher of Growth." *Journal of Philosophy* 56 (1959): 1010–18.

Jacoby, Robin Miller. "The Women's Trade Union League and American Feminism." *Feminist Studies* 3 (Fall 1975): 126–40.

Kenneally, James J. "Women and Trade Unions, 1870–1920: The Quandary of the Reformer." *Labor History* 14 (Winter 1973): 83–91.

Kerr, Thomas J. "The New York Factory Investigating Commission and the Minimum Wage Movement." *Labor History* 12 (Summer 1971): 373–91.

Kessler-Harris, Alice. "'Where Are the Organized Women Workers?'" *Feminist Studies* 3 (Fall 1975): 92–110.

Kirschner, Don S. "The Ambiguous Legacy: Social Justice and Social Control in the Progressive Era." *Historical Reflections* 2 (Summer 1975): 69–88.

Kugler, Israel. "The Trade Union Career of Susan B. Anthony." *Labor History* 2 (Winter 1961): 90–100.

Lemons, J. Stanley. "The Sheppard-Towner Act: Progressivism in the 1920s." *Journal of American History* 55 (Mar. 1969): 776–86.

Levine, Susan. "Labor's True Woman: Domesticity and Equal Rights in the Knights of Labor," *Journal of American History* 70 (Sept. 1983): 323–39.

Link, Arthur. "What Happened to the Progressive Movement in the 1920s?" *American Historical Review* 64 (July 1959): 833–51.

McArthur, Benjamin. "The Chicago Playground Movement: A Neglected Feature of Social Justice." *Social Service Review* 49 (Sept. 1975): 376–95.

McLaughlin, Virginia Yans. "Patterns of Work and Family Organization: Buffalo's Italians." *Journal of Interdisciplinary History* 2 (Autumn 1971): 299–314.

Montgomery, David. "The New Unionism and the Transformation of Workers' Consciousness in America, 1909–22." *Journal of Social History* 7 (Summer 1974): 509–29.

Morantz, Regina Markell. "Feminism, Professionalism, and Germs: The Thought of Mary Putnam Jacobi and Elizabeth Blackwell." *American Quarterly* 34 (Winter 1982): 459–78.

Patterson, James T. "Mary Dewson and the American Minimum Wage Movement." *Labor History* 5 (Spring 1964): 134–52.

Riegel, Robert E. "Changing American Attitudes toward Prostitution, 1800–1920." *Journal of the History of Ideas* 29 (July–Sept. 1968): 437–52.

Rosenberg, Carroll Smith. "Beauty, the Beast and the Militant Woman: A Case Study in Sex Roles and Social Stress in Jacksonian America." *American Quarterly* 23 (Oct. 1971): 562–84.

Rosenberg, Charles E. "The Place of George M. Beard in Nineteenth-Century Psychiatry." *Bulletin of the History of Medicine* 36 (May–June 1962): 245–59.

Schiller, Francis. "The Migraine Tradition." *Bulletin of the History of Medicine* 49 (Spring 1975): 1–19.

Scott, Andrew M. "The Progressive Era in Perspective," *Journal of Politics* 21 (Nov. 1959): 685–701.

Scott, Anne. "On Seeing and Not Seeing: A Case of Historical Invisibility." *Journal of American History* 71 (June 1984): 7–21.

Scott, Joan W. and Louise A. Tilly. "Women's Work and the Family in Nineteenth-Century Europe." *Comparative Studies in Society and History* 17 (Jan. 1975): 36–64.

Sicherman, Barbara. "The Uses of Diagnosis: Doctors, Patients and Neurasthenia." *Journal of the History of Medicine and Allied Sciences* 32 (Jan. 1977): 33–54.

Smith, Timothy L. "Immigrant Social Aspirations and American Education, 1880–1930." *American Quarterly* 21 (Fall 1969): 503–43.

Smith-Rosenberg, Carroll. "The Female World of Love and Ritual: Relations between Women in Nineteenth-Century America." *Signs* 1 (Autumn 1972): 1–29.

Storr, Mark. "Organized Labor and the Dewey Philosophy," In *John Dewey: Philosopher of Science and Freedom*, pp. 184–93. New York: Barnes and Noble, 1950.

Strout, Cushing. "Pragmatism in Retrospect: The Legacy of James and Dewey." *Virginia Quarterly Review* 43 (Winter 1967): 123–34.

Treudley, Mary Bosworth. "The 'Benevolent Fair': A Study of Charitable Organization among American Women in the First Third of the Nineteenth Century." *Social Service Review* 14 (Sept. 1940): 509–22.

Vercoli, Rudolph. "Contadini in Chicago: A Critique of *The Uprooted*." *Journal of Social History* 2 (Spring 1969): 217–68.

Walkowitz, Daniel J. "Working-Class Women in the Gilded Age: Factory, Community and Family Life among Cohoes, New York Cotton Workers." *Journal of Social History* 5 (Summer 1972): 464–90.

Weiler, N. Sue. "Walkout: The Chicago Men's Garment Workers' Strike." *Chicago History* 8 (Winter 1979–80): 238–49.

Witte, Edwin E. "Organized Labor and Social Security." In *Labor and the New Deal*, edited by Milton Derber and Edwin Young. Madison: University of Wisconsin Press, 1957.

Wolfskill, George. "New Deal Critics: Did They Miss the Point?" In *Essays on the New Deal*, edited by Harold M. Hollingsworth and William F. Holmes. Austin: University of Texas Press, 1969.

III. THESES

Buroker, Robert Lesley. "From Voluntary Association to Welfare State: Social Welfare Reform in Illinois, 1890–1920." Ph.D. dissertation, University of Chicago, 1973.

Camitta, Hugh D. "Raymond Robins: Study of a Progressive, 1910–1917." Honors thesis, Williams College, 1965.

Cohen, Ricki Carole Myers, "Fannia Cohn and the International Ladies' Garment Workers' Union." Ph.D. dissertation, University of Southern California, 1976.

Daly, John Marie. "Mary Anderson: Pioneer Labor Leader." Ph.D. dissertation, Georgetown University, 1968.

Donata, Mary Yates. "Women in Chicago Industries, 1900–1915: A Study of Working Conditions in Factories, Laundries, and Restaurants." M.A. thesis, University of Chicago, 1948.

Dye, Nancy Schrom. "The Women's Trade Union League of New York, 1903–1920." Ph.D. dissertation, University of Wisconsin, 1974.

Endleman, Gary. "Solidarity Forever: Rose Schneiderman and the National Women's Trade Union League." Ph.D. dissertation, University of Delaware, 1977.

Estes, Barbara Ann. "Margaret Dreier Robins: Social Reformer and Labor Organizer." Ph.D. dissertation, Ball State University, 1976.

Halfant, David Mandel. "Attitudes of the American Federation of Labor toward Unskilled and Women Workers." M.A. thesis, University of Chicago, 1921.

Jacoby, Robin Miller. "The British and American Women's Trade Union League, 1890–1925: A Case Study of Feminism and Class." Ph.D. dissertation, Harvard University, 1977.

Keiser, John H. "John Fitzpatrick and Progressive Unionism, 1915–1925." Ph.D. dissertation, Northwestern University, 1965.

Levine, Susan. "Their Own Sphere: Women's Work, the Knights of Labor, and the Transformation of the Carpet Trade, 1870–1890." Ph.D. dissertation, City University of New York, 1979.

Lunardini, Christine A. "From Equal Suffrage to Equal Rights: The National Woman's Party, 1913–1923." Ph.D. dissertation, Princeton University, 1981.

McCreesh, Carolyn D. "On the Picket Lines: Militant Women Campaign to Organize Garment Workers, 1880–1917." Ph.D. dissertation, University of Maryland, 1975.

Magee, Mabel Agnes. "The Women's Clothing Industry of Chicago with Special Reference to Relations between the Manufacturers and the Union." Ph.D. dissertation, University of Chicago, 1927.

Meyers, Howard Barton. "The Policing of Labor Disputes in Chicago: A Case Study." Ph.D. dissertation, University of Chicago, 1929.

Palmer, Phyllis Marynick. "Two Friends of the Immigrant, 1908–1920." M.A. thesis, Ohio State University, 1967.

Powers, Dorothy Edwards. "The Chicago Woman's Club." M.A. thesis, University of Chicago, 1939.

Reid, Robert Louis. "The Professionalization of Public School Teachers: The Chicago Experience, 1895–1920." Ph.D. dissertation, Northwestern University, 1968.

Ruegman, Lana. "'The Paradise of Exceptional Women': Chicago Women Reformers, 1863–1893." Ph.D. dissertation, Indiana University, 1982.

Salzman, Neil V. "Reform and Revolution: The Life Experience of Raymond Robins." 2 vols. Ph.D. dissertation, New York University, 1973.

Sandquist, Eric Lawrence. "Leonora O'Reilly and the Progressive Movement." Honors thesis, Harvard College, 1966.

Schaefer, Robert Joseph. "Educational Activities of the Garment Unions, 1890–1948: A Study in Workers' Education in the International Ladies' Amalgamated Clothing Workers of America in New York City." Ph.D. dissertation, Columbia University, 1951.

Sherrick, Rebecca Louise. "Private Visions, Public Lives: The Hull-House Women in the Progressive Era." Ph.D. dissertation, Northwestern University, 1980.

Spaeth, Louise. "Women's Trade Union League and Leadership." M.A. thesis, Columbia University, 1925.

Watkins, Bari Jane. "The Professors and the Unions: American Academic Social Theory and Labor Reform, 1883–1915." Ph.D. dissertation, Yale University, 1976.

Williams, William A. "Raymond Robins and Russian-American Relations, 1917–1938." Ph.D. dissertation, University of Wisconsin, 1951.

Young, Angela Nugent. "Interpreting the Dangerous Trades: Workers' Health in America and the Career of Alice Hamilton, 1910–1933." Ph.D. dissertation, Brown University, 1982.

IV. OTHER UNPUBLISHED SOURCES

Benson, Ronald M. "Searching for the Antecedents of Affirmative Action: The Case of the Cleveland Conductorettes in World War I." Paper presented at Conference on the History of Women, Oct. 21–23, 1977, at College of St. Catharine. Mimeographed.

Boris, Eileen. "'Art and Labor': Ellen Gates Starr, Vida Scudder and the Theory and Practice of Craftsmanship." Paper presented at Fourth Berkshire Conference on the History of Women, Aug. 23–25, 1978, at Mount Holyoke College. Mimeographed.

———. "The Chicago Public School Art Society: The Hegemonic Use of Art." Paper presented at Conference on the History of Women, Oct. 21–23, 1977, at College of St. Catharine. Mimeographed.

Hoeffecker, Carol. "The Bryn Mawr Summer School: A Project in Search of a Purpose." Paper presented at Third Berkshire Conference on the History of Women, June 9–11, 1976, at Bryn Mawr College. Mimeographed.

Jensen, Joan M. "All Pink Sisters: The War Department and the Feminist Movement in the 1920s." Paper presented at Fourth Berkshire Conference on the History of Women, Aug. 23–25, 1978, at Mount Holyoke College. Mimeographed.

Levine, Susan. "The Knights of Labor Romantic Ideology." Paper presented at Knights of Labor Centennial Symposium, May 17–19, 1979, at Newberry Library, Chicago. Mimeographed.

———. "'Then Strive for Your Rights, Oh, Sisters Dear': The Carpet Weavers' Strike and the Knights of Labor." Paper presented at Third Berkshire Conference on the History of Women, June 9–11, 1976, at Bryn Mawr College. Mimeographed.

Snay, Mitchell. "Limits to Fellowship: Denison House and Working Women in Boston, 1890–1925." Paper presented at Conference on the History of Women, Oct. 21–23, 1977, at College of St. Catharine. Mimeographed.

# Index

216                                    *Reform, Labor, and Feminism*

New Deal, 5, 160, 161, 162–63, 164–65, 167, 170, 171, 183; and progressives, 173–76; and unions, 169; and workers, 168–69

Newman, Pauline, 53, 71, 118, 121–22

New York Association for Household Research, 26, 28

New York Charities Aid Association, 23, 24

New York School of Civics and Philanthropy, 12, 29

New York State Factory Investigating Commission, 99, 129

New York Women's Trade Union League, 33, 53, 58, 69, 84, 90, 99, 106, 119, 120, 121, 130; and MDR, 28; and MED, 34

Night work, 131

Norris, George, 31

Northwestern University Social Settlement, 28, 44, 62

O'Reilly, Leonora, 47, 48, 53, 54, 57, 59, 68, 98, 105, 121, 124, 128, 134, 158

O'Sullivan, John F., 46

O'Sullivan, Mary Kenney, 46, 47, 55, 56, 83, 88, 98, 106, 124, 129

Parsons, Lucy, 78

Paul, Alice, 143

Perkins, Frances, 125–26

Philadelphia Shirtwaist strike, 90, 143

Philadelphia Women's Trade Union League, 83, 107

Philanthropy, 23

Phillips, Wendell, 97, 105

Pickets, 90

Pike, Violet, 86

Playground Association, 162, 173

Post, Alice, 66, 68

Post, Louis F., 68, 84

Potter, Frances Squire, 81

Preferential shop, 91, 93

Progressive party, 31, 107, 163–64

Progressive reform, 1, 26, 160–64, 174, 183, 184; and Chicago, 29–30, 120–21; and democracy, 163, 172; and Emerson, 181; ethos of, 179;

and the individual, 161; and the New Deal, 166, 171–73, 180–81; and volunteerism, 168, 173; and women, 168; and WTUL, 180

Prohibition, 31, 165

Prostitution, 24, 25, 26–27, 33, 129; and the minimum wage, 130

Protective legislation, 2, 99, 123, 132–33, 143–45

Protestantism, 8, 10, 13, 50, 167

Public health movement, 162

Recreation, 14

Red Scare, 156

Religion: and reform, 50; *see also* Protestantism

Rickert, Thomas, 87, 91

*Rise of David Levinsky,* 138

Robins, Margaret Dreier: activism of, 175; attitude toward sex, 18; and children, 135–36; on citizenship, 167; death of, 180; disillusionment of, 156, 157–59, 175, 176–77; education of, 23; family background, 7–15; feminism of, 117, 126–27; finances of, 51; health of, 15–16, 18–21, 33; ideology of, 9, 10, 12, 79–82, 123, 174–75, 177–78, 180, 184; and Jane Addams, 63–64; marriage of, 28, 31, 32; and the New Deal, 167–69; and new generation, 147; optimism of, 10, 22; parents of, 15; personality of, 10, 17, 34–35, 62, 68–69, 72, 122, 142–43, 178–79; psychological crisis, 15–22, 33; and reform, 13, 14–15, 22, 27; relationship with father, 10–11; religion of, 13; as a representative figure, 180; role in Chicago Clothing Workers Strike, 90–91; and rural America, 170; and Samuel Gompers, 96–107; and Tennessee Valley Authority, 170–71; and trade unionism, 168; and trade-union leaders, 158–59; view of Franklin D. Roosevelt, 164–65; and the Women's Municipal League, 25–26; and WTUL finances, 34, 69–71

Robins, Raymond, 16, 18, 21, 28–29,